Beginner's Guide To Camera Accessories

ALSO BY BRUCE MITTON:

PHOTO DISPLAY

Beginner's Guide To Camera Accessories

Bruce H. Mitton

DOLPHIN BOOKS

DOUBLEDAY & COMPANY, INC. GARDEN CITY, NEW YORK
1981

Library of Congress Cataloging in Publication Data

Mitton, Bruce H 1950–
 Beginner's guide to camera accessories.

 Bibliography: p. 170
 1. Photography—Apparatus and supplies. 2. Photog-
raphy—Handbooks, manuals, etc. I. Title.
TR265.M57 771.3

ISBN: 0-385-15993-5
Library of Congress Catalog Card Number 80–2426

Contents

Chapter III Camera Body Accessories

Chapter IV Film Selection and Accessories

Chapter V Camera Protection: Cleaning, Storage and Equipment Holders

Chapter VI Artificial Lighting and Lighting Accessories

Chapter VII Accessories: Convenient and Specialized

Chapter VIII Accessory Improvisation and Construction

Preface

I debated with myself whether or not to organize and write this book. My apprehension came from knowing how quickly and often cameras and their accessories change as they are replaced by new and more advanced models.

Why write a book which could have been out of date by the time it reached the reader? Accessories do not change quite as quickly as cameras. There may be slight modification or improvement, but basically they stay the same. As you read *Beginner's Guide to Camera Accessories,* you will notice that specific camera models are not covered in detail. I decided to tread lightly on topics like camera models, since specific ones that are significant today may be inconspicuous or obsolete tomorrow.

The photographic industry is highly competitive. Camera and accessory manufacturers want their share of the professional and amateur market. Names like Nikon, Minolta, Pentax, Olympus, Hasselblad, and Mamiya are cultivating buyers through innovation, pricing structure, advertising, and quality. All cameras are good— they have to be to compete with one another. Certainly one camera may have more features than another, but you pay for each feature that makes a particular camera unique.

Every camera is a quality tool, each with its own limitations and each capable of capturing quality images on film. There's one stipulation. The photographer has to know how to use the equipment, as well as understand the fundamentals of good photography.

Beginner's Guide to Camera Accessories will help you to learn how to select and use a wide range of camera accessories. The book is not an instruction manual informing you how to use your camera or how to take quality photographs. I leave that to you.

Taking pictures is a personal achievement. The reasons for taking pictures and the choosing of subject matter and equipment is up to the individual. The fundamentals of quality photography can be discovered from experience, by studying other photographers' work, by getting assistance from photography instructors and photo workshops, and by picking up knowledge found in any of the many photographic books and magazines available.

Use *Beginner's Guide to Camera Accessories* as a guide to help you understand camera accessories and their functions as tools of the trade— tools which can help you to get the precise photographic images you want.

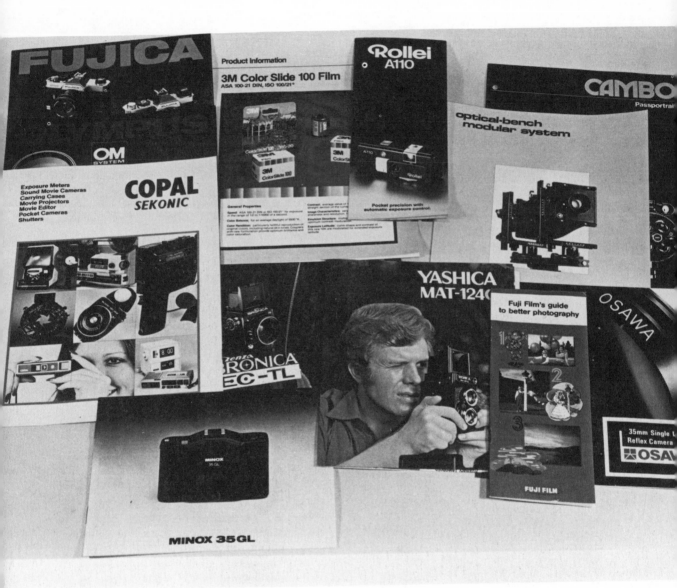

To have versatility in your picture-taking, you need to study various types of cameras and the accessories available for each. One way to learn which cameras offer the most versatility is to read equipment brochures such as the ones illustrated here.

Chapter I

Photographically Speaking

As beginning, amateur, or professional photographers, there is one problem that confronts us all. How much, and what kind of photographic equipment does each individual need? No one can answer the questions for you. The response depends on what you can afford, what kind of pictures you'll take, and how serious you are about photography.

You may like to know what kind of equipment the author of this book uses. (You would be assuming what's good enough for the author is good enough for you. I'm flattered with the thought, but I know that's not always true, because each individual's equipment needs can vary.) My answer as to the type of equipment I use would simply be a camera and, more importantly, I use my visual insight or imagination whenever I can. Good pictures are based on the subject, its handling (composition and exposure) by the photographer, and, in addition, if it's a print, the print quality.

I have not put this book together to endorse a specific brand of camera. With today's technological achievements any camera you purchase will produce quality images on film or the self-developing papers.

With that in mind, let's return to the variables mentioned in the first paragraph of this chapter, starting with cost. Obviously, if you have one hundred dollars to spend you don't buy a camera that costs two or three hundred dollars. Instead, you might invest thirty or forty dollars in a small

camera with a built-in or attachable flash unit. Then all you need is film and you're ready to take pictures.

Keep in mind that the thirty or forty dollars is an initial investment. You'll have to spend additional money on batteries, film and processing. If you decide to shoot slide film, you'll need to invest in an inexpensive slide viewer or, possibly, a slide projector and screen.

There's no secret about the cost of photography. If you take picture after picture it becomes expensive. Try keeping records of your film and processing costs over a one- or two-year period. You'll be surprised to discover how much money you spend on your photographic endeavors.

Next, consider the type of pictures you want to take. You may wonder why we didn't discuss the types of pictures first. The answer is easy. Our lifestyles and wants are ruled by our incomes. A few of us may wish to own a Mercedes-Benz, but our income dictates that we drive a Ford Pinto. The cars' costs vary, but they will both get you to work. The same principle works for cameras. They vary in cost, but all do exactly the same thing—produce pictures in one form or another.

What type of pictures would you like to take? You'll probably answer, "Well, uh . . . just pictures." No, not just pictures. There are different types of pictures—for example: landscapes, seascapes, wildlife, portraits, close-ups, action, nature, and the all-encompassing "snapshot." All

cameras do not have the capabilities to take all types of photographs.

Consider wildlife photography—not the pictures of animals taken at the local zoo, but pictures of animals captured in their own environments. A friend once asked me to look at a color print of a coyote he took with a pocket camera. Looking at the picture, the first thing I noticed was the desert vegetation, consisting of tall saguaros, cholla, prickly pear and other cacti. In the background was a rocky hill. As far as I could see there wasn't a coyote in the photograph.

"Don't you see it?" I looked again and asked, "Give me an idea where it might be." "Right there," he said as he pointed to the top of the hill. In all honesty the coyote was there, about the size of a pinhead. "Hey, that's great!" I lied.

If my friend had owned a camera with the capabilities of interchangeable lenses, and had had a 300mm telephoto lens to put on the camera, he would have had an interesting wildlife photo. As it was, all he had was a mediocre landscape with a speck of a coyote.

My friend, like many other beginning photographers, was unwilling to accept the limitations of his camera equipment. He wanted diversity in his photography. He wanted to take portraits one day and an airplane race the next. His pictures fell into the "snapshots" category—anything and everything, without giving any real consideration to the end result or the limitations of his photographic equipment.

To be versatile in picture taking, one must study the different types of cameras available and decide which ones give the greatest latitude for various photos. That's when the word "accessory" becomes important.

If you are truly serious about your picture taking and wish to get the best possible photograph of a particular subject, whether it be a landscape, portrait, or action shot, you need to study cameras offering a variety of photographic accessories.

That's what this book is all about. It's a written and often illustrated guide to camera accessories you may or may not need. It should help you to decide what you need and why.

Do You Need Everything?

As you take more and more pictures, you may find yourself thinking you never have the right equipment when you need it. It happens to every ardent photographer at one time or another. Learn to accept the fact. Don't let an occasional shortage of equipment push you into the accessory trap. Too many gadgets can distract from quality and consistent photography.

Modern cameras and their accessories are "tools, not jewels." They are meant to be used, not stored in a camera bag or closet.

Far too often the beginning photographer becomes engulfed in the accessories. When he's taking pictures, he is surrounded by the equipment stashed in the bottom of a camera bag or case. Usually it's too difficult to pull the might-be-needed gadget from the bottom of the bag, or there isn't enough time to attach the accessory to the camera before the picture he wanted to capture has passed into oblivion. When he starts spending more time fooling with equipment than he does taking pictures, he can consider himself in the accessory trap.

The secret is to have the right amount of equipment to fit your specific needs, and nothing extra to be carted around or to distract from taking the type of pictures you wish to capture on film.

Many professional photographers have two or three camera bodies and an assortment of lenses. Their reasoning is simple. The bodies hold different films, one camera for color and one camera for black-and-white. A third camera body may be a backup in case one of the other two cameras fails.

All those cameras are justifiable. A professional photographer makes his living from his pictures. He can't return to his client and make excuses for not getting the pictures he was sent, and usually paid, to get. If he did, he wouldn't be in business very long.

How much equipment do you need? Once again, it depends on what you can afford, the

type of pictures you plan to take, and how seriously you take your photography. If you choose the right sort of camera you can gradually build around it until you have the accessories you need.

Keep records of your picture-taking experiences. Make a note every time you confront a situation where you require a specific photographic accessory to get the precise picture you want. If that situation arises over and over again, you can be confident the investment in the accessory will be worthwhile.

On the other hand, if the need for a specific item occurs only once a year, then the purchase of the accessory would be foolish. You would be better off to invest in an enlargement of your favorite picture and hang it on the wall where your work could be enjoyed by everyone who sees it.

Anyone can become enticed into buying every little camera item he comes across. Wandering through a well-stocked camera store studying the display racks of items will give you the urge to buy, whether you need the gadget or not.

I have a gadget bag of accessories I purchased on impulse. Some of the items are three years old and have never been used. It's my collection of tools I treat like jewels. The accessories should have been left in the photo store to be purchased by someone who needed them.

Someday I'll pull the bag from the closet and carry it to the local swap-meet, where I'll sell the collection of accessories to other photographic impulse buyers. Until that time, those jewels are irritating reminders of squandered spending.

Where to Purchase Cameras and Accessories

When you've made plans to purchase a camera or a necessary accessory, it doesn't hurt to look for the best buy. Sometimes the accessory you want for your camera is manufactured by several different companies. The quality is usually as good as the equipment manufactured by a name-brand camera company.

If you own a Nikon, you may feel that you want Nikon lenses and accessories. That's fine. The Nikon people will be happy to have you as a loyal customer. The same goes for Olympus, Minolta, Canon, Kodak, Yashica, Mamiya, Hasselblad, and any other camera manufacturer. You certainly have the freedom to purchase what you want and can afford.

I feel the same way, to a limited degree. Some accessories must be from my camera manufacturer or I won't buy them—but not all. My thinking changed somewhat when I purchased an eyecup manufactured by the same people that made my camera. At that time it cost about $7.95.

The second day I owned the eyecup I lost it. Somehow it slipped off the rim of the viewfinder while I was carrying the camera around my neck. I spent over an hour retracing my steps trying to recover my loss. Unfortunately, I never found it.

I need an eyecup when I take pictures. It holds a corrective piece of glass that enables me to take photographs without wearing glasses. I can't afford to buy a $7.95 eyecup one day (plus two or three dollars for the corrective piece of glass) and lose it the next.

Following that experience, I spent less than three dollars for an eyecup. It wasn't manufactured by my camera maker, but by a company that specializes in camera accessories. The less expensive eyecup worked just as well as the brand-name one. I own three or four of them now, and strangely enough I haven't lost one in five years. A quick lesson in economics: There's nothing wrong with saving a little money when you can.

Cameras and their accessories can be purchased at various prices. It depends on where you buy them and how much the retailer wants to charge. Shop and compare prices.

If you have your heart set on a particular camera or gadget but can't find the price you can afford, you might want to consider used equipment. Watch the classified ads of your local newspaper, check the pawnshops and visit your local photo retailers that accept trade-ins.

Whenever you purchase used equipment, remember, "Buyer Beware." Until you've actually

taken pictures with a camera you can't be sure whether it's in good working condition. The shutter speeds may be off, the meter may not work—any number of things could be wrong.

Photography equipment retailers selling used equipment usually stand behind their products, and if something is wrong with the camera they will be willing to have the camera fixed or return your money.

You may feel the only place to buy cameras and supporting equipment is from a camera store. That's not true. Many large discount houses have camera departments. They don't offer the vast selection of photography equipment a specialty store might offer, but they do carry the majority of popular cameras and the basic accessories like flash units, tripods, and camera bags or cases.

A final, or maybe first, place to look is at a mail order outlet. Purchase a current copy of *Popular Photography* or *Modern Photography* and flip through the back pages. There you'll find a great number of mail order camera stores. Compare the prices in each of the ads, and if you know what you want, mail a check or give them a call to charge it. If the merchandise is in their warehouse, you'll have it within ten days.

The problem with mail order is the lack of personal communications. The employees are not going to spend much, if any, time discussing why you need a particular piece of equipment. On occasion they'll tell you they have something in stock when they don't. Your wait is increased and you'll become impatient. When you call them asking where your order is, they'll tell you it's on back order. Chances are you'll get angry and cancel your order. Then you try another mail order house or drive to your local retailer and purchase the item you wanted.

Misunderstandings happen in mail order, and with local retailers too. I've been waiting for an accessory I ordered through a local retailer for over five years. Of course I got tired of waiting and bought the item from another merchant, and I no longer deal with the one that promised equipment but didn't deliver.

There are some additional problems you should be aware of in ordering from mail order houses. It may be inconvenient to wait for par-

ticular accessories, and in rare cases you'll order from a company that exists one month and files for bankruptcy the next. Also, be very sure what you're getting when you order. At times, some of the mail order companies don't tell everything in their advertisements. For example, you may order a lens, expecting it to come with a protective case. Not so. The mail order people will send you the lens and an invoice. At the bottom of the invoice will be a little note saying something like, "We can supply you with a case for the lens you just purchased for $5.95." It's their way of trying to make a little more profit. When in doubt, ask before you commit your order.

Your local retailer will give you all the help you need in choosing a camera and answering your questions. Mail order can save you money, providing you know exactly what you want.

Modern Photography and *Popular Photography* have a wealth of information on photography equipment and picture-taking techniques. In addition, each issue has a list of mail order companies which sell photographic equipment at reasonable prices. *Petersen's Photographic* magazine has plenty of photo-related information and limited mail order listings.

Here's a small sample of mail order camera equipment catalogs you can write for once you know the companies' addresses.

Choosing a Camera

Decisions, decisions. Which camera do you need? This book is about camera accessories, not specific cameras. There are numerous other books on the market that will inform you about the pros and cons of particular types of cameras. All I will attempt to do is give you an idea of camera variation, hoping it will give you a starting point in your search for the right camera for your own photographic needs.

One thing to remember: Generally, the more expensive your camera, the more versatile it will be. Picture taking flexibility comes from the camera's capabilities to accept accessories.

The Self-Processing Camera

At one time, when the word self-processing was mentioned, the only name known was Polaroid. Now the Eastman Kodak Company, with its own line of self-processing cameras, is competing face to face with Polaroid.

The consumer can only benefit from the competition between the two companies. Already Polaroid has introduced their sonar, self-focusing cameras. As I write this, Polaroid is introducing a new film called "Time-Zero Supercolor." The film will speed up the processing time and provide improved color. We can only wait to see what the Eastman Kodak Company will introduce in the spirit of competition.

Some readers may be thinking the self-processing cameras are not the "real thing" for picture

taking. Oh, yes they are! If you accept the camera's limitations, you can learn a lot about photography without having to wait two or three days to get your prints back from a photo processor.

The self-processing cameras are for mass market appeal. They are for the friends and families that get together for picnics, holidays, parties, and so on. This type of camera is a crowd-pleaser. There's no better way to capture the mood of an event and share it with the participants almost instantly.

Another practical use of the self-processing camera or film is to aid in composition. Sometimes, especially if you're shooting studio or contrived pictures, what you see through your eyes may appear differently in printed picture form. By taking a preview picture with your Kodak Colorburst or Polaroid SX-70, you can get an idea of how the finished photo will look. Many professional photographers use the instant developing films through their large- or medium-format cameras for just such a purpose.

Depending on the model, the cost of the self-processing cameras is relatively low, and there are few accessories. One does not get the versatility of interchangeable lenses or the latitude of quality exposure control. Nor do you get slides or negatives, unless you take your print to a photo processor and request that a negative or slide be made. All offer built-in or optional flash attachments.

If you are willing to accept the limitations of the Kodak and Polaroid self-processing cameras, you will get many instantly-pleasing pictures as well as help in subject composition.

This Kodak Colorburst 250 instant camera features no-focus operation, producing color pictures from four feet. When using the built-in flash, pictures can be taken in the four- to ten-foot range. Photo courtesy the Eastman Kodak Company.

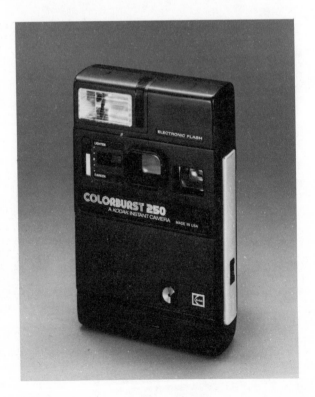

The 110 Pocket Cameras

Like the instant-processing cameras, the pocket 110's were manufactured for mass market appeal. They are simple to load with film (open the back of the camera and drop in the 110 film cartridge), and they are easy to use.

The pocket cameras must be popular or there would not be such a wide range of manufacturers (Kodak, Keystone, Canon, Agfa, Minolta, Hanimex and Pentax, to name a few) fighting for a share of the market.

Like the instant cameras, the 110's (negative size 13×17mm) have their limitations. Many are preset aim-and-shoot cameras without the availability of any accessories other than some sort of supporting flash.

With so many 110 camera manufacturers, there were bound to be competitive innovations in an attempt to capture a larger piece of the market. Two examples are the Kodak Tele-Extralite and the Minolta 110 zoom Mark II single-lens reflex.

The Extralite offers the choice of two lenses, both built right into the camera. One is for normal photography; the other allows for modest use of a telephoto lens. The two lenses allow for limited diversity in your picture taking.

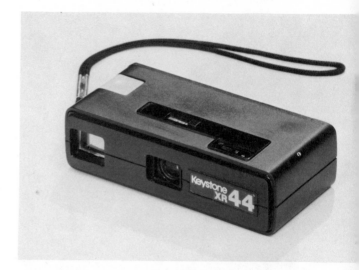

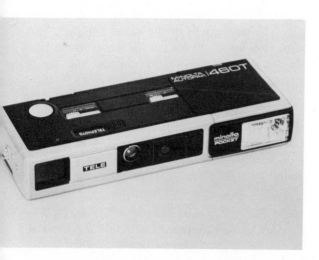

Another two-lens 110 camera. Small button on top slides to set normal or telephoto operations. Flipflash for low light operation. Photo courtesy the Keystone Camera Corporation.

An ultra-small 110 cartridge camera from Rollei. It weighs a mere six and a half ounces and has a flashcube attachment—the type of camera you can carry anywhere and have ready to take pictures in an instant. Photo courtesy Rollei of America, Inc.

A simple pocket 110 with normal and telephoto lens operation. Built-in flash for shoot-anywhere convenience. Photo courtesy the Minolta Corporation.

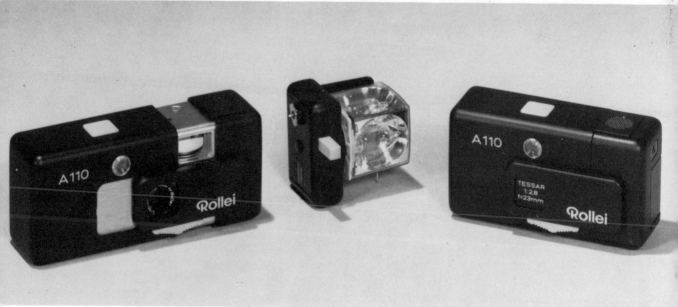

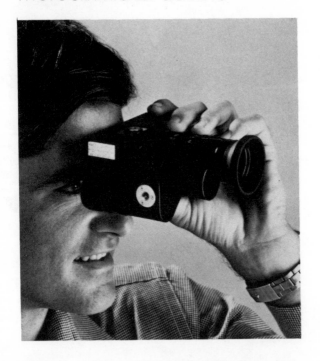

Here's a combination binocular and 110 camera from Tasco called the bino/cam. Photo courtesy Tasco Products.

The Minolta's 110 zoom provides an assortment of focal lengths ranging from 25 to 67mm, plus through-the-lens viewing. The camera offers filters and an electronic flash among its limited accessories.

The Pentax System 10 was the first pocket camera to offer interchangeable lenses and an array of accessories. Besides the small assortment of lenses, there's a winder that can be added to the bottom of the camera. Filters, lens caps, lens hoods, and close-up lenses are available. If the System 10 catches on with the buying public, other camera manufacturers may enter the market with their own pocket camera systems.

The 110 cameras are small and easy to use. The pricing structure is reasonable and there is a wide selection to choose from, making it possible to find the right pocket camera to fit your needs.

The Minolta Mark II camera looks like a 35mm format. It's not. Instead, it's an automatic 110 cartridge camera with a built-in 25 to 67 zoom lens. It has close-focusing capabilities to 7.7 inches. You set the aperture; the camera sets the proper shutter speed. Photo courtesy the Minolta Corporation.

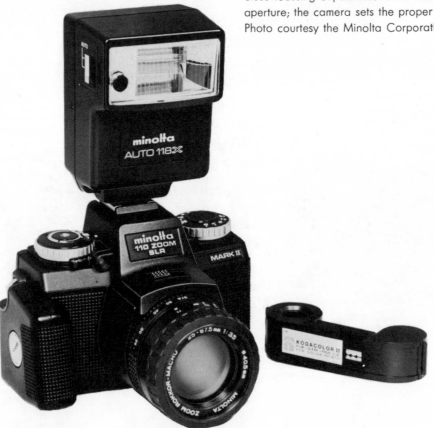

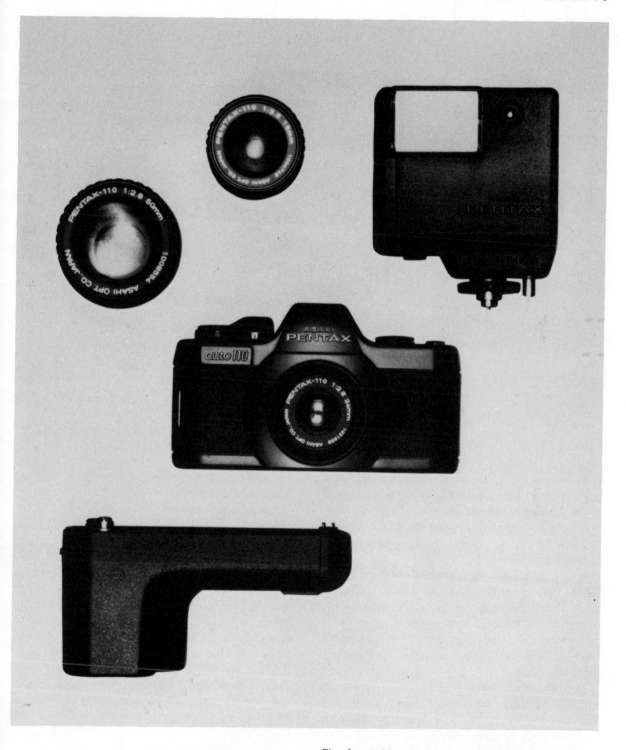

The first 110 camera system from Pentax. Winder, interchangeable lenses and other accessories are available. Photo courtesy the Pentax Corporation.

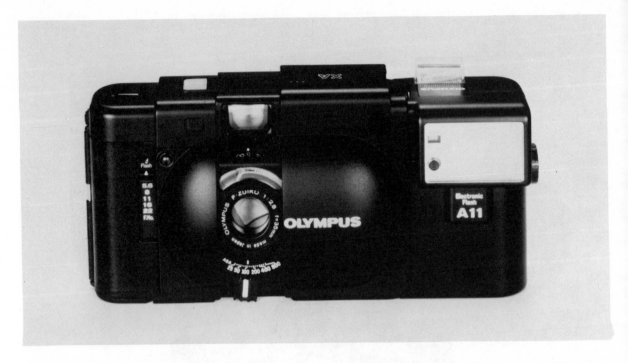

A small 35mm camera from Olympus. Flash attachment is optional, but when attached to the camera it looks like an integral part of the unit. Photo courtesy the Olympus Corporation.

The 35mm Cameras

Subcompacts, rangefinders, viewfinders, and the popular single-lens reflex (SLR) are names given to the variety of 35mm cameras. They all have one thing in common; they use the 35mm (negative size 24×36mm) film cartridges, which offer a superb assortment of films.

Rollei, Olympus, and Minox are manufacturers that offer the smallest 35mm cameras. They have their limitations and do not accept interchangeable lenses. For the photographer who believes in the 35mm film size, the subcompacts make good, take-anywhere cameras for catching the unexpected.

The rangefinder and viewfinder cameras are somewhat similar. You do not look through the lens for composing your pictures. Instead, you look through a direct vision viewfinder that's away from the lens.

The viewfinder cameras are relatively simple in their operation. Some have fixed-focus lenses, or they have a symbol-type scale for limited focus-ing. These symbols would represent portrait range, medium range, and infinity.

Rangefinder cameras do have a method of focusing. When the subject is brought into sharp focus, instead of appearing as a blurred or ghostly image through the viewfinder, the photographer is ready to shoot. Canon, Olympus, Leica Konica, Minolta, Yashica, Ricoh, Rollei and Vivitar are among the vast selection of 35mm rangefinder and viewfinder cameras to choose from. Some offer built-in electronic flash, while others have attachable flash capabilities.

Very few of the rangefinders accept interchangeable lenses. That immediately puts restrictions on the camera's picture-taking capabilities. Most offer automatic exposure control, with some allowing for a manual override for depth-of-field or shutter-speed control.

The single-lens reflex camera systems are among the most popular cameras today. Pentax, Yashica, Contax, Nikon, Olympus, Canon, Mi-

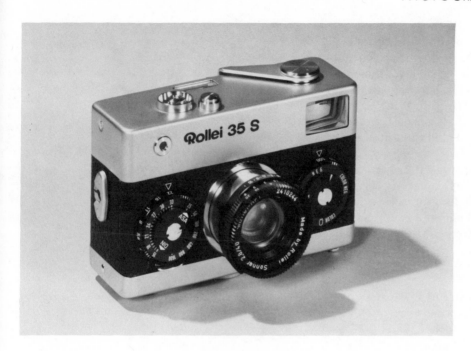

This Rollei full-frame 35mm camera is small but offers both shutter and aperture control. Photo courtesy Rollei of America.

The Minolta Hi-matic AF 35mm camera has automatic focusing and exposure control, plus the convenience of a pop-up electronic flash. Photo courtesy the Minolta Corporation.

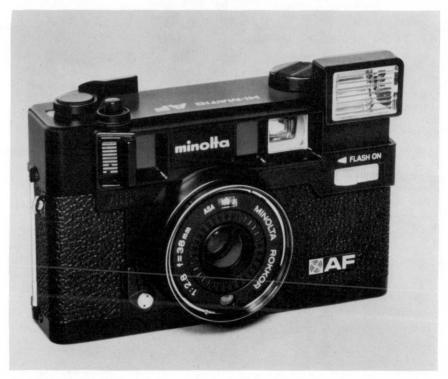

nolta and Leica are some of the best known because of advertising, innovation or reputation. These cameras and others, depending on the model, offer photographic versatility. There's a long line of interchangeable lenses to fit these cameras. Winders, motordrives, focusing screens, filters, flash units, and bellows are just a sample of the many accessories that will fit most of these cameras.

Not every model of a particular camera brand will accept every accessory. Some models will allow for interchangeable focusing screens while less expensive models will not.

Today's camera producers are leaning toward

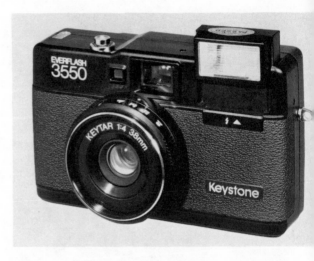

The simple 35mm Everflash camera from Keystone has built-in electronic flash that is turned on automatically when the flash is pushed up. Photo courtesy the Keystone Camera Corporation.

A beginner's set from Olympus. The kit includes a 35mm rangefinder camera, flash and carry case. Photo courtesy the Olympus Corporation.

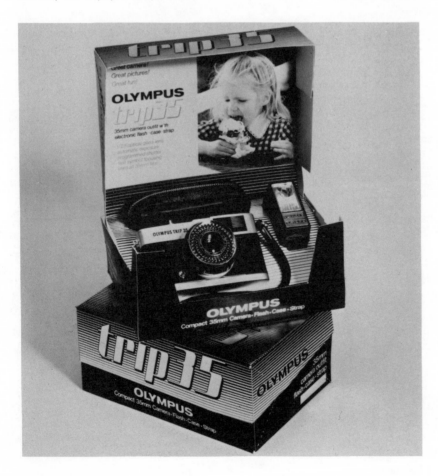

aperture- or shutter-priority automatic exposure. Some cameras offer both, plus the advantage of manual override so you can use your creative control in your picture taking. Depending on the model of camera, you may have to set the aperture (lens opening), and the camera will then automatically set the correct shutter speed for proper film exposure. This is for aperture-preferred or -priority cameras. The opposite, shutter priority, allows the photographer to select the shutter speed; the camera will then automatically set the aperture (lens opening) for proper film exposure. There may be some argument about which system is better. To please everyone, some cameras have both systems.

Frankly, it's confusing to choose which you want, unless you simply don't want an automatic camera. Before you buy any camera you need to see them all. While looking, pick up and hold the cameras you are considering. Get the feel of the equipment. Is it too big or too small? Take a lens off and put it back on to see just how fast and easy it is. Look through the viewfinder in both a well-lighted and a dimly lighted situation. Make sure you can read your exposure controls.

If you want just an automatic camera, no problem. If you want an automatic with manual override, pick a camera that offers it.

Shopping for a new 35mm camera is not easy; there are just too many to choose from. See what the camera offers. If it has functions you don't think you'll need on a regular basis, why pay for them? Remember, your prime interest is to get good pictures without having to spend countless seconds fooling with all the dials and buttons on a camera.

This can happen when there are too many dials. A friend offered to show me his new camera. I asked questions about this and that and he didn't know the answers. He had trouble comprehending everything his camera was capable of doing. In time, I'm sure he'll master the precision of the camera and then realize he purchased more camera than he needed.

These interchangeable lenses from Yashica give versatility to 35mm photography, from super-wide-angles to mirror telephotos. Photo courtesy Yashica, Inc.

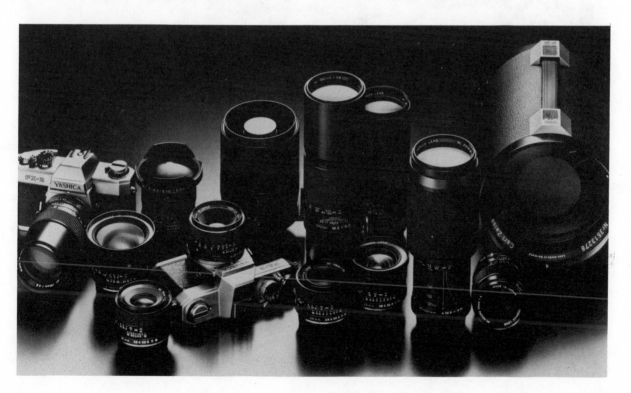

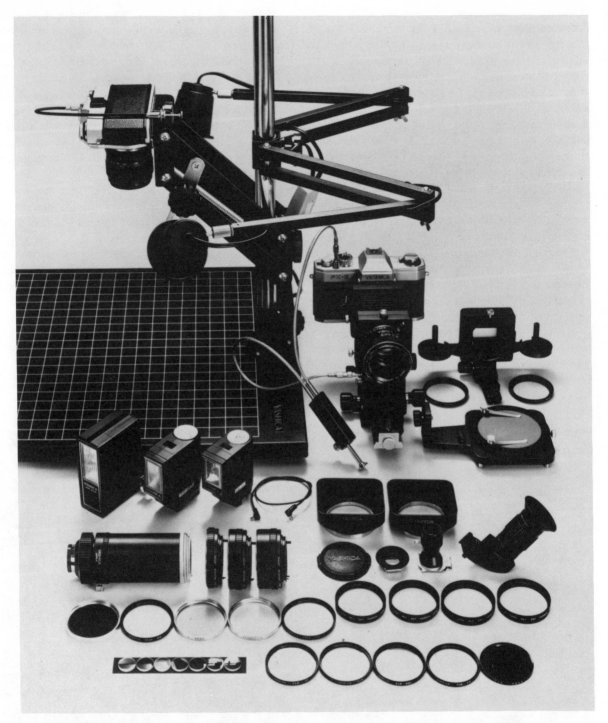

Yashica FX-2 35mm camera accessories for all types of close-up work: copy stand, bellows, slide copier, correction lenses, right angle viewfinder, extension tubes and more. Photo courtesy Yashica, Inc.

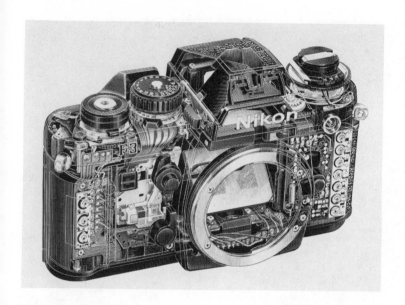

The see-through illustrations of the Contax 139 Quartz and Nikon F3 camera give you an idea of the sophistication and electronics incorporated into today's cameras. Photos courtesy Yashica, Inc., and Nikon.

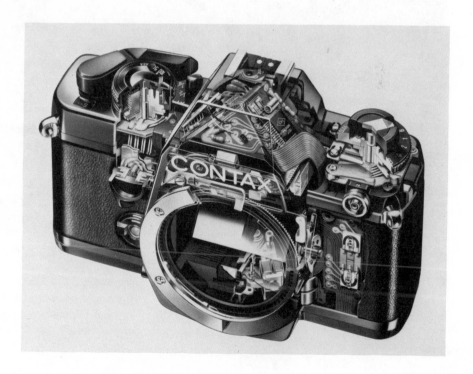

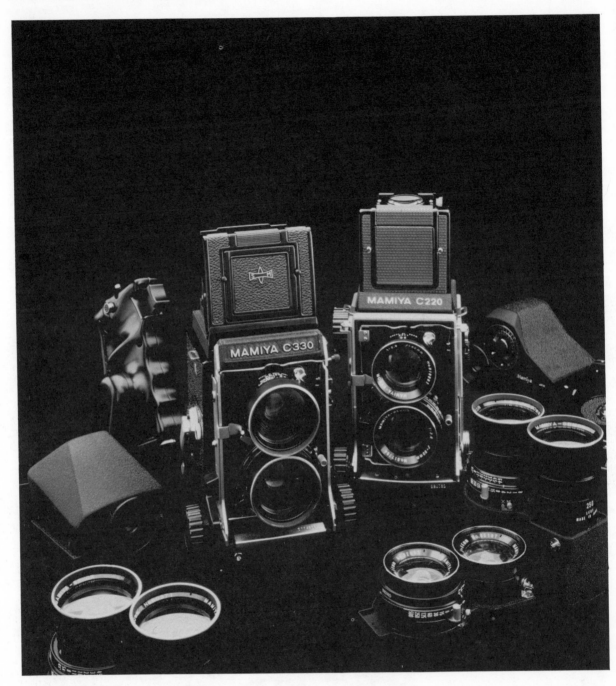

The Mamiya C330 and C220 twin-lens reflex cameras.
The only twin-lens reflex equipment that offers
interchangeable lenses and a wide assortment of
accessories. Photo courtesy Bell & Howell/Mamiya
Company.

The Medium-Format Cameras

We've gone from no negative to 110 and then to the popular 35's. Next is the medium-format cameras, which produce a variety of negative sizes. There's the 2¼"×2¼" (6 cm.×6 cm.) which is a fairly large, square negative. The Hasselblad, which offers numerous accessories (as well as the reputation of having gone to the moon) and the Rolleiflex are two cameras that produce the square image using the single-lens reflex method. Both are very expensive cameras.

The Yashica Mat 124G is an inexpensive 2¼"-square-format camera. It's a twin-lens reflex, with one lens for viewing and one for shooting the picture. It has fixed-mount lenses, compared to the Mamiya C220 and C330F, which are the only twin-lens reflexes offering interchangeable lenses and a sizable selection of accessories.

After the 2¼ or square-format cameras, one can look at the single-lens reflex camera like the Pentax 6×7 or Mamiya RB 67 which produce a 2¼"×2¾" (6 cm.×7 cm.) negative. Both are camera systems offering accessories and lenses.

Mamiya also makes the 645 cameras. The negatives or transparencies are 2¼"×1⅝" (6 cm.× 4.5 cm.) in size. Mamiya manufactures a fine line of accessories and lenses for their cameras.

Two other cameras in the medium-format range are the Mamiya Universal Press and Rapid Omega. Both use range-finding focusing as opposed to through-the-lens viewing.

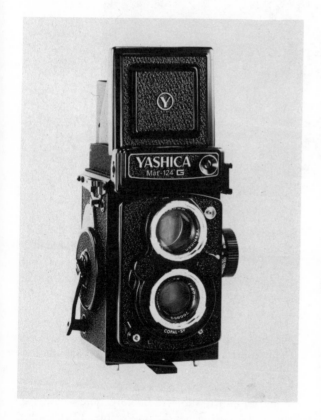

The twin-lens reflex from Yashica doesn't offer interchangeable lenses, but it does have lenses that attach to the lens already on the camera for limited versatility. Photo courtesy Yashica, Inc.

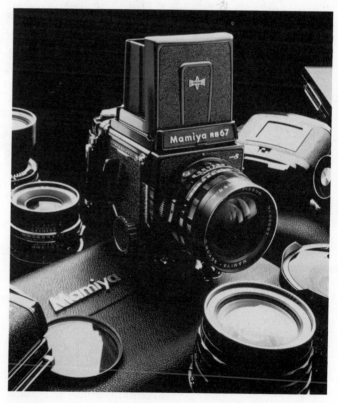

The Mamiya RB 67 Pro-S and some of its many accessories. A medium-format camera with a 2¼"×2¾" image production. Photo courtesy the Bell & Howell/Mamiya Company.

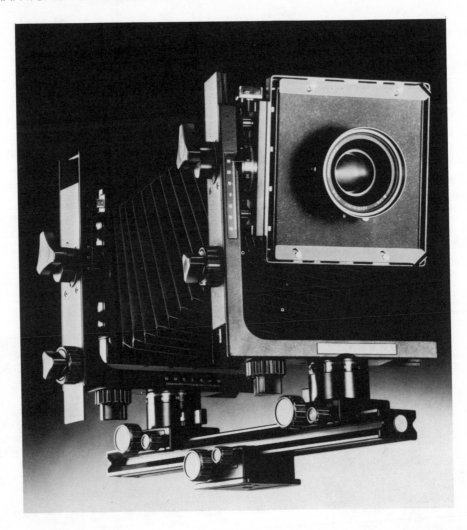

A precision view camera. Note the dials and scales on the camera. The photographer needs to understand the camera's operation. It's not a beginner's tool with aim and shoot characteristics. Photo courtesy Calumet Scientific, Inc.

Large-Format View Cameras

Big negatives or transparencies call for big cameras. These cameras can produce 4″×5″, 5″×7″, and even 8″×10″ exposed sheets of film. Many photographers swear by large-format cameras, believing the clarity of the large negative or transparency is the only way to take pictures. Photo editors for advertising firms and some magazines will agree. It makes their job of viewing large transparencies much easier, with less eyestrain.

One definite advantage to the large-format view camera is the distortion control capabilities.

The tilts and swings of the camera's bellows are useful tools for studio and architectural photography.

What you see through a large-format camera is an upside-down subject, making quick composition and focusing nearly impossible. If you are a beginning photographer planning to take pictures of sporting events or to shoot rapidly, you don't want a view camera. The view cameras are not convenient to use. They are precision instru-

ments that require a patient and skilled photographer.

Calumet, Linhof, Horseman, Toyo, and Cambo are some of the names of large-format camera manufacturers. The cameras are expensive, as will be your film and processing costs. There are a number of accessories for the view cameras, including film backs, which use the self-developing films. There is no doubt that the view cameras are capable of producing extraordinary results. When you place a 35mm slide next to a 4″×5″ or a 5″×7″ transparency, there's something that says, "Big can be beautiful."

Special-Purpose Cameras

Briefly I should mention that there are cameras designed for specific uses. One is the Nikonos II, which is a rangefinder 35mm camera designed for taking pictures underwater. A limited-use underwater camera is the Minolta 110-format Weathermatic-A which can be taken to a maximum depth of 15 feet. It's more of a "safe from moisture" camera that would be safe to use around the local swimming pool. Another special-purpose camera is the 140-degree Widelux, which takes panoramic type photos. The lens moves, capturing segments of a scene on film. Both are limited-use cameras, unless you specialize in underwater photography or in landscapes.

No Help So Far?

By now you're ready to take this book back to the library or return it to your bookstore and ask for a refund. You still don't know what type of camera you should own. You do know that everyone's picture-taking needs vary, and what you purchase depends on your personal likes and dislikes.

I have hardly skimmed the surface of the cameras available. I did mention many of the names of camera manufacturers you have probably heard from friends, read in advertisements, and seen on television.

The only way to choose a camera is to go look at them at your friendly photo supply retailer. Make sure the salesperson you talk to behind the counter knows camera equipment and can answer all of your questions. If the salesperson is too quick to recommend "the right camera for you," be wary. He or she might be trying to sell you more than you need, or trying to liquidate a model that's about to be changed by the manufacturer.

Be honest with yourself. Are you looking at a particular camera because your best friend has one? Are you planning to own the camera because it's the most expensive camera you can buy? If these are some of the reasons for your looking at a particular camera, you had better give your picture-taking needs a little more thought. Keep in mind that *people* take good pictures; the camera is only there to help in as many ways as it can.

Once you own a camera, or maybe before you trade in one that no longer fits your photographic needs, you should consider the availability of accessories. That's how this book will help. It's a guide to camera accessories and how to use them. Many may not be needed for your type of picture taking, or maybe they just aren't made for your camera.

Photography is something that grows. Your picture-taking attitude may change tomorrow. Today you only want to take pictures of landscapes; tomorrow you may want to learn the art of studio portraiture, and when you're ready, who knows, you may try your skills with *National Geographic*.

Your photography equipment can be built into a family of useful and practical tools that can help you to broaden your knowledge and understanding of photography.

Prices and Model Numbers Subject to Change Without Notice

The camera market is competitive. The manufacturers and distributors do everything they can to sell their equipment to the millions of people

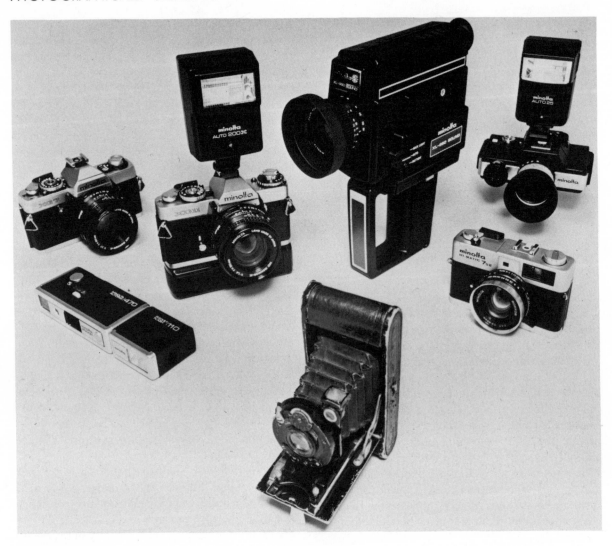

These Minolta cameras, both still and movie, show how cameras have changed. The camera in the foreground is Minolta's first camera, the Nifcalette. Photo courtesy the Minolta Corporation.

who take pictures. Some companies may offer a $30 rebate once you purchase their cameras. Another may give you discount coupons toward the purchase of lenses. So the fight goes on.

Another method of capturing the camera buyer is innovation—the introduction of a new camera with new features. Does that make your older model obsolete? My personal opinion is no, but some photographers may rush down to their photo retailer to trade their older model in on the newer one. The decision to keep up to date is up to the individual. If you think owning a camera with both aperture- and shutter-preferred automatic exposure will help you to take better pictures, then buy one. New camera models wouldn't be introduced if the manufacturer weren't sure someone (preferably thousands) would buy it. Generally, the camera *bodies* change, not the entire camera system of accessories and lenses. But even entire systems are changed when a better or preferred system is found. You can bet your lens cap that the camera manufacturers do not want to lose their share of consumers who buy photographic equipment.

Chapter II

Lenses and Lens Accessories

The beginning photographer who has taken a number of pictures in a variety of environments understands the limitations of a single lens. Too many good pictures can be missed when a camera is restricted to one lens.

Not all cameras offer interchangeable lenses, and those that don't offer the feature shouldn't be misjudged. A skilled photographer under-stands what a single lens is capable of capturing and at the same time understands its restrictions. The secret to a fixed-lens camera is to use it to its fullest, exploring every conceivable subject-

Nikon manufactures seventy lenses for use with Nikon cameras, ranging from the super-wide-angles to the super telephotos. Photo courtesy Nikon, Inc.

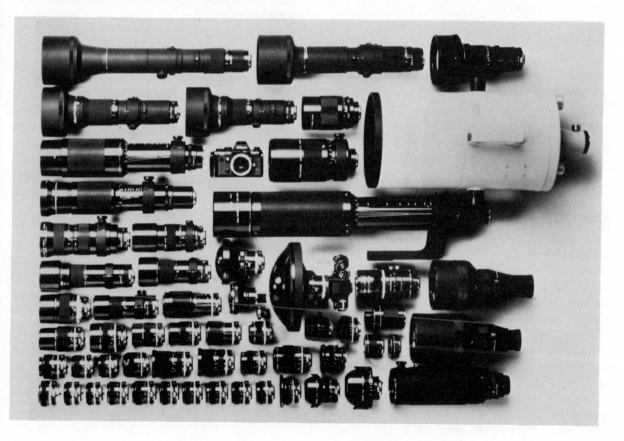

to-lens relationship. The end results will be pleasing photos.

Cameras that do offer interchangeable lenses may cause some confusion. Which lens or lenses will be needed to give the photographer the best results and greatest latitude in various photographic situations? For the most part, it's not practical to own a great number of accessory lenses, because you can't haul them around without getting bogged down, and also because they are expensive camera accessories.

You need to shop around for the lenses you need. Compare prices, and compare the overall quality, but before you decide to choose one or two accessory lenses, you need some knowledge of what's available and how to get the most out of a particular lens.

Focal Length

The term focal length can be easily understood if we correlate the term with lens size. In other words, a 50mm lens has a focal length of 50mm. A 150mm lens has a focal length of 150mm. Actually, focal length is determined by focusing the lens on infinity and then measuring the distance between the optical center of the lens and the film plane. This is a loose definition of the term, stated to give you a better understanding of what the focal length is.

The focal length of the lens will establish the size of the final image of your subject imprinted on the film in the camera. The subject's size will increase as the focal length gets longer and will shrink in size as the focal length gets shorter.

At this point you might be a bit confused. Don't be. Think of focal length as lens size and lump your choice of lenses into three groups: wide-angle, normal, and telephoto. Wide-angles will have small focal lengths and telephotos will have large focal lengths. The normal lenses are usually sold with a camera and you can use its size as a median. A normal lens is considered about the size of a diagonal (in millimeters) drawn across the film used in the camera. A

50mm would be about normal for 35mm cameras and an 80mm would be about normal for a medium-format camera using 120 film.

Lens Speed

You may have heard some of your picture-taking friends refer to lens speed. One lens is fast, another is slow. Before we can discuss lens speed, we have to make sure you understand the term f/stop. It's nothing more than a number given to various openings in the lens diaphragm. The diaphragm hole is the aperture, and the various sizes of the aperture are called f/stops (Fig. 1).

This variation of the aperture or diaphragm decides whether a lens is fast or slow. The larger the maximum opening (f/stop) the faster the lens. When I say the larger the opening, I mean the smaller the f/stop number. For example, a lens with a maximum 1.2 f/stop has a larger aperture and is a faster lens than, say, a lens with a maximum f/stop of 3.5

If you're still confused, forget everything you just read and remember only the following: A fast lens allows more light to strike the film, using faster shutter speeds. This is important when you are shooting with available light rather than using flash or studio lighting. You pay extra for the faster lenses and, depending on your photography and the type of film you use, you may or may not need a fast lens.

Angle of View

The angle of view you have for each picture will decide what sort of lens you need to use. A wide-angle lens, just as the name states, is going to give you a wide angle of view. It's going to capture a broad area, which can be very important in composing some of your pictures.

If you were taking pictures inside a room and wanted to capture the entire room on film, you would need a lens that offers a wide angle of view. If you were using a 35mm camera, you

Interchangeable lenses give the photographer versatility in the angle of view. These four pictures were taken from a single location. A 28mm and a 50mm lens were used, and two pictures were taken at different points within the range of a 75-150mm zoom lens. The same subject is photographed, but the composition is altered with the use of interchangeable lenses.

The same picture, using a normally balanced daylight film, compared to a photograph taken with Kodak Ektachrome Infrared film. Photographs courtesy the Eastman Kodak Company.

Creative exposure control is available on many cameras. You can increase or decrease the film's saturations, as illustrated by this silhouette of a cowboy.

This flower was taken using Kodak Ektachrome balanced for tungsten lighting. The bluish cast gives an artificial quality to the subject.

Kodak Ektachrome film balanced for daylight was used to shoot these performers under bright floodlights. The incorrectly light-balanced film gives a warm cast that may or may not be desirable.

Kodak Ektachrome film balanced for tungsten lighting was used to take this picture and produced the right color renditions.

Polarizing filters can produce crisp, dark blue skies, providing the sun is in the correct position. Here the line of demarcation between the zone of polarization can be seen where the sky goes from light to dark blue.

Electronic flash is balanced with daylight film. Unusual results can be produced by getting the flash away from the camera, as illustrated with this back-lighted tarantula.

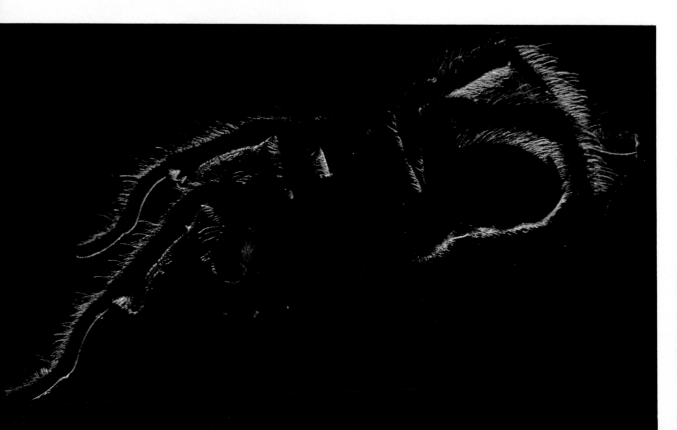

might need a 24mm, 28mm or 35mm wide-angle lens. For a medium-format camera, you might need a 40mm or 50mm lens. (Notice the focal lengths of the lenses vary. Remember, a normal lens is about the same size as a diagonal drawn through the film used.)

You might ask why you can't use a normal, 50mm lens on the camera. You could, if you could cut out one of the room's walls and stand far enough away so the entire room could be seen through the viewfinder. Let's say you were standing up against one wall of the room. First you put a 50mm lens on the camera and look through the viewfinder. The normal lens would cover about 50 degrees. Without moving, put on a wide-angle lens and look through the viewfinder. You would be able to see about 70 degrees. Put on a telephoto and all you could see would be about 10 degrees of the room. This variation in degrees of vision is what gives versatility in photography when using interchangeable lenses (Fig. 2).

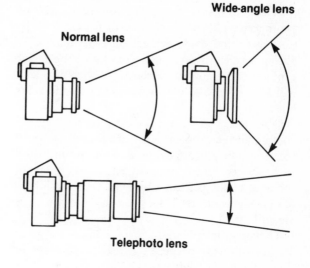

FIELD OF VISION

Fig. 2.

Wide-Angle, Normal and Telephoto Lenses

I've already said a *wide-angle lens* is capable of capturing a large area of space. That makes it practical when your movement is restricted and you can't position yourself to use a normal lens to capture the picture you want.

Another advantage to the wide-angle lens is its depth-of-field capabilities. This is the area that will stay in focus in front and behind the main subject in your photograph. The depth-of-field varies as you use larger aperture openings and close focus.

The disadvantage of the wide-angle lens is the subject distortion it can cause when you get in very close and shoot at strange angles. It's not the type of lens you want to use when shooting portraits. If you do, your subjects are not going to be pleased with the results.

A *normal lens* can be an all-around picture-taking tool. Some photographers shy away from normal lenses for one reason—because everyone else is using them. They want their pictures to be somewhat different, so they use a telephoto or slightly wide-angle lens as their normal lens.

Personally, I feel the idea is a little foolish. Composition, exposure and subject matter is going to make or break the final picture. If you can take good pictures with a 50mm lens, why use a 35mm or 105mm lens? Use whichever lens it takes to get the pictures you want.

Fig. 1.

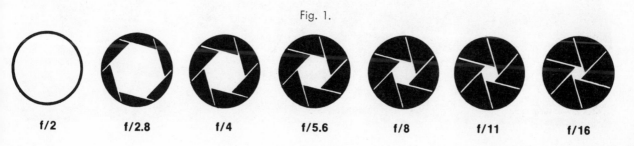

f/2 f/2.8 f/4 f/5.6 f/8 f/11 f/16

Telephoto lenses are needed for some types of photography. They enable you to get in close to a subject. You can't run out on a football field during a game to get a nice close-up of the facial expressions on the quarterback. A telephoto lens will let you zero in on the subject from the sidelines.

Long lenses are generally slow lenses, and to compound the problem some are literally long in size and difficult to hand-hold. You end up using slow shutter speeds and large f/stops, reducing the area of sharp focus. But even with the inherent problems or restrictions, a telephoto can be a versatile tool.

The small telephotos 70mm–150mm, are great for portrait work because they enable you to stay away from the subject and still fill the film frame. Your subject will be more comfortable with the added space between himself and the camera. Also, this sort of lens tends to flatten perspective and therefore presents a more flattering portrait.

The telephotos can also add dramatic effects to your photographs by compressing and enlarging your subjects. A large, glowing sun in your sunsets always impresses people. The telephotos can alter reality and fool the viewer. I remember seeing a beautiful shot by photographer David Muench, taken in Monument Valley. It showed an Indian hogan at the base of some weather-worn sandstone called Yebechai Rocks. When I visited Monument Valley I searched for the location. Two days later I found the hogan. Yebechai

Telephoto lenses allow you to get in close to the subject without getting in the way. Using a 150 mm lens, I was able to catch the action at the finish line, showing the victor and the loser of this motocross bicycle race.

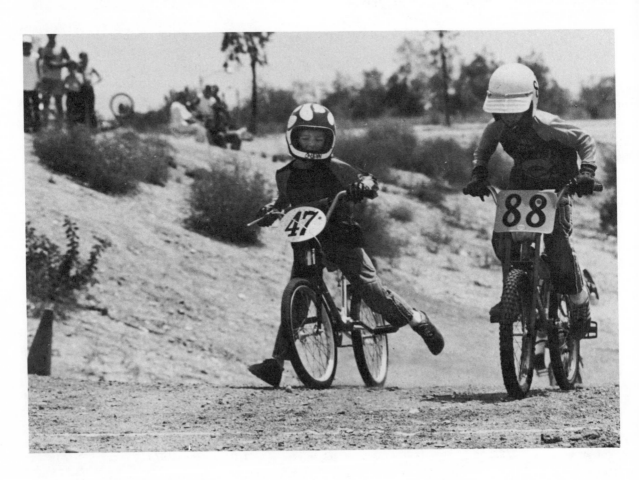

Rocks was several miles in the distance. The long lens used by the photographer to compress the distance had fooled me, but his photographic results were impressive.

Zoom Lenses

Ideally, the way to have picture versatility is to have a number of lenses on one camera. This is possible with the use of a zoom lens, which offers a number of focal lengths. A zoom can offer a range from 35mm to 70mm, 75mm to 150mm or even 100mm to 300mm. With a zoom you get a wide range of lenses but limited lens speed. There are a number of lenses inside a zoom, which makes it fairly long in size. Some of the wide-to-normal-lens zooms are fairly compact and quite convenient to use. Some not only offer a wide range of focal lengths but also have close focusing abilities. It's like getting more for your money.

A zoom is a valuable tool for all sorts of photographic situations. The slow f/stop and long lengths of some mean sacrificing speed and stability, but it is well worth the sacrifice when you think of the versatility you get from several focal lengths in a single lens. You'll have to be the judge.

What Lenses Do You Need?

Owning two or three lenses should give you considerably more diversity in your photography. I worked for a regional publication as a photographer and never used more than three lenses: a 28mm, a 55mm macro and a 105mm telephoto. For the type of photography I was required to do, that was all I needed—no more and no less.

You need to try to gear your equipment to your photographic needs. It's possible you may only need two lenses, like a 35mm to 70mm and a 100mm to 300mm zoom. You'll be sacrificing lens speed, but that's all. The small zoom will offer limited wide-angle and normal photog-

raphy, while the longer zoom will give you pretty good telephoto capabilities. Using just those two lenses may give you all the focal-length variation you'll ever need.

If you can obtain the versatility you need from two or three lenses, why own five or six? Carrying all of them in a camera bag or case is no easy task, and if you have to change lenses often you can waste valuable time.

Buying an accessory lens may be difficult. There's usually a vast selection to choose from. No doubt you want to learn everything you can about photography and the various lenses, but be sure you're not going through a fad when you buy. For example, you might think the only good pictures are taken through a 600mm telephoto lens. You buy one and shoot two or three rolls of film using the lens. As the novelty wears off you're stuck with the lens, which no longer offers any appeal. Or, you might decide that a different camera or format is more to your liking. If you can't sell your equipment through the want ads of a newspaper you may have to trade the equipment and take a considerable loss.

Be careful in buying some lenses. Make sure you're going to use them and that they're not just a passing fancy, because quality lenses are expensive, and there's no reason to buy one you're not going to use on a regular basis.

Specialty Lenses

Camera and lens manufacturers try to offer equipment to give you the flexibility you need for a wide range of photographic situations. Some offer specialty lenses.

Many view cameras offer bellows constructions, which allow for a number of tilts and swings for perspective control. The feature is a must for architectural pictures. If you don't have the feature, the lines of buildings begin to tilt and slope, giving the viewer the impression that the building is falling over, slanted or distorted.

The 35mm cameras don't offer tilts and swings because they don't have a built-in bellows. If you were to shoot a building at close range and have to tilt the camera skyward, you'd end up with a

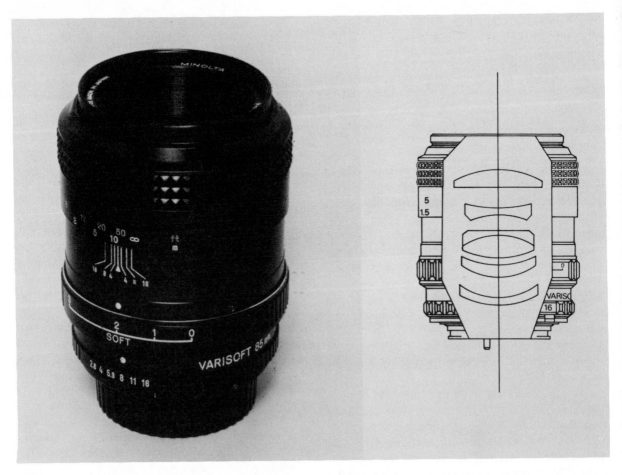

distorted picture. To help with the problem, some camera makers offer a shift lens, such as the Zuiko 35mm, f/2.8 shift for Olympus cameras and the Canon FD 35mm f/2.8 SSC TS shift.

Not all the shift lenses offer the same capabilities. Depending on the construction, one may offer a little more control in the tilt or swing. When you need to control the distortion, the front of the lens actually shifts up and down or to the left or right. This can be a useful feature for the architecturally inclined photographer.

Other specialty lenses include the 85mm f/2.8 Varisoft Rokkor-X for Minolta cameras, which can be used for portrait or mood photography. The four-position adjustment ring varies the image from sharp to soft focus.

Close focusing has become increasingly popular. Insect life and "the little things" have opened up a whole new world to the photog-

A special-purpose Minolta 85mm Varisoft Rokkor-X lens which allows sharp-to-soft focus without the need for an additional soft-focus filter. Photo courtesy the Minolta Corporation.

rapher. At one time, if you wanted to do close-up photography, you would purchase special camera attachments or lenses made specifically for close focusing. The attachments and macro lenses are still available, and so are a whole new line of lenses that offer close-focusing capabilities. The Vivitar Corporation has been a leader in zoom lenses that offer close-focusing capabilities. Other independent lens manufacturers like Sigma, Soligor and Tamron also offer lenses with the macro or close-focusing abilities.

Other lenses that may be of interest to some photographers are the super wides. The pictures they produce are circular or arching in appearance and are often used to show interiors of

large buildings like the Astrodome in Houston. The superwide lenses are expensive, and the beginning photographer would find their novelty diminishing after a roll or two of film.

Mirror Lenses

Normal telephoto lenses get longer and longer the more powerful they get. Try carting around a two-foot lens for a day and you'll think you've grown a third arm. There is an alternative to the super-long telephoto lenses, called a mirror lens, which is similar in its working to some telescopes. Although it has its pros and cons, it works.

The unique design of the mirror lenses makes it possible to have 500, 600 and 800mm telephoto lenses that are only five to eight inches long. They are lightweight and can even be hand-held if you're using a fast enough shutter speed.

Sad to say, the mirror lenses have only one f/stop, so you don't have any depth-of-field control, and exposure is controlled by shutter speeds of the camera. The front of the lens is large, and

it's impractical to use filters with the lenses. However, some do offer filters that go between the camera and the lens, allowing smaller filters to be used. Some even have built-in filter systems which allow you to dial in a limited number of filters.

A final characteristic of the mirror lenses is the donut-shaped images produced from bright spots in the backgrounds. The donuts can be a creative tool for many photographs; however some photographers think they are a pitfall of the mirrored lenses.

Selecting a Lens

The simplest approach to buying a lens is to purchase only those manufactured by the companies that make your camera—Zuiko lenses for

A 1000mm mirror lens telescope from Celestron International makes it possible to get unique photos with your 35mm camera. Photo courtesy Celestron International.

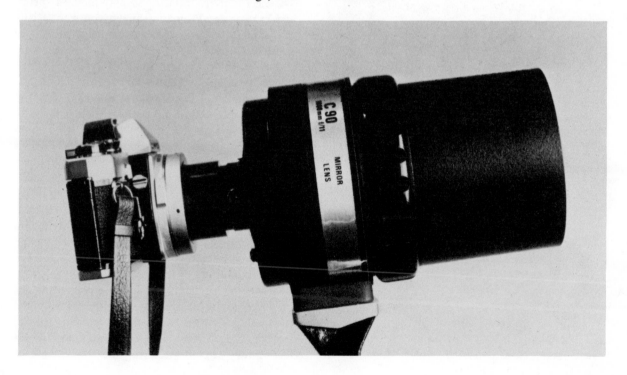

Olympus, Canon lenses for Canon, Nikkor for Nikon and so forth.

Another approach to lens selection is to buy from the manufacturers that make lenses for a wide array of cameras, especially the 35mm. Vivitar, Sigma, Soligor, Osawa, and Asanuma are a few of the names. These lenses will be fixed mount (made with a specific camera-brand lens mount) or will have variable mounts, which make it possible to buy a lens and a number of different camera mounts that can be changed at any time. All sorts of lens adapters are available too, allowing various lens makes to be attached to different cameras.

Are these non-camera-manufacturer lenses any good? You'd have to look at the lenses and de-

This 80mm to 200mm zoom for many 35mm cameras offers one-touch control. You can zoom and focus at the same time. Photo courtesy the Vivitar Corporation.

cide for yourself. Keep in mind that lens making has become a science. Lenses are designed using the aid of a computer, and many are geared toward compactness. Quality is a must if these independent lens makers want to stay in business. When quality is lacking, word gets around quickly and you'd have trouble giving the lenses away. Competition is keen, as are the prices of some lenses.

I don't suggest you purchase a lens unseen and untouched. You need to look at it and judge whether it's well made before you commit yourself to ownership. Get the feel of the lens by checking the focusing ring to see if it's too loose or too tight. Is the lens bulky to handle, or is it so small you can't get a good grip?

Other things to look for concern the actual construction methods. Some zoom lenses offer one-touch control. This gives you a single action for both zoom and focus control. Other zooms may have two movements, one for focus and one for altering the focal length. The one-touch zoom may be a little faster to use than the two-control zoom.

Another thing to consider is the lens automation. The more sophisticated the lens coupling system, the more money you may have to spend. If you have an automatic camera you want a lens that makes use of the automatic aperture or shutter setting.

You'll pay a lot less for a preset lens, which means you have to close the aperture to whatever setting you need before you can take the picture, but having to do that will defeat the purpose of the automatic camera you own.

The TX lenses that allow alternate camera mounts can be a worthy investment if you're not really sure you are going to keep the camera you've been using. It's a lot less expensive to replace adapters than it is to replace an entire lens. Of course, if you decide to change camera formats—from 35mm to view camera, for example —then you're going to have to buy a new camera and a new variety of lenses.

Lenses are certainly the most important aspect of photography equipment. Quality lenses make for quality pictures. Care should go into the selection of each lens. You don't want to leave a lens sitting around gathering dust from lack of

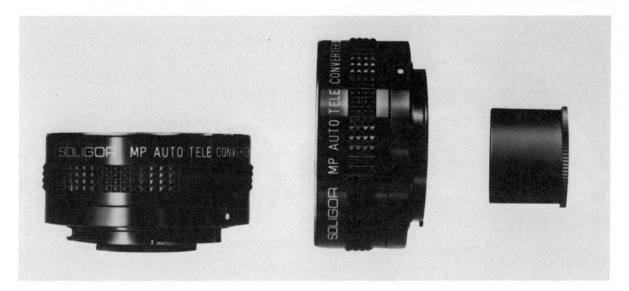

use. Try to buy only the lenses you know you'll use on a regular basis. There's no sense in investing hundreds of dollars in a lens to use it for shooting one or two rolls of film, just to quell your curiosity.

Usually there are alternative methods to get what you want out of your photography at considerably less expense. When you cut corners you will have to make some sacrifices, but these may be justified by the money you save.

Tele-Converters

One way to get more out of a single lens is by purchasing and using tele-converters. You generally have two to choose from, a 2X or 3X. Their purpose is to double or triple the focal length of your lenses.

Tele-converters go between the lens and the camera body. They can be automatic, coupling the camera's light meter and the diaphragm of the lens. If you have a normal 50mm lens for a 35 mm camera, you can add a 2X tele-converter and get a 100mm lens. A 3X converter added to the same 50mm lens would make it a 150mm telephoto lens. A 150mm lens would cost you two hundred dollars or more, while a tele-converter, purchased for as little as fifty dollars, can give you a long lens from a short one.

A Soligor auto tele-converter doubles as an extension tube when the center lens is removed. Photo courtesy Soligor, AIC Photo, Inc.

Some tele-converters have a removable center optic which changes the tele-converter into an extension tube for close-up photography. It gives you one piece of equipment which serves two functions.

Now for the sacrifices you make by cutting your costs. A 2X converter added to a lens will cut its speed by two f/stops. A 3X tele-converter will cut it by three f/stops. In other words, if you are using a lens with a maximum speed of f/4 and you add a 2X to it, the maximum speed will be f/8. A 3X tele-converter will cut the lens to f/11.

The loss of lens speed is the major drawback of the tele-converters. Another possible characteristic is a matter of opinion. Some photographers swear a tele-converter added to a lens reduces the quality of the image produced. Others believe that's not true. A lot depends on how the tele-converter is used and the quality of the lens it's connected to.

Generally, tele-converters should not be used with zoom lenses. More optics added to movable optics won't produce the best results. Now, to contradict myself before you take my word as gospel: The Vivitar Corporation makes zoom lenses (a 75mm to 150mm f/3.8 and a 100mm

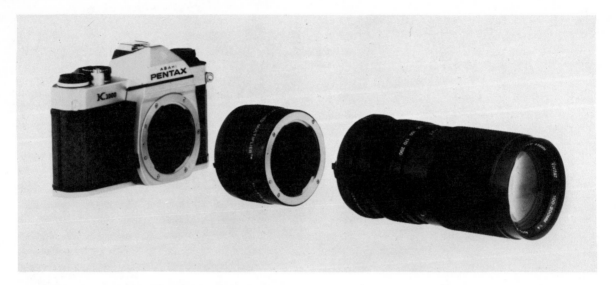

to 200mm f/4.0) with 2X Matched Multipliers™ available. The tele-converters for these lenses are designed as part of the overall configuration of the zoom lens in an effort to ensure good resolution throughout the focusing range.

The tele-converters are available for the medium-format cameras as well as for a wide range of 35 mm cameras. The independent camera equipment manufacturers—Sigma, Vivitar, Tamron and others—make a variety of 2X and 3X tele-converters to fit many different cameras and lenses.

Extension Tubes

Similar in appearance to the tele-converters are extension tubes. The difference is the absence of optics. They act as a sort of spacer that fits between the lens and the camera body. Their purpose is to help the photographer take close-ups.

Most extension tubes come in sets of three. They vary in length, and can be used together or in different combinations. The varying length of extension allows you to reach the right distance for the magnification of the subject you want.

Most extension tubes offer coupling devices for use with the meter or automatic exposure of the camera. However, some don't; then the expo-

The Vivitar 100mm to 200mm close-focusing zoom has an optional 2X Matched Multiplier™ to double the focal length of the lens to 200mm and 400mm. Photo courtesy the Vivitar Corporation.

A set of K Extension rings from Nikon. They act as spacers between the camera body and the lens, allowing for added close focusing. Photo courtesy Nikon, Inc.

sure must be judged or figured manually. This can be a problem, because the amount of light striking the film is considerably less than it would be if you used the lens without the extension tubes.

You could guess at the exposure by opening up the f/stop, allowing more light to strike the film. To be on the safe side and get consistent results, you need to run a test roll of film using the extension tubes in various combinations. Make sure you write down all the exposure information on a piece of paper so you can judge which was the correct exposure once the film is developed.

If your camera is automatic and the extension tubes have an aperture coupling device, then you don't have to worry about exposure other than using your camera in its normal manner.

Minolta auto bellows units and their accessories for copying slides and extreme close-up work. Photo courtesy the Minolta Corporation.

Reversing Rings

Instead of extension tubes you can use an inexpensive reversing ring with your normal camera lens. It's nothing more than a threaded ring that attaches to the front of the lens and then has a camera mount on the ring.

After attaching the ring to the front of the lens, you attach the front of the lens to the camera body. This reversed lens allows you to shoot close-ups with a normal lens, but it can cause some difficulties at the same time. Automatic controls of the camera lens become useless. You will have to set the f/stop manually.

Although this reversed lens gives you limited magnification, it can produce pleasing results with a minimum of investment. For best results the reversing rings should be used on normal lenses only.

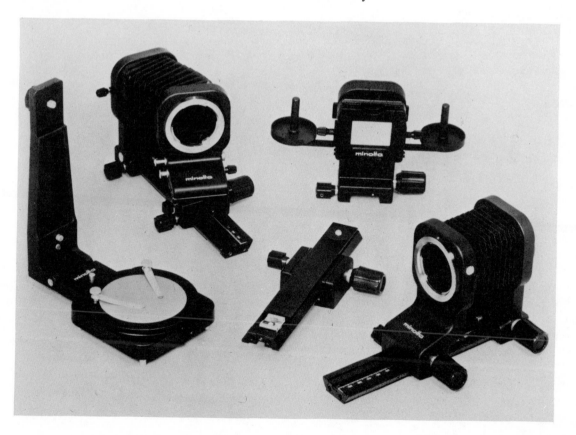

Bellows Attachments

The ultimate in lens extension for macro or close-up photography is a bellows. Like the extension tubes, the bellows puts length between the lens and camera body. The flexible bellows is generally on a track with a set of knobs to let you vary the length of the bellows.

The purpose of the bellows is to allow for extreme enlargement of subjects. At first look, a camera, bellows and lens combination may seem a bit awesome and confusing. It can be if you don't have automatic exposure control. The amount of light passing through the lens, then traveling the length of the bellows, gets reduced somewhere along the way. If you have to guess at the exposure you may have a problem. Again,

a test roll of film and accurate record keeping will help you maintain consistent results.

Most cameras offer through-the-lens and bellows light readings to help you determine exposure. However, you'll still have to set the aperture on the lens.

Extension tubes, reversing rings and bellows all offer macro or close focusing. All three systems offer various ratios of subject to image. A 1:1 ratio would mean the subject photographed is the same size as the image it produces on film. From the 1:1 ratio you can go up the ladder, making the image on the film larger than life size, all the way to about 1:10. The ratio you obtain varies depending on the equipment you use. The bellows and special macro lenses allow for the greatest magnification.

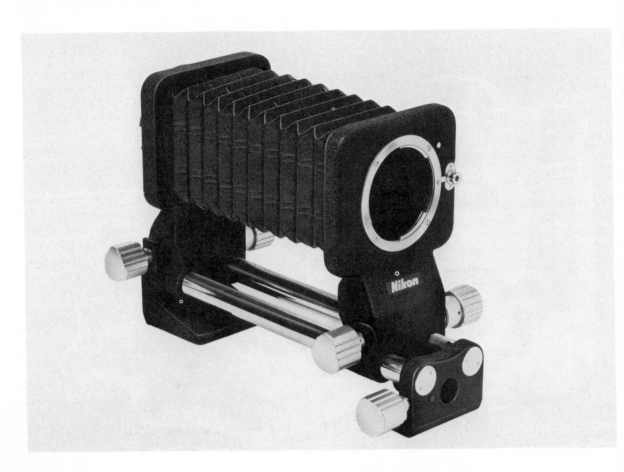

A Nikon bellows unit and focusing rail. Photo courtesy Nikon, Inc.

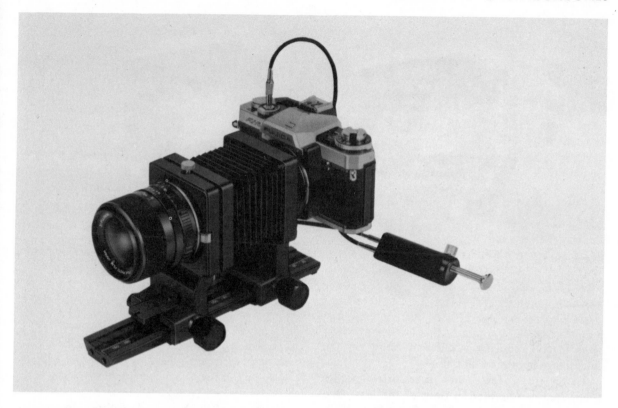

Reversing rings and extension tubes can be used in conjunction with the bellows to help you get the picture you want. However, the greater the magnification the less depth-of-field or area of focus you'll have.

Close-up or macro photography can be very interesting and can add a new world of visual impact to your photography. Because magnification ratios, exposure control, lighting and other information about close-up work could fill a book, I cannot cover the topic in depth. All I can do is give you an idea of what's available and what cost variation there is.

Bellows Accessories

Besides the basic bellows units, special accessories are available depending on the make and design. Some have special double cable releases that attach to the bellows lens and the camera shutter release to close down the aperture in the lens as the shutter opens.

A Fujica camera and bellows unit with a dual cable-release attachment. Photo courtesy Fuji Photo Film.

Another valuable accessory for bellows are slide copiers. They allow copying of your favorite slides or creating of special effects. You can crop slides, vary exposure, do limited color correction, add creative color, and combine slides.

A final accessory for some slide copiers and bellows are film holders for allowing the use of an entire roll of film rather than inserting individual slides into the copier.

Front-of-the-Lens Attachments

Many beginning photographers think of camera accessories only as the things you put in front of the lens because there are quite a few accessories that fit that spot. The most common in-front-of-the-lens attachments are filters—all kinds and all

43

sizes, each producing a different effect on the final image imprinted on film.

There are a few other accessories besides filters that can be used in front of the lens. One is a right-angle attachment, available from Kalt, which enables you to shoot around corners. This isn't for the photographer who has visions of becoming a secret agent or a peeping Tom, but it is for the photographer who wants to take pictures of people in an unobtrusive manner. The camera will be pointing in one direction while the right-angle attachment is zeroing in on the unsuspecting subject to the right or left of the camera.

Other common lens attachments are lens caps and lens shades. The caps are vital for protecting the front element of your camera lens when it's not being used. (There are all types to choose from; they are discussed in further detail in Chapter V.)

A lens shade can function as a lens protection device or as a method to keep stray light from striking the lens and showing up on the film as a ghostly image. Some lenses have built-in lens shades which slide out over the barrel when they are to be used. Some attachable lens shades are made of metal, while others are rubber. Both screw into the front of the lens and have a circular or square shape.

Two slide copier attachments from Nikon. One is used for single slides while the other is set up for copying entire rolls of film. Photo courtesy Nikon, Inc.

The size of the lens shade will decide how well it reduces lens flare (images of the diaphragm on the finished picture) and keeps out unwanted reflections at various angles to the sun. When using wide-angle lenses you want to make sure that the shading device is large enough so that the image doesn't vignette (have dark edges caused by the lens shade.)

If your camera is mounted on a tripod and lens flare can be seen through the viewfinder, you can hold your hand between the sun and the front of your lens, producing the needed shade to reduce glare and reflections. Personally, I often wear a hat when I take pictures outside on bright sunny days. When I need to shade the lens I remove my hat and hold it in a position to shade the front of the lens. Of course, you can't hold a hat and a camera, focus the lens, set an f/stop and take pictures all at the same time. It helps to have the camera mounted on a sturdy platform like a tripod.

The most commonly used in-front-of-the-lens attachment is some sort of filter. There are virtually hundreds to choose from, each producing some sort of effect on the film within the camera.

Some attachable lens shades are made of metal and
screw into the threads incorporated into the front of
the lens.

Lens shades can be made of rubber, offering limited
protection to the lens if it's struck accidentally against
a hard object.

Filters

You have a choice of glass, acetate or gelatin filters. The most durable are the glass. Gelatin filters may come in 50mm (2"), 75mm (3"), 100mm (4") and 125mm (5") squares. They can be cut with scissors to fit any sort of holder or retaining ring you might have. The acetate or plastic type filters are generally used over a light source rather than over the front of the lens. Colorful sheets of acetate can be purchased at many art supply stores.

Your type of camera will help you to decide what sort of filters and lens mounting system you use. The filters might be bayonet, screw-in or a mounting system that slips on over the lens. The most common is the screw-in type, which comes in a wide assortment of thread sizes.

Filters are valuable for color correction, special effects, lens protection, color compensations and contrast control. Photo courtesy the Vivitar Corporation.

FILTER ADAPTER RINGS

Listed below are a number of adapter rings available from Tiffen Manufacturing. They are to be used with series-sized filters. This system allows the photographer to use the same filter with a number of different lenses requiring various-sized mounts. The series numbers range from 5 to 9. The filters are held in the adapter by a retaining ring and are actually more difficult to use than filters with direct fitting mounts because of the time involved to change filters to fit the adapters.

Screw-in adapter rings:
Each ring is threaded to fit the correct diameter of the camera lens.

Slip-on adapter rings:
The ring slips over the lens mount and has a limited amount of flexibility to fit lenses of similar but not exactly the same size.

Bayonet adapter rings:
The rings are to be used with bayonet-type lens mounts.

Set-screw adapter rings:
The rings slide over the lens barrel and are locked into place by means of tightening a small set-screw on the adapter ring.

Roto-adapter ring:
A simple ring that rotates, allowing you to insert your own filter combinations and rotate them for creating special effects.

Relatively new in the United States is the "Cokin" Creative Filter System marketed by Minolta. It offers a special filter holder and more than 75 filters to choose from. Check with your local photo retailer to see the system or write Minolta for their forty-page, full-color guide to the system. (The guide was selling for one dollar, but write Minolta first to see if there has been a price change.)

A 49mm and 52mm filter. Either can be used on the lens. The 52mm filter will require the use of the 49mm to 52mm step-up ring in the foreground of the picture.

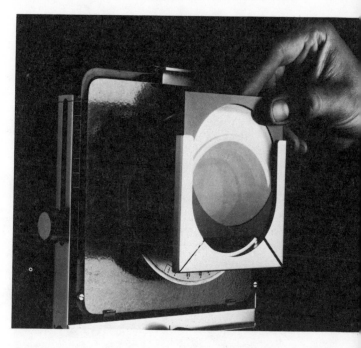

A simple filter holder that fits on the front of the lens. Photo courtesy the Eastman Kodak Company.

The Cokin Creative Filter System is adaptable to all 35mm single-lens reflex cameras and is made up of more than 75 filters, masks, frames and lens attachments. Photo courtesy the Minolta Corporation.

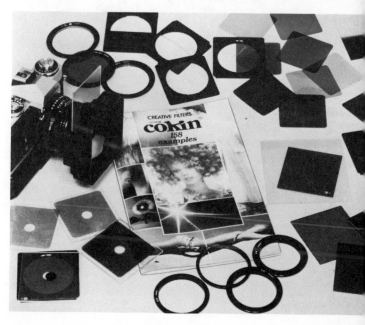

The screw-in variety of filter should be given careful consideration before you buy, because what may fit one of your lenses may not fit another. Let's say you have a 50mm lens for your 35 mm camera and it uses a 49mm threaded filter. You may have a 28mm wide-angle lens that uses 52mm threaded filters. That means you might have to buy two of the same filter if you want to use it on both of your lenses.

However, there are two routes to go to cut your costs. You can purchase step-up or step-down rings, the former being the best route to take. If you were to purchase a 52mm to 49mm step-down ring you could use a 49mm filter on your normal and wide-angle lens with a 52mm thread size. However, you are going to have a

problem. The small filter will cause vignetting around the edges of your photographs when used on the wide-angle lens, which may be pleasing on some pictures but not on all.

The alternate route is to purchase a step-up ring from 49mm to 52mm. Then you can use a 52mm filter on the wide-angle and the normal lens without producing any vignetting. If you plan to use your filters on all your lenses, be sure to purchase the largest filter needed and then get

When the filter is too small for the lens, the edges of your picture become dark. This is called vignetting.

any step-up rings you need. You pay a little extra for the larger filters, but it's a lot less expensive than having to buy two of the same filter.

Many of the camera and lens manufacturers are trying to offer lenses that use the same filter size. They can do that with many of their lenses, but not with all. Sooner or later, especially if you purchase some of the specialty lenses like super-wide-angles or the extra-long telephotos, you'll have to buy extra-large filters.

If you plan to use the gelatin filters, which are relatively inexpensive, you'll have to purchase some sort of holder for the front of your lens. There are all types to choose from, such as Kalt's combination gelatin filter holder and lens shade. It holds 3"×3" gelatin filters and can be attached to any lens from 20mm to 70mm in diameter. Gelatin filters are delicate and can easily get scratched or dirty. They won't last you a lifetime.

For the beginning photographer, the glass filters with screw-in, bayonet or slip-on mounts are the better choice. Once they are attached to the camera you needn't worry about them, and with reasonable care they should last a very long time.

What Filters Do You Need?

First, find out what's available. Then decide which filters you will use regularly in your photographic work. There are numerous ones to choose from, but as with all photographic equipment, if you're not going to use it on a regular basis then there's no sense in purchasing it.

There are a couple of filters, clear in appearance, that might appear to do nothing except cost money. They're called skylight or UV (ultraviolet) filters and do cut down on the ultraviolet light that reaches the film. For color, they cut the bluish cast that might be caused. How-

A diffusion filter was placed over the front of the lens to soften the image of this rose.

An impromptu diffusion screen, made from a nylon stocking held over the front of a camera lens with a rubber band.

A rotating chromo blend filter was used to take the picture of these red roses. The darkened area at the top of the picture could be moved by rotating the filter.

The Galaxia filter from the Cokin Filter System produced these rainbow-surrounded lights. Photo courtesy the Minolta Corporation.

A red filter was used with color film to copy this print created using Kodak high-contrast-producing Kodalith film.

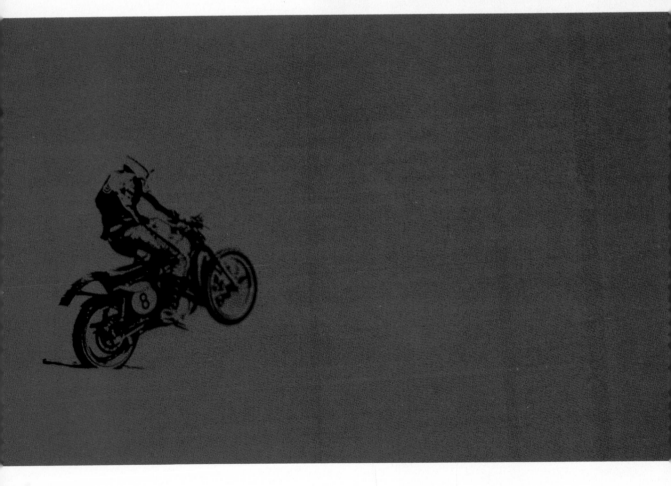

A 4-by-5 inch positive image film was dipped in water and placed in the freezer. The film was removed from the freezer in its frozen state and copied, using a macro lens. The background and lighting was provided by the sky and sun. Sometimes you don't know what sort of photograph you're going to create until you try.

These deformed autos were created using the linear shutter B354 from the Cokin Filter System. Photos courtesy the Minolta Corporation.

A star filter and graduated filter were combined from the Cokin Filter System to produce a dramatic image of a sailplane. Photo courtesy the Minolta Corporation.

Created by using a double mask from the Cokin Filter System, this combination of two images produces a strange, if not pleasing, effect. Photo courtesy the Minolta Corporation.

Some cameras allow for double exposure capabilities, enabling the creative photographer to place one image on top of another. When purchasing a camera you might want to consider whether the camera offers this option.

ever, today's lenses are usually multicoated with materials to prevent any bluing, so it's debatable whether the UV or skylights are needed.

These filters do not noticeably affect color or black-and-white film, but they do protect the front element of a lens, and that's a good reason to own one. When I purchase a new lens, I purchase a skylight filter to cover the front of the lens. It helps to keep dirt and fingerprints off the lens, reducing the number of times I have to clean the lens, thus reducing the risk of scratching the element. It's considerably less expensive to replace a filter than it is to buy a new lens.

Black-and-White, Color, and Dual-Purpose Filters

Some filters are designed specifically for use with black-and-white films. Their purpose will be to vary contrast or correct gray tones.

For color films there are correction or light-balancing filters, compensation filters, and a variety of specialized filters that may add special effects and modify color.

Many filters can be used for both black-and-white and color films. For example, a polarizer can be used to reduce reflections from the sun's striking the surface of water for both color and black-and-white films. Some of the contrast filters used for black-and-white are used with color films to create special effects. A red filter might be used with color film to produce an exceptionally dramatic sunset.

If you use black-and-white film you might want to invest in one or two filters made for that type of film. Some of the colors available are yellows, oranges, greens and reds. Usually, when you use black-and-white film, it's difficult to obtain any tone separation between the clouds and the blue sky. A yellow, orange or red filter will darken the sky, helping the clouds to stand out. The darker the filter, the darker and more dramatic the sky will be.

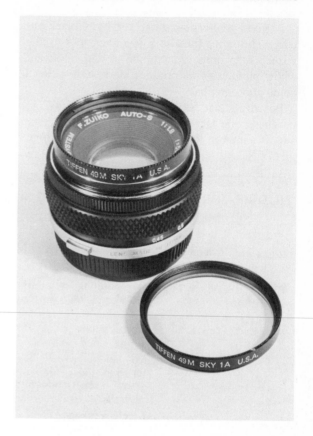

This clear 1A filter from Tiffen is kept on the lens at all times for protection.

Besides making your skies stand out, the filters are good for cutting through haze. When you're using telephoto lenses, it's a good idea to use a filter to help reduce the haze, which is actually compacted, making it denser than it really is, when a telephoto is used.

The final use of black-and-white filters is to alter the reproduction of the gray tones. As a general rule, a filter that is similar to the color of the object you're photographing will lighten that particular color and darken the others. If you were to use a green filter on the front of your lens when you photograph foliage, it would lighten the green leaves on the final print. If a red filter were used when photographing an apple, the apple would appear lighter in color than if the film were used without a filter.

A good all-purpose filter for both black-and-white and color films is a polarizer. It's used to reduce reflections, darken the sky in black-and-white pictures, and produce dark blue skies in color photographs.

Polarizers are expensive, so make sure you purchase one large enough to fit all your lenses and, if you need them, purchase step-down rings.

FILTERS FOR BLACK-AND-WHITE FILM
(*Tiffen Manufacturing Filters*)

FILTER NUMBER	COLOR OR NAME	SUGGESTED USE
6	Yellow 1	For outdoor use, darkens sky slightly, emphasizes clouds.
9	Yellow 3	Deep yellow color for strong cloud contrast.
11	Green 1	For landscapes and better skin tones for outdoor black-and-white portraits.
13	Green 2	Lightens foliage.
21	Orange	Absorbs blues and blue-greens. Good for marine scenes.
25A	Red 1	Dramatic sky effects. Used with infrared film to turn foliage white. Cuts haze, fog, or mist.
56	Light green	Darkens sky, gives good flesh tones in portrait work.
61	Dark green	Extreme lightening of plant foliage.
Neutral Density	Vary in density reducing the amount of light. No change in tones.	Used for depth-of-field control or shutter-speed variation.
Polarizer		Eliminates surface reflections.

The above list of filters is not complete. There are other degrees of filters, such as a yellow 1, 2 and 3. The colored filters can be used with color films for creating special effects.

A polarizer will not darken the sky every time it's used. It depends on whether the sun is at the right position. The area that will "polarize" varies as the sun changes its position. A "rule of thumb" is to aim a thumb of one of your hands at the sun and then stick your index finger straight out. The index finger will be pointing at the area of the sky that is likely to polarize.

The majority of polarizers have a rotating mount that is turned manually by the photographer. You can actually see the change in color or glare reduction. When that point is reached, you stop rotating the polarizer. If your camera has through-the-lens focusing, you rotate the polarizer directly on the camera. For other cameras (like the rangefinders or viewfinders, where you don't actually look through the lens), you have to hold the polarizer in your hand, rotate until the desired effect is reached, and then place the adjusted polarizer over the front of the lens.

For color films, there are all sorts of filters you might need. Many are for special effects and some are for color correction. The most important filters are used for color correction. Color film is balanced for various types of light. Generally, the film you use outdoors is balanced for daylight and for the harsh light produced by electronic flash or blue-coated bulbs.

This polarizer has a removable arm for rotating the filter. If a lens shade is used, the arm needs to be removed.

Other films, like tungsten, are balanced for lighting such as that produced by incandescent lightbulbs. Fluorescent lighting is totally different from normal bulbs, so that it's somewhat difficult to balance the film to the lighting. There are, however, color compensation filters available for fluorescent lighting.

FILTERS FOR COLOR FILM
(Tiffen Manufacturing Filters)

FILTER NUMBER	SUGGESTED USE
Sky 1A	Use at all times to reduce blue and add warmth to scene outdoors.
UV15	Haze filter for 3200° K film with photofloods.
UV17	Haze correction and reduces blue cast in shade.
80A	Balances daylight film for use with 3200° K lamps.
80B	Balances daylight film for use with 3400° K lights.
85	Balances type A film with daylight.
85B	Balances type B film with daylight.
FLB	Eliminates the deep blue-green cast resulting from shooting color film with fluorescent lights. For type B film.
FLD	Same as FLB, but for daylight films.
Neutral Density	Vary in density reducing the amount of light. There is no color change. Used for depth-of-field control and shutter-speed variation.
Polarizer	Eliminates reflections and increases color saturation.

The above list of filters is not complete. There are other filters available for color correction and balancing.

When you buy film you should check the instruction sheet that comes with it. The instructions will give you a list of filters needed for various corrections when different light sources are used. Both Kodacolor 400 and Ektachrome 400 can be purchased for daylight balance and flash. If you use the film outdoors you won't need a color correction filter. On the other hand, if you go inside and plan to shoot using available light from a lamp (incandescent), you'll need a color correction filter to get the right colors in the final print or slide. For both the Kodacolor and Ektachrome 400 film you'd need an 80A, dark-blue filter. The end result would be natural colors instead of a color that would be warm, having a red or orange tint to it.

Color correcting isn't too difficult if you use the proper filter, which is easily decided by reading the instruction sheet that comes with each roll of film. The only time it's rather difficult is when you shoot under fluorescent lights. The fluorescent lights can be rated daylight, white, warm white, cool white and cool white deluxe. I think there is even a warm white deluxe to choose from as well.

How do you tell one fluorescent from another? It's easy enough—just look at one of the bulbs. It should be written right on the bulb. Of course, in some photographic situations it's not possible to climb to the ceiling to see what bulbs are being used. If you use daylight film with fluorescent lighting you'll get a greenish cast, and tungsten film will produce a bluish cast.

The combination of filters you use for correcting fluorescent are compensating filters. They filter some of the light spectrum, allowing the necessary colors to pass through the filters and strike the film.

Special-Effect Filters

The list of special-effect filters is a long one. They allow the photographer to be creative and often produce surprising results. The best way to find out what's available is to check the literature from the different filter manufacturers like Vivitar, Tiffen, B + W, Hoya, and others.

SPECIAL-EFFECT FILTERS
(*Tiffen Manufacturing Filters*)

Diffusion Filters	Tiffen diffusion filters are graded 1 to 5, giving a range of effects from slight overall image softening to complete diffusion.
Center-Spot Filters	A diffusion filter with a clear center for softening the outer areas of the picture and a sharp center.
Fog Filters	Tiffen fog filters are made with densities ranging from 1 to 5 for an assortment of fog effects.
Star Filters	Four point stars, or vara-cross star, allows for rotation of the filters for creative star effects.
Multi-Image Lenses	Several to choose from for producing various numbers of the same image on the same picture.
Vari-Color Filters	When used in conjunction with a rotating polarizer, two colors or shades in between can be produced.
Color-Grad Filters	The filters are part clear and gradually denser in color. A wide assortment of colors is available, and all have rotating mounts.
Split-Field Lenses	One half close-up lens, one half clear. Available in $+\frac{1}{2}$, $+1$, $+2$, $+3$ and $+4$ diopters.

Some of the creative filters are not available in series adapter mount sizes.

The beginning photographer usually wants to learn everything he can about creating special effects using filters. Sometimes this becomes a fad that can be overdone. Still, many pleasing and fine-quality photographs are made using filters and creative control.

Diffusion filters are popular with portrait photographers because they can soften the appearance of the subject, helping to create a mood.

Another type of filter can produce soft focus around the edges of the photograph, leaving the center clear and in sharp focus.

Other filters produce *multiple images* in threes, fives or sixes. Many rotate, allowing the images to vary in their locations.

Split-field filters (actually they're lenses) enable you to increase your depth-of-field. One half of the filter is a magnifying lens while the other half is clear. The lens can be rotated to help in composition.

The *cross-screen* or *star filters* produce starlike patterns from any light source. They can be used to enhance night photography or day scenes when there are a number of bright reflections. When color film is used the stars produce a combination of colors emitted from the light source.

Some filters are available that *mix colors*. There might be a blue top half and a clear bottom half or maybe an orange top half and a blue bottom half. The more expensive color combina-

Two identical pictures, except that one was taken without a filter and the other had a diffusion or soft-focus filter over the camera lens.

tion filters combine a polarizer with a color filter, giving you a selection of color intensities.

Neutral density filters do not alter black-and-white or color film, but they do restrict the amount of light striking the film. They are available in various densities and are used when you need slow shutter speeds or large apertures for controlling focus. One of the most common uses is when you take pictures of moving water. With a neutral density filter you can slow the shutter speed, producing a soft flow from the water rather than the stop action you usually get when you're shooting under sunlight.

In this chapter I have mentioned macro lenses, extension tubes, reversing rings and bellows—all for close-up photography. Another method for taking close-ups is by attaching *close-up lenses.* (They look like a filter and attach to the camera in the same way as a filter, but they are actually magnifying lenses.) You can purchase the close-up lenses in sets of three, which can be used in front of the lens, one at a time or in combinations with one right on top of the other.

Each close-up lens is rated as a diopter, which is nothing more than an optical term to rate the power of the lens. They can range anywhere from +1 to +10 diopter values. The +10 will be for extreme close-up work. As with all short-cuts in cost, the diopters may have some limitations as to which lenses they can be used with; there may also be a question as to the quality of the results, depending on who's looking at the final slide or print.

Filters can be very useful photographic tools. You will have to decide how many to own and whether the special-effect filters truly make your photography better. They can improve some photographs and they can be overused in some cases.

You might want to invest in a filter wrench if you have a tendency to overtighten screw-in filters. Generally the filters should be put on carefully, making sure you don't strip the threads. However, once in a while you might find you can't get a filter off. If that ever happens, you can buy an inexpensive filter wrench that will help you to get some leverage in taking it off. *Don't use the wrench to put filters on.* Use your fingers and tighten the filter until there's a snug fit.

Filter Factors

Before I leave my discussion of filters I need to mention "filter factors." If you look through a yellow, red or polarizing filter it should be obvious that it restricts the amount of light passing through it; that's what happens when filters are mounted on the front of a lens. The light passing through the filter is reduced, so to get the correct exposure on the film you're using you have to increase it. A filter factor is the number you use as a guide to adjust exposure.

If your camera uses a light meter built into the camera and you have through-the-lens metering, you don't have to worry about exposure control. The meter will do the work for you.

If you have to figure exposure with a hand-held meter, you'll need to know that a filter factor of two means altering the exposure by one f/stop, allowing more light to strike the film. A filter with a factor of three would mean 1½ f/stops. This is a good generalization but you'll also have to keep in mind that the filter factor can vary for a filter, depending on the film and light source.

Each filter manufacturer supplies instruction sheets with their filters. Read the literature to find their filter factor recommendation. Each roll of film you purchase will also have an instruction sheet and filter recommendations under various lighting situations.

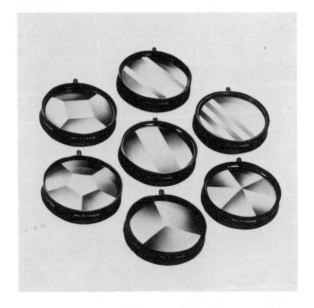

Seven filters; they produce various multi-image effects, depending on their construction. Photo courtesy Tiffen Manufacturing.

Odds and Ends

Besides the filters, there are some systems available which attach to the front of your lens and allow you to insert special *cutout masks* for special image effects. The cutouts might be in the shape of a cross, heart, circle or star. By placing the cutout in front of the lens, the final image produced on the film takes the shape of the cutout.

Another accessory for telephoto and zoom lenses is a *quick focusing lever* that attaches to the barrel of the lens. The lever extends out from the lens and is easy to grab, speeding the process of focusing or zooming.

If you want an accessory for your camera, no matter what type—pocket, rangefinder, instant, 35mm, medium-format or view camera—don't be afraid to ask your local photo retailer what's available. Surprisingly, there are a lot more

One subject converted into six by using a 6D multi-image lens from Tiffen. Photo courtesy Tiffen Manufacturing.

Split-field lenses with $+1$, $+2$, and $+3$ diopter ratings. They rotate, so you can place the magnification where you want it. Photo courtesy Tiffen Manufacturing.

Two star filters, each producing a different effect because of the variation in grid size. Photo courtesy Tiffen Manufacturing.

A split-field lens enables close and far focusing, as illustrated with this pair of shoes. Photo courtesy Tiffen Manufacturing.

The bright lights produce eight-point stars when an 8-point star filter is used over the front of the lens. Photo courtesy Tiffen Manufacturing.

A case and a set of three diopters numbered 1, 2 and 4. They can be used alone or in combinations to increase the magnification.

better-than-average results. However, the lenses you use every time you click the shutter of your camera should be the best you can afford. For the once-in-a-while pictures, like the fish-eye type, you can afford to take shortcuts on equipment. While you're learning about photography you don't need the best. Concentrate on taking quality pictures and getting the most out of each piece of camera equipment you own.

A normal 50mm lens took this picture. The lens could not be used any closer to the subject and still be in focus.

A normal 50mm lens with a $+4$ diopter over the front of the lens allowed for closer focusing.

accessories available than people think. The accessory may not produce perfect results if it's an inexpensive alternative. When you cut corners you may have to sacrifice convenience, speed or even quality.

Photography is an endless learning experience. Every time you take a picture you should be able to learn something. Camera accessories are part of the experience. It can't hurt to learn what each accessory does. Don't rush out and buy expensive accessories you won't be using on a regular basis. If there's a less expensive model, try it first to find out if the accessory is your cup of tea. A good example is the fish-eye lens. It can be very expensive, but you can purchase a fish-eye auxiliary lens that attaches to a normal lens. You will have to make a few more adjustments than with a regular fish-eye, but it should produce pleasing results. It'll certainly give you an idea whether or not a fish-eye is what you want for everyday use.

Lenses are the most important accessory you can own. Quality lenses produce quality images in the sense of sharpness and contrast. The less expensive lenses may be a good buy and produce

Chapter III

Camera Body Accessories

The camera's body is important to the photographer not only because it holds the film, metering system, and electronics, but also because its design or format determines the camera's versatility—versatility in its ability to accept a number of useful accessories.

If you were to ask a beginning photographer what accessories were available for his new camera, chances are the answer would be "lenses and filters." These accessories, which attach to the front of the camera, generally affect the final image produced on the film, whereas the majority of attachments to the camera body simply make picture-taking easier or, in some cases, more consistent.

Depending on the type of camera (pocket, 35mm, view, etc.) and manufacturer (Nikon, Fujica, Rollei, etc.) there may be a few or there may be numerous accessories available for use with the camera body. This chapter will help give you a better understanding of various camera body accessories and how they can be useful to the photographer.

Camera Straps

At first glance you might think camera straps aren't very important. Most cameras come with some sort of strap anyway. Right? A small pocket camera may have nothing more than a large loop which makes a wrist strap. It gives the photographer something to hold on to besides the camera and, at the same time, reduces the risk of dropping the camera.

The 35mm and medium-format cameras may come with a narrow leather or synthetic-material strap which attaches to both sides of the camera's body. The photographer then has the option of placing the strap over his neck, so the camera dangles in front of him somewhere between the chest and waist or, when walking, of tossing the strap over the right or left shoulder so the camera rests along his side and can be held in place by his hand or arm.

At this point you may feel the camera strap you have does just what it's supposed to do. But ask yourself whether the strap causes any unnecessary discomfort or is inconvenient in any way. Until you've been out in the field pursuing pictures for an hour or two, you won't realize the importance of a well-designed camera strap.

Length is very important. Some straps are adjustable; others are not. Preferably, the strap you use is one that can be adjusted so the camera will lie against your body without being burdensome. You don't want it to be so long that the camera will hit you in the groin or interfere with your legs while you're walking. Nor do you want the strap so short that the camera cuts into your armpit or hits you on the bottom of the chin every time you look down. By using an adjustable strap, you can vary the length until you find a comfortable position for the camera you are using.

Another important consideration is the strap's width. A narrow strap can be annoying if it cuts into the back of your neck or shoulder. An extra

wide strap may be as insufferable as one that's too narrow. If the wide strap is made of a flimsy or thin material, as many of them are, it will have a tendency to fold over, causing the same distress as a narrow one. You end up spending much of your photographic time running your fingers the length of the strap, trying to keep it flat so it will lie comfortably on your shoulder or the back of your neck.

Narrow chain straps coil nicely to fit in the palm of your hand. That is the only pleasing thing I can say about them. The one I tried pulled the hair on the back of my neck and had the effect of a burning match when the sun glared down on a hot summer day. It was by no means one of my favorites.

By now you're beginning to wonder if there are any good straps available. Certainly there are. My preference is a medium-width leather strap, one thick enough so that it won't fold over and one that has snap-lock safety hooks so it can be easily removed from the camera. The quick attachment and removal feature is useful when you mount the camera on a tripod because a long, dangling strap can interfere with a tripod's controls.

Maybe you have found the strap supplied with your camera perfect for your picture-taking needs. If not, however, consider the pros and cons of certain straps before you buy a new one. It's better to spend a little extra money for a sturdy and comfortable strap than to buy something which will cause unnecessary discomfort when you're taking pictures.

While using a neck strap, the camera is going to dangle in front of you and bounce around

Camera straps come in all sizes. They are made of fabric, metal or leather. A quality strap fits comfortably on your shoulder or the back of your neck, depending on how you transport or carry your camera.

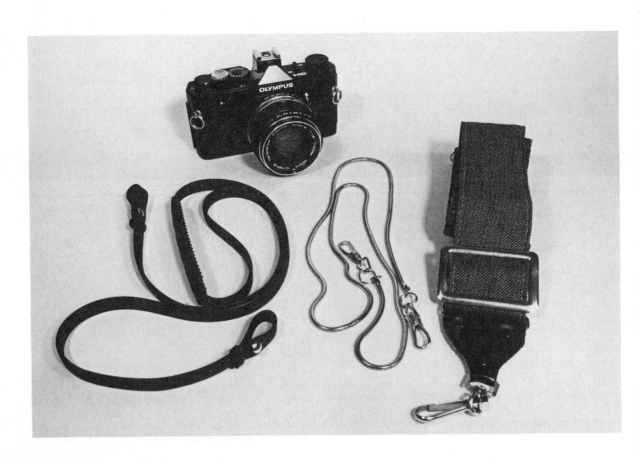

every time you take a step unless you hold it in place with your hands. If you find it annoying, especially if you're a hiker, you may want to invest in a "Kuban-Hitch." This strap is designed to hold the camera securely against your chest until you're ready to use it. There's no bouncing around as you hike or run after a moving object you want to photograph.

Besides the "Kuban-Hitch" there are other straps available that will hold the camera securely in place until you're ready to use it. An inexpensive alternative is a "Bungee Strap," an elastic cord you can purchase at a motorcycle shop. The cord has two hooks, which can be slipped into the split rings of your camera. You place the cord around your back and attach the hooks to the camera. When you're ready to take pictures, undo the hooks. The only problem with this method is what to do with the elastic cord when you're using the camera. I bring the two hooks together around my waist and wear it like a belt.

Camera Strap Attachments

A few photographers like to attach film, filters, or even a small lens case to the neck strap of a camera. Film holders which slide over the strap or attach to cloth straps with Velcro are available. They are small, and one or two dangling from the strap will not hinder picture-taking.

Filter holders and lens cases can only cause trouble. They'll get in your way and add unnecessary weight to what you are already carrying.

In an attempt to make a narrow strap comfortable or to keep a wide strap from folding over, you can purchase a shoulder pad. Compare the price of a pad with the price of a new strap and then decide on the lesser of two evils. Some of the straps allow too much play in the shoulder pad, so that it slides back and forth, making the photographer constantly rearrange the position of the camera for maximum comfort.

Eyecups

Most camera manufacturers and independents like Kalt, Dot Line, and Coast make eyecups to fit a variety of cameras. Some are circular in design; others are oval. Their main function is to keep stray light from interfering with the sharp focus of the camera lens.

If you wear eyeglasses but find them awkward when you take pictures, you can buy a corrective lens that fits into the eyecup. Then you won't

Some cameras accept eyecups that fit over the viewfinder of the camera. The cup will help to keep stray light from interfering with the sharp focus of the lens.

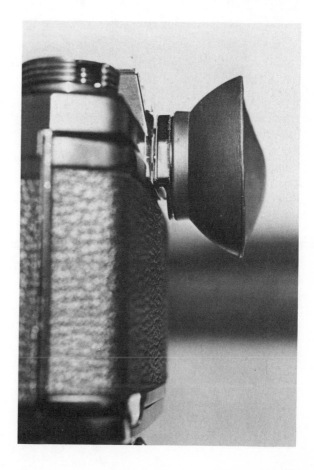

have to worry about banging your glasses against the edge of the viewfinder. Check with your optometrist to find out the type of corrective lens you need. (Some cameras offer corrective lenses that slip over the viewfinder instead of fitting into an eyecup.)

Eyecups are not necessary for quality photography, but they are available for a number of cameras and, depending on the photographer, they may or may not be useful accessories.

Some eyecups allow corrective lenses to be held in place by a retaining ring. Using the corrective lens allows the photographer to focus the camera without wearing prescription glasses.

Right-Angle Viewfinders

When you take pictures at waist level or close to ground level, it's difficult to look through the viewfinder of a 35mm or other camera that requires holding the camera in front of your eye to view and focus. Some cameras, like the twin-lens reflex and several of the medium-format models, are convenient for low-level viewing because you look straight down, into the camera, for composition and focusing. With a right-angle viewfinder accessory you can convert 35mm and other cameras for low-level photography.

Many camera manufacturers make right-angle finders for their cameras, similar to the Olympus right-angle viewfinder illustrated here. This one has an added feature of both normal and magnified viewing. The right-angle attachment also rotates for both vertical and horizontal composition of pictures.

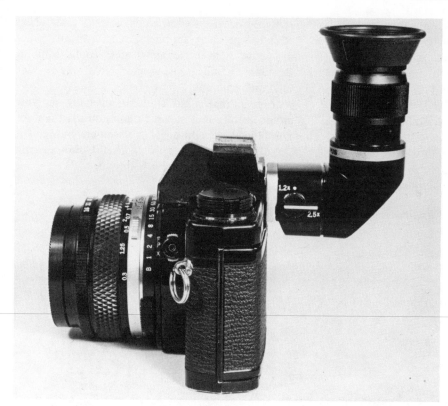

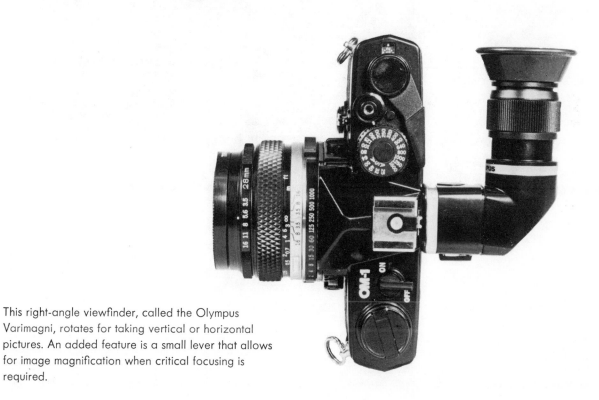

This right-angle viewfinder, called the Olympus Varimagni, rotates for taking vertical or horizontal pictures. An added feature is a small lever that allows for image magnification when critical focusing is required.

The magnification lever is used for critical focusing, and not all right-angle viewfinders offer this feature. However, there are a number of viewfinder attachments which are designed just for image magnification and critical focusing. Once sharp focus is obtained, the magnifying viewfinder can be flipped up so it's out of the way.

If you own a camera with through-the-lens viewing and focusing, check with your local photo retailer to see if the manufacturer makes a right-angle viewfinder. You might also check with independent suppliers, such as Kalt, which distribute right-angle viewfinders to fit Minolta, Pentax, Konica, Canon, Nikkormat, and Olympus cameras.

If you don't mind stooping or lying on your stomach for some of your photography, then you don't need a right-angle viewfinder, but if you want the convenience, it's a useful photographic tool and well worth the investment.

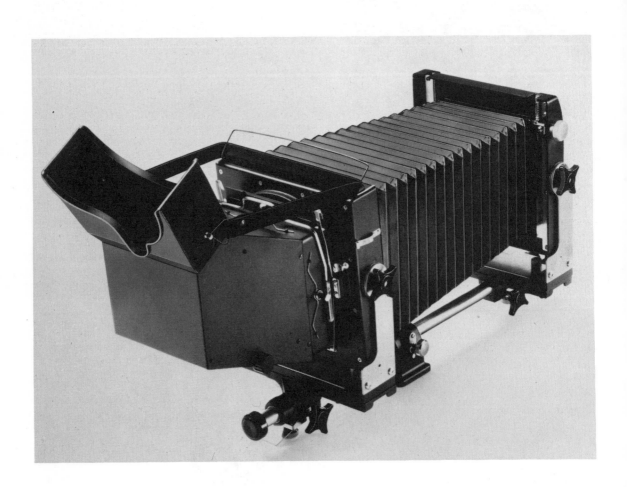

The right-angle attachment for this view camera makes it easier to focus because stray light is kept away from the film plane. Photo courtesy Calumet Scientific, Inc.

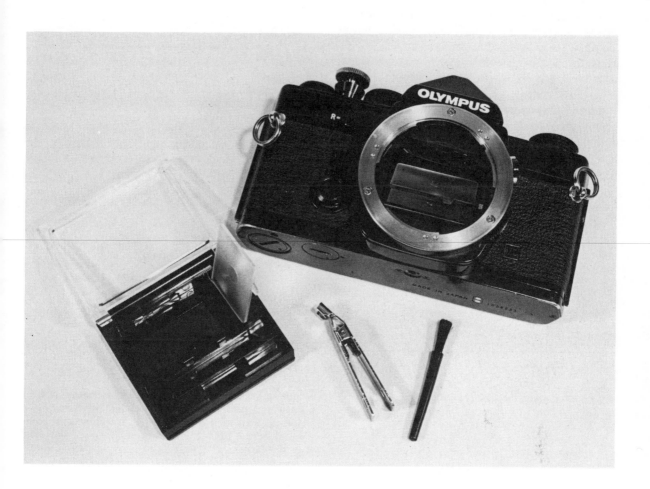

Some cameras, like this Olympus model, allow various focusing screens to be used. They are changed through the lens opening rather than through the top of the camera as with other camera models.

Interchangeable Focusing Screens

Many of the cameras available today offer a selection of interchangeable focusing screens. Some are designed for usage with particular lenses, while others are nothing more than a convenience for the photographer, making it easier to focus a lens.

Not all cameras accept interchangeable focusing screens. If you can focus your camera in the

63

majority of lighting conditions with the screen built into the camera, you needn't worry about the camera's inability to accept accessory screens.

Each manufacturer offering interchangeable focusing screens has a different name, letter or number to indicate the type of screen. You'll have to check with your camera's manual, a catalog or your photo dealer to find out exactly what's available.

I've listed some of the fourteen interchangeable screens available for the Olympus OM-1n and OM-2n and how they are used (below). Similar screens are available for some Pentax, Canon and Nikon cameras, and for the medium-format models. How the screens are changed is determined by the camera. Some, like Pentax and Olympus models, are changed through the lens opening of the camera, while others, like Canon and the medium-format Mamiyas, are changed through the top of the camera.

Below is an example of several of the fourteen interchangeable focusing screens available for the Olympus 35mm OM-1 and OM-2 cameras with the manufacturer's suggested use.

1-2

1-2 Microprism matte (*for standard and telephoto lenses*)

When a lens with a maximum speed of f/8 or slower is used, the microprism spot gets dark and the surrounding matte area, which is ground comparatively rough, must be used.

1-3

1-3 Split-image matte (*for most lenses*)

Suitable for general photography, ensuring critical focusing; particularly of advantage when taking a subject with vertical lines. When a lens with a maximum speed of f/5.6 or slower is used, the split prism darkens.

1-1

1-1 Microprism matte (*for most lenses*)

The subject is in focus when the jagged pattern of the microprism spot disappears and the spot becomes crisp and clear. When a lens with a maximum speed of f/5.6 or slower is used, the microprism darkens and the focusing must be made on the matte area. The meter needle indicates correct light readings.

1-4

1-4 All matte (*for most lenses*)

Suitable for super-telephotography as well as close-up photography in conjunction with macro lenses and Auto Bellows. For easy focusing, the matte surface is ground rough.

1-5

1–5 Microprism—clear field (*for wide angle and standard lenses*)

The transparent screen provides a bright finder image. Suitable for snapshots using wide-angle lenses. The subject is in focus when the image becomes crisp and clear. The lack of a matte surface means depth-of-field effects cannot be ascertained. The meter needle does not indicate correct light readings, because its movement varies depending on the lens used.

1-10

1–10 Checker-matte type (*for shift lens*)

This screen was specially designed for use with the Zuiko shift lens. The line grid engraved on the all-matte ground screen is used for vertical and horizontal picture alignment in architectural and composite panoramic photography. The screen is also suitable for general photography, super-telephotography, and close-up photography.

1-13

1–13 Microprism/split-image matte (*for most lenses*)

The focusing screen is standard type and assures pinpoint focusing. The central split image is encircled

by a microprism collar. Since the outer area has a matte surface, the screen can be used in the same way as the standard 1-1 and 1-3 screens. When a lens with a maximum speed of f/5.6 or slower is used, the prism darkens and focusing must be made on the matte area.

1-14

1–14 Microprism/angled split-image matte (*for most lenses*)

The central split image, encircled by a microprism collar, is inclined 45 degrees to allow easy focusing on subjects with vertical or horizontal lines. When a lens with a maximum speed of f/5.6 or slower is used, the split image darkens, so focusing must be made on the microprism collar or matte area.

The Olympus 1-13 and 1-14 illustrate how similar screens can be. The 1-13 is a microprism/split-image/matte, and the 1-14 is a microprism/angled split-image/matte. What's the difference? One has an angled split-image, the other a horizontal split-image. So, which is better? There's a fine line of distinction between the two screens, and under most conditions the screens should be equally easy to focus. Here, the individual photographer needs to decide his personal preference.

Three other screens available from Olympus for the OM-1 and OM-2 are the 1-5, 1-6 and 1-7. All are called microprism/clear field screens. The 1-5 is for use with wide-angle and normal lenses; the 1-6 is for normal and telephotos; the 1-7 is for super-telephoto lenses. There are small variations in the screens' microprisms.

These are definitely specialized focusing screens. If you were to run out and buy one for use with your OM-1 or OM-2 without reading

the instructions, there's a good chance all your pictures would be incorrectly exposed. No, there's nothing wrong with the screens or cameras, but the metering needles in the OM's do not work with the screens. The OM-2 is both automatic and manual. The automatic setting would work, giving correct exposure, but if the camera were on manual operation, exposure would have to be figured by using a hand-held meter and not the meter in the camera. The OM-1 is a manually operated camera, and exposure would be incorrect unless it were figured by some means other than the meter within the camera.

From the example above, you should realize how important it is to understand photographic equipment and its limitations before you purchase it.

Interchangeable Viewfinder Systems

For the majority of photography situations one viewfinder is adequate, but some cameras offer alternate viewing systems that can replace the one already on the camera. Their purpose is to give the photographer the advantage of having a selection of different viewpoints for focusing: low-level, eye-level, right-angle, etc.

A Nikon F3 camera and twenty focusing screens to choose from, in addition to the four interchangeable viewfinders. Photo courtesy Nikon, Inc.

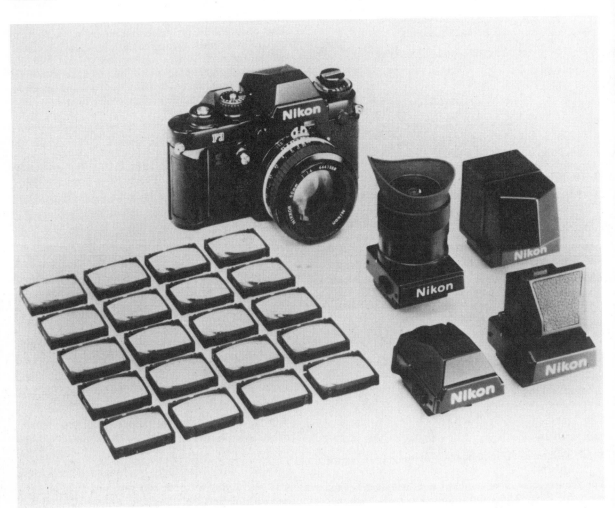

For example, instead of camera-to-eye viewing, a waist-level finder can be added to allow for low-level viewing. It might make shooting on a tripod easier, or it could be useful for taking candid portraits.

Another viewing system is called the sports finder. Its purpose is to allow the photographer rapid composition of fast-action subjects which are features of many sporting events.

Other interchangeable viewfinders may have built-in metering systems or offer rotary, right-angle viewing, along with magnification for critical focusing.

The average photographer doesn't need the latitude offered by interchangeable viewfinders. However, if you're system-conscious and plan to own many accessories someday, you may want to check which cameras offer the viewing diversity. A selection of viewfinders does not come with the camera; you have to purchase each one separately.

Soft Shutter Releases

If your camera's shutter button accepts a screw-in cable release, it also accepts a soft shutter release. These are nothing more than extensions of the camera's shutter button. They aren't very expensive and could reduce the risk of camera shake when you're taking pictures. (Keep in mind that considerable care goes into the design of a camera, and that includes the shutter release button. You should be able to push it without the aid of a soft shutter release and produce minimum camera movement.)

There's one available for Nikons and another for most other cameras that use a threaded cable release. Do you really need one? The only way to find out is to put one on your camera and push the shutter-release button. Does it make it smoother, with less chance of jarring the camera? If so, by all means purchase one.

The narrow, cable-release-type screw does have a tendency to come loose when one is carrying or transporting the camera. In a two-year period I lost seven soft-shutter-release buttons; I no longer use them.

This soft shutter release screws into the cable-release hole.

Self-Timers

Most cameras have a built-in timing mechanism. You set it, push a lever or a button and, in a matter of seconds, the shutter goes click. Its purpose is either to let you take a picture of yourself or, when necessary, substitute for a cable release.

If your camera doesn't have a built-in timer, there are some available that screw into the shut-

Some cameras have built-in timing mechanisms. You set the mechanism, push a lever or button and, in a matter of seconds, the shutter goes click.

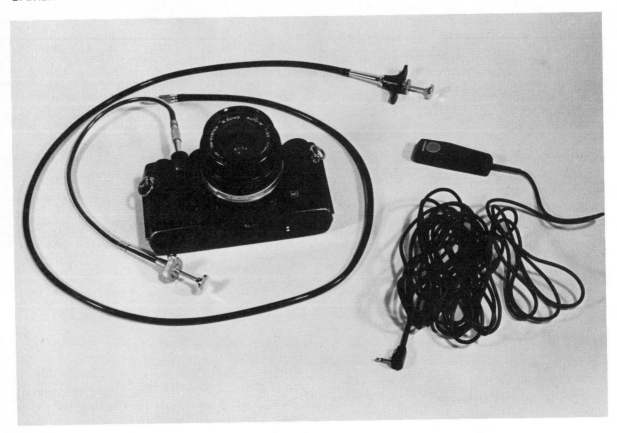

Three cable releases. The two on and near the 35mm camera are standard and have locking mechanisms for time exposures. The other is an extra-long cable release for use with an Olympus Winder.

ter button just as a cable release would. If your equipment doesn't have the threaded hole for a cable release and you want the accessory, ask your photo dealer if there is an adapter available, such as the one made for some Kodak and Polaroid cameras.

Cable Releases

A cable release is like giving yourself an extra-long and flexible arm. Cable releases come in a variety of lengths and deployment methods. Some use air pressure, others are push-button and a third type is electronic.

The cable release has two functions. First, it enables you to stand away from the camera and, if desired, get into your own pictures. The second and most important function is its ability to absorb movement and reduce, if not totally eliminate, camera shake.

Some releases have a locking mechanism, which is to be used when you want to take time exposures longer than one or two seconds. Your camera must have a B (bulb) setting, which enables the shutter to be held open as long as the release button is held down or locked in place.

A cable release should be used when the camera is in a stable position, such as resting on a table or, preferably, mounted on a tripod. The cable is flexible, so when you use it, any movement you might cause is absorbed into the cable and does not affect the camera.

How long a cable do you need? For most photographic applications, a cable release from eight to twelve inches long should be adequate. However, extra-long releases can be useful in some situations.

If you like to shoot portraits, you might want a cable release three feet in length or longer. That way, once the camera is focused and composition is decided, you can stand away from the camera and casually coax the subject into the proper expression. When the subject is least expecting it, you can quickly click the shutter.

An extra-long cable, twenty feet long or more, can be useful for wildlife photography. Once again, you can set the camera on a tripod and pre-focus. Then, run the long cable release to a blind where you hide and wait patiently for the wildlife to arrive. Click, and it's over. If you don't have an automatic film winder, you'll have to get up and advance the film before you can take another picture.

Winders or motor drives, which automatically advance the film after each picture, may need a special cable release rather than the type that screws into the shutter button. If your camera accepts a winder, you'll have to know whether it's activated by the camera's shutter button or by a separate button built into the winder. If it's the latter, you'll need to purchase an electronic cable release or make one. (See Chapter VIII for making a cable release for some winders and motor drives.)

Tripods

For some reason, beginning photographers have an aversion to tripods. It's understandable: some tripods are cumbersome and certainly restrict one's rapid mobility when it comes to taking pictures. If you can overcome tripod inconvenience and use one whenever possible, you'll see a difference in picture sharpness. A tripod is vital for sharp pictures at almost every shutter speed.

Selecting a tripod is not an easy task. There are hundreds to choose from, in all sizes and various capabilities. You'll have to choose one that fits your photographic needs and budget. To help, I've listed several things you should consider before you purchase this reliable and viable photographic tool.

How large a tripod do you need? There are compact models, and there are large, bulky ones for view cameras. If you're a backpacker, you

Tripods of all sizes and characteristics are available, as illustrated by this selection from Vivitar. Photo courtesy the Vivitar Corporation.

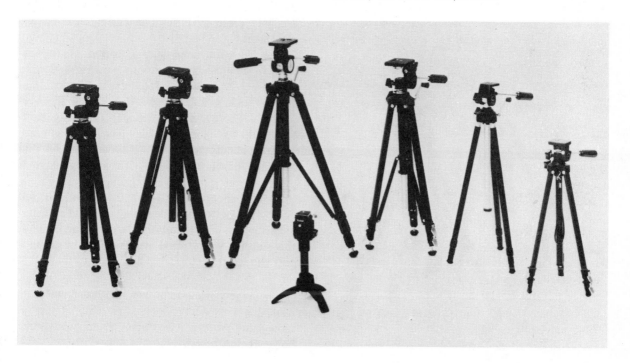

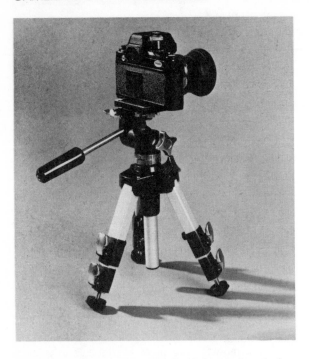

The Smith-Victor Kenlock Mini Tripod might be ideal for the backpacker or camper who hates to cart around large, bulky equipment. Photo courtesy the Smith-Victor Corporation.

This Velbon tripod has legs capable of spreading very far apart for close-up work near the ground. Photo courtesy Velbon International.

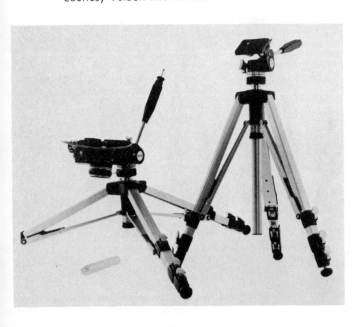

want a compact version that offers a minimum of weight and fits into your pack or knapsack. On the other hand, if mobility isn't a factor, a large and somewhat bulky tripod will work just fine as long as you don't have to carry it and your equipment over long distances.

The first thing to look for in a quality tripod is sturdiness. There are some that will blow in the wind when the legs are fully extended or will wobble when a camera is mounted to the platform. If a tripod is flimsy, it's useless as a camera support and should be avoided. Be careful about considering a tripod with several segments that need to be extended for proper height. The more segments, the less apt the tripod is to be stable.

Be sure to check how easy it is to extend the legs and how secure and reliable the leg-locking mechanisms are. There's nothing more frustrating than owning a tripod with legs that suddenly begin to retract or collapse as you try to take pictures.

Several manufacturers make tripods with legs capable of spreading far apart so the camera can be supported very close to the ground. A substitute method is a tripod that has a reversible center column—one that can be removed and then replaced so the head is beneath the top of the tripod. It will enable you to support the camera very close to ground level for close-ups or copy work.

The head movements of a tripod are important. It should have a smooth panning action so the camera can be moved left and right, then quickly locked into place. Also, check the vertical tilt. There should be enough tilt so the camera will be perpendicular with the ground. You're actually better off to have a tripod that overtilts for vertical shots. It's an advantage if you're shooting on uneven terrain.

A little shopping and tripod comparison will give you a better understanding of what's available. Keep in mind that the larger your camera, the sturdier your tripod will have to be to support the weight.

For the large view cameras and for regular studio work, you might want to invest in a rolling camera support like this one from Bogen. Photo courtesy the Bogen Photo Corporation.

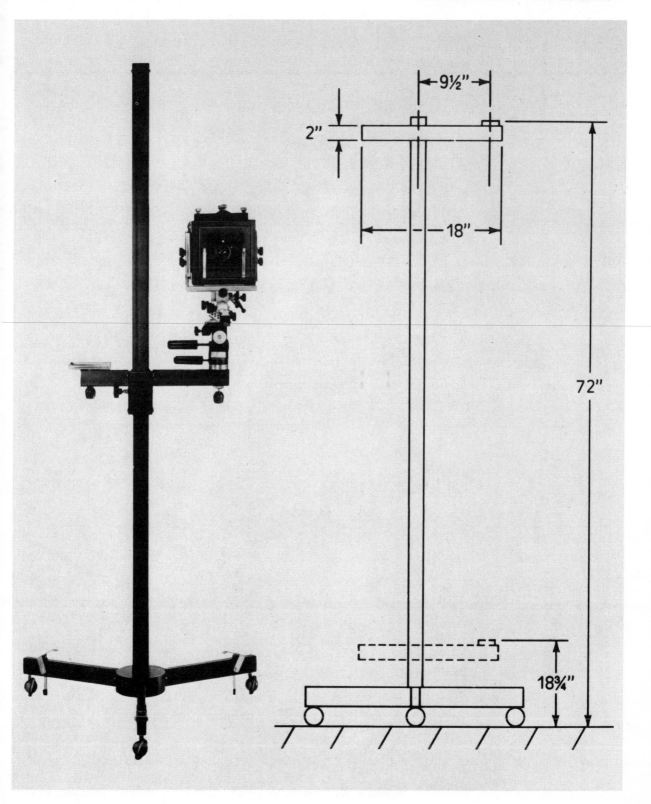

This is an optional pan head from Velbon. The smooth movement allows you to follow action and still get support from the tripod. Photo courtesy Velbon International.

Tripod Accessories

Depending on how you use your tripod, there may be a limited number of accessories you'll find of value. There are a number of *tripod heads* available. They attach directly to the mounting screw to give you added height or to give diversity to the tilt and swing movement.

Quick couplers are useful if you want instant camera-to-tripod attachment. The two-piece couplers attach to the bottom of the camera and the tripod thread. Instead of screwing the camera to the tripod, you join the two pieces and a locking mechanism holds them together.

Make sure to check for any play between the two pieces. Some allow for slight movement when the two pieces are joined. This movement will defeat the purpose of the tripod, which is stability.

Some tripods allow the center column to be reversed for close-focusing work. A right-angle finder makes it easier to focus the camera.

Here's an inexpensive quick coupler. Half of the unit attaches to the tripod and the other half to the camera. The two pieces slide together and are locked in place.

73

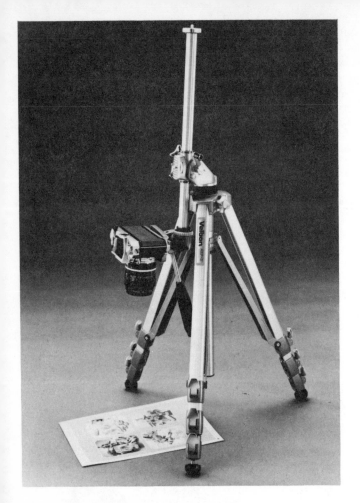

The Velbon Super Arm makes it easy to do copy work using a tripod. Photo courtesy Velbon International.

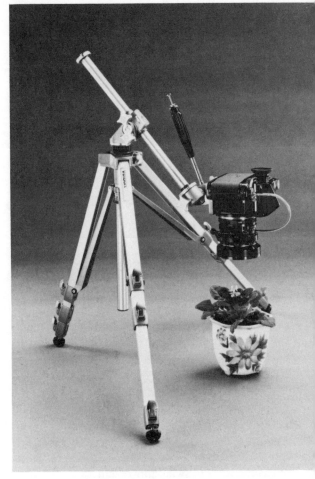

A Velbon Tripod with Super Arm and cable release built into the handle for simple shutter-release operation. Photo courtesy Velbon International.

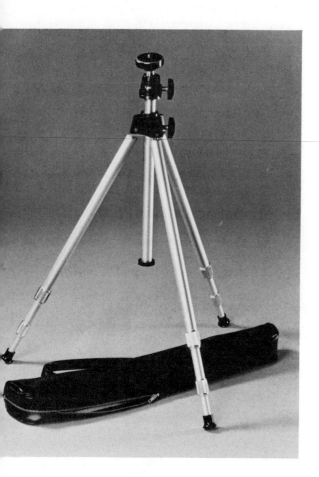

A Kenlock tripod with carrying case. Photo courtesy the Smith-Victor Corporation.

This looks like a lens case, but it's not. It's an adjustable tripod case from Fiberbilt Photo Products. Photo courtesy Fiberbilt Photo Products.

A *twin camera platform* is available for using two cameras on a single tripod. The accessory attaches to the platform of the tripod. It might be useful if you like to shoot two cameras using different films in each camera. Or, to get variation in your pictures, you can use two cameras, each having a different lens.

Safe-Lock and other companies make *dollies* to put wheels on the legs of your tripod. A locking device for each wheel adds safety when the tripod is positioned. Its use would be limited to locations where a smooth floor would allow easy rolling of the wheeled tripod.

Another accessory from Safe-Lock is a *two-wheel caddy* which attaches to a single tripod leg. As long as you're on solid ground or rushing through an airport terminal, your camera bag can be strapped to the caddy and wheeled behind you as you walk. There are built-in locks on the wheels for when the tripod is positioned for picture taking.

A limited-use accessory, made by Slik, is a *snowshoe* for tripods. The shoes will keep the narrow legs of the tripod from sinking into the snow while you're taking photographs.

Slik also makes a *V-lens support* that screws into the thread of the tripod. Its purpose is to support extra-long telephoto lenses. You rest the lens in the V of the support and it allows smooth horizontal movement while giving support to the camera. The device would be ideal for photographing fast-moving sporting events.

Another accessory from Slik is a *tripod bag* that straps to all three legs of a tripod. If you're in a stationary position and need to change lenses or filters, the accessory bag gives you some place to put them quickly and easily. The

Two accessories from Velbon: a tripod carrying strap and an adjustment arm with a built-in cable release. Photo courtesy Velbon International.

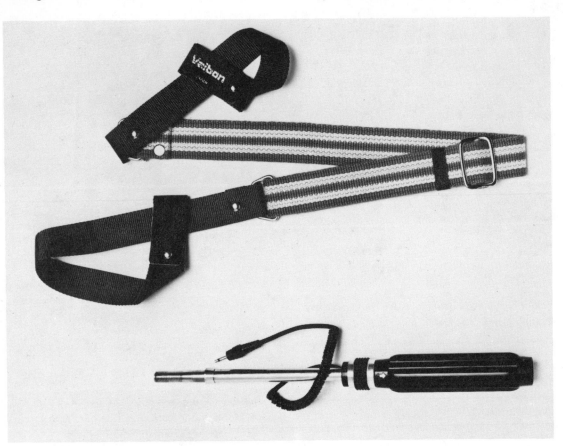

added weight of accessories in the bag also increases the stability of the tripod you are using.

A final consideration for your tripod accessories list may be a *carrying strap* or *bag.* Tripods, especially the bulky ones, are not easy to haul around. I've found putting a heavy rubber band around the three legs makes it easier to carry, preventing the legs from spreading. If you want to carry the tripod like a camera, you can buy a heavy-duty strap that attaches to the unit. Besides the strap, some manufacturers make carrying bags which hold the tripods and allow for over-the-shoulder or hand transporting.

Minipods

Minipods are the baby brothers to the tripods. They have limited usage, but if you don't like hauling a regular tripod around, little brother is better than nothing. A minipod that will fit snugly into your camera bag and supplies good support for your camera can be used for taking close-ups at ground level, on table tops, or as needed support for extra-long telephoto lenses.

If your regular tripod does everything, including enabling you to get close to the ground for low-level pictures, there may be no need to invest in a minipod.

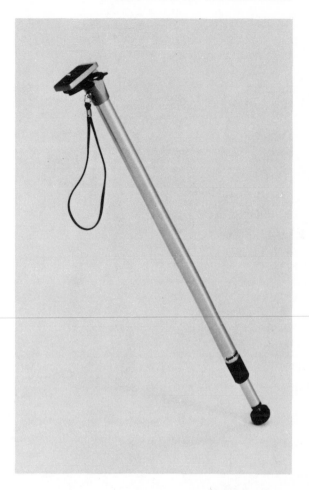

A simple monopod with a wrist strap for easy and secure holding. Photo courtesy Velbon International.

Monopods

A distant relative to the three-legged tripod is the monopod. It is lightweight, not very expensive, and sometimes useful. If you're a backpacking enthusiast or a nature photographer who likes to take leisurely strolls through the woods, you'll find that a monopod makes a handy walking stick.

If you ever watch the news and happen to keep your eyes on the still photographers in crowd shots you might see a photographer using a monopod as a device to get the camera above the crowd. A long cable release is attached to the camera and the photographer can hold the mon-

opod high over his head and click off shots. I think it's a final act of desperation to get a photo. You have to pre-focus and set your exposure. Composition is guesswork because all you do is point the camera in a general direction before you click the shutter. It's best to have a wide-angle lens on the camera for these desperation shots, because it will cover a larger area, making sure you get what you're aiming at somewhere on the film frame.

The monopods are not going to give the stability of a tripod. You still can get movement, but not as much as you would when hand-holding a camera. For true stability, use a normal, well-made tripod whenever you can.

A single-column camera support with armrests. Could be used at sporting events while you sit comfortably and watch for action shots. Photo courtesy Arm-Rest Products.

Camera Clamp Supports

Several photographic equipment companies make clamps with tripod heads attached. Some even have small tripod legs. They will work, providing you have something solid to attach the clamp to. Most times, you'll find there's nothing around to give you the support when you need it. If there is something, like a tree limb, it's at a bad angle, too high, or too low to give you the proper composition.

One thing the clamps can be attached to are tripod legs for low-angle photography. However, if you have a tripod which is capable of obtaining low angles, you really don't need the clamp.

Basically, the clamps are a good idea, but you should be aware of their limited usage before you decide to add one to your list of necessary accessories.

Pistol Grips

Small, hand-held grips are made for attaching to the tripod socket on the bottom of many cameras. All will have a trigger, button or electronically activated cable release to fire the camera.

It's like having a small monopod attached to the bottom of the camera. Instead of resting the support on the ground or some other solid surface, you hold it in your hand and fire off the pictures you want.

Personal photographic experience and preference will decide whether you need the grip. If you're certain that a pistol-shaped handle attached to the camera will help you hold the camera steadier, then a grip might be worth the investment.

I've never used a true pistol grip on a small camera, but I have found one useful on the medium-format models. The design puts the grip to the side of the camera body rather than below it. The medium-format camera mounts to a platform with the handle off to the side. It is much easier to hold this narrow, grip-type handle than it is to wrap a hand around the camera. Depending on the size of the camera, the grip will either be below or to the side of the camera body. The smaller cameras can use grips both ways, to the side or on the bottom.

Shoulder Pods

If you plan to do much of your photography using longer-than-normal lenses and you refuse to use a tripod, then you should consider purchasing a shoulder pod. These support systems are similar to, and sometimes duplicate, a gun stock.

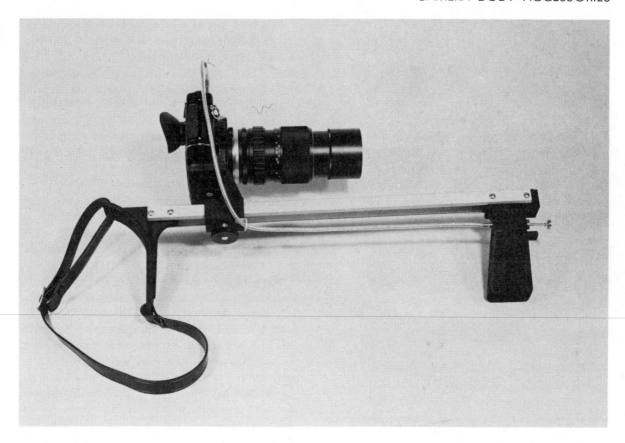

This shoulder pod is to be used with extra-long telephoto lenses and cameras with eye-level viewing. The camera platform is movable for adjustment.

Long lenses, 200mm telephotos and larger, are very difficult to hand-hold at any shutter speed. The long length of the lens seems to amplify any camera movement the photographer might cause. A tripod will give the camera and lens maximum support, but as already mentioned, some photographic situations don't allow time for setting up a tripod. The alternative is the shoulder pod, which will help to reduce camera movement.

The camera will attach to a platform, which may be movable, allowing precise positioning of the camera for maximum photographer comfort. A cable release mechanism attaches to the shutter button of the camera. Once the lens is focused, you gently squeeze the trigger or push the cable release to take a picture. Your shoulder gives added stability to help limit camera movement.

Flash, Flash Brackets and Hot Shoes

(See Chapter VI, *Artificial Lighting and Lighting Accessories.*)

Winders

All cameras do not have winder capabilities. Those that do offer the convenience of automatic film advance: every time you take a picture the film advances to the next picture. Camera manufacturers are realizing the growing popularity of automatic film advance, and some are building the devices directly into their cameras. As technology advances and winders become smaller, they may eventually become a standard feature of many makes and models.

79

Two designs in camera winders. The Contax winder has an extra shutter-release button on the winder for vertical picture-taking. The Olympus winder has a grip and shutter-button combination for easier holding of the camera. Photos courtesy Yashica, Inc., and the Olympus Corporation.

Winders are a convenience. It's much easier to push a button, focus, and push a button than it is to push a button, advance the film, focus, push a button, etc. More than that, an automatic winder aids in composition of the pictures. You are able to keep your eye on the subject at all times without having to take the camera away from your field of vision to advance the film. If you're shooting action photography, there's less chance of missing the peak of excitement.

Do you really need a winder? If your favorite photographic subject is landscapes, you don't need a winder. Timing isn't vital; the subject isn't going to run away. On the other hand, if you like to shoot people and sports, a winder could very well improve your pictures.

If you like to take portraits, a winder could be an advantage. People often get "gun shy" when they know their picture is about to be taken. With a winder, you can set the camera on a tripod and attach the proper cable release. Once you decide composition and focus, you can step away from the camera. Next, verbally coax the subject into a proper pose. Once the first picture is taken, your subject might relax a split second and you have the opportunity to quickly click another picture because the winder will have advanced the film for you. The subject's expression may be more natural.

Wildlife photographers will find a winder indispensable if a blind and a long cable release are used. You don't have to jump up from wherever you're hiding to advance the film every time you take a picture. You're less apt to scare away any animals you managed to get within your camera range.

The winder and the batteries that operate it do add weight to the camera. My first experience with repeated use of a winder was at a birthday party where I was asked to take a few pictures while the two-year-old opened her gifts. Frankly, I wasn't ready for the added weight on the borrowed camera. The quick film advance was great for catching all the facial expressions of the child; the added weight of the winder hurt my wrist. By the time I had finished shooting two 36-exposure rolls of film from ground level, my wrist was throbbing with pain. That was the first time I ever had doubts about purchasing a

winder attachment. I liked the idea of keeping my eye on the subject. I didn't like the way my wrist felt.

Fortunately, not all winders have the same design. Some attach to the bottom of the camera and are activated by the camera's normal shutter-release button. Others, depending on the manufacturer, attach to the bottom of the camera but have an extra handle or grip that comes up the front of the camera. The shutter-release button is built into the extra grip. This handle helps compensate for the added weight. You're less likely to get wrist strain.

Does the beginning photographer need the speed offered by a motor drive? My feeling is no, but then I don't know what other photographers are taking pictures of. If they shoot subjects which move so fast the only way to capture the action is to machine-gun shots, then maybe they do need a motor drive. The photographer who shoots some sports, landscapes, portraits, wildlife, and other types of mixed subjects could get enough continuous action from a winder and not really need a motor drive. As the photographer, you will have to decide if a winder or motor drive will best fit your photographic needs.

Winder Accessories

Two basic accessories for the winder are an external power pack and, for some makes, an electronic cable release.

The extra power pack is not needed unless you go out and shoot several hundred rolls of film on a single day. At the same time, if you plan on much winter photography, the external power pack is a must. Extreme cold will reduce the energy supplied by the batteries which operate the winder. By using an external power pack with an average-length relay cord, the batteries can be kept inside a coat or pants pocket, where they will be kept warm so they will function properly.

Motor Drive Units

Similar to the winder is the motor drive. Basically, a motor drive will do the same as a winder—advance the film after each exposure. The difference is the quickness with which the film is advanced. A motor drive is considerably faster.

For example, the Olympus Winder One will allow the photographer to take pictures at a maximum rate of three frames per second, while Motor Drive I, by the same manufacturer, allows five frames per second—plenty of speed to catch all the stop action you want.

Motor Drive Accessories

As with the winder, there are alternate or remote power sources for the motor drives. One possible source is a pistol grip which holds a number of batteries; another is a remote power pack kept inside a jacket or worn on a belt.

A motor drive that uses rechargeable batteries may have a cord and adapter for recharging from regular household current. Some may even have adapters for using direct household current. Use would be limited to repetitive studio work or to anywhere you could get direct access to electrical current.

I doubt that the beginning photographer will have the need to own a motor drive unit and its accessories. At the same time, beginning photographers can become the skilled professionals of tomorrow. So, when you're investing in equipment and there's a little thought in the back of your head that says, "Someday I'll need a motor drive," you may want to make sure you purchase a camera that offers motor drive capabilities.

Camera Backs

When you adapt your camera to winder or motor drive use, you'll find you can go through a normal-exposure roll of film rather quickly. In some cases a roll of 20-exposure film can be depleted

in a matter of seconds. Conceivably, you can end up spending more time changing the film in the camera than you do taking pictures. To help the photographer concentrate on his photography without having to change film every few minutes, several manufacturers produce bulk film-roll backs.

An example is a 250-exposure film-roll back. Don't rush down to your local film retailer and ask for a roll of 250-exposure film. You'll have to buy bulk rolls of film and load the giant 250-exposure spools yourself. You can buy bulk film loaders just for loading the oversized spools.

Besides the bulk film backs for 35mm cameras there are a number of varied backs or film holders available for both medium- and large-format cameras. Their purpose is to give diversity not only in the number of possible exposures, but also in film size. For example, some cameras will have backs for roll film, but the window in the back will be different in size depending on the back used. You could have a back for 6 cm×9 cm (2¼″×3½″) pictures, or a back for 6 cm×7 cm (2¼″×2¾″). Other backs are for use with Polaroid film and still others for 4″×5″ or smaller sheet film.

A combination of the F2 Data Back, a 250-exposure film back, a motor drive and the Nikon F2 Data Back Camera. Photo courtesy Nikon, Inc.

The Olympus Recordata Back 3 is capable of imprinting the year, month and day or the time in day, hour and minutes. The camera can be left on either the OM-1 or OM-2 models and set to function without leaving an imprint on the film. Photo courtesy the Olympus Corporation.

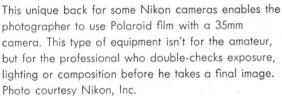

This unique back for some Nikon cameras enables the photographer to use Polaroid film with a 35mm camera. This type of equipment isn't for the amateur, but for the professional who double-checks exposure, lighting or composition before he takes a final image. Photo courtesy Nikon, Inc.

The unique Fujica Photo Recorser allows the photographer to write directly on the film for keeping accurate records of each photograph taken. The back replaces the normal camera back on some Fujica cameras. Photo courtesy Fuji Photo Film.

Data Back

For scientific data-keeping and for the amateur who likes to keep records of his pictures, some cameras offer special record or data backs. They replace the regular film back on the camera and have a number of adjustable dials. The dials have letters or numbers which let the user set up a code system or allows for dialing in the date.

Once the code or date is dialed in, it's printed directly onto the film. The code is unobtrusively

placed in a corner, or at the bottom of each exposed film frame.

Fuji Photo film has a data back called the "Photo Recorser," for use with some Fujica cameras. It allows the photographer to hand-write memos on the film; these show up on the lower left corner of the film frame. Up to 30 letters or numbers can be placed on a single frame before or after the film is exposed.

Data backs are generally used in the medical, scientific research, or education fields, but they can also be used by any photographer who likes to keep track of his pictures.

Memo Holders

Many of the 35mm cameras now constructed have a memo holder on the camera's back. Its purpose is to help the photographer remember what film is in the camera. The end flap of a film box is slipped into the holder and replaced whenever a different film is placed in the camera.

If the accessory is needed and your camera doesn't have a memo holder, you can purchase self-adhesive memo holders to stick on the camera. A less expensive approach is to use transparent tape to hold the end of the film box somewhere on the camera.

Levels

Beginning photographers have a tendency to shoot landscapes and other pictures with tilted or sloping horizons. The finished picture gives the viewer the impression of falling sideways or off the edge of the world. The problem can be easily overcome by investing in a small camera level. The level can be attached directly to the camera's hot shoe, which usually holds a flash attachment. When the bubble in the level is centered the camera is level and the subsequent pictures should be also.

A level isn't needed if you carefully compose your pictures, making sure that the horizon of your subject is parallel with the bottom of the camera's viewfinder. Quick, aim-and-shoot photography can cause sloping pictures, so try not to be in a hurry. Take your time composing the picture and clicking the shutter-release button.

Know Your Equipment

I've listed many of the camera body accessories available for any number of cameras. Still, there are other items available, depending on the camera manufacturer. There's no guarantee you'll know what's available until you check with your camera retailer, or better yet, read the literature produced by each camera company.

Another thing to keep in mind is the vast selection of camera models. The manufacturer is attempting to make a camera available for every type of photographer he can think of. He's trying to capture his percentage of the buying public, which puts profit in his bank account. Every camera he makes does not do the same thing. One camera model may accept interchangeable focusing screens while another won't. One may accept winders and motor drives while another will accept winders only. The list could go on and on.

As a beginning photographer you face a dilemma. You may not know what type of pictures you're going to be taking, so you won't know what type of accessories you'll need. As your skills and knowledge gradually grow, you'll begin to realize the limitations of some photographic equipment. As your enthusiasm for photography develops, you will begin to realize the importance of camera versatility. When that happens, you'll have to decide what sort of financial investment you want to make in a camera and whether that camera will accept the number of accessories you will need. The camera and its accessories will give you the picture-taking versatility you want.

Chapter IV

Film Selection and Accessories

Photographic film for your camera isn't an accessory. Without it, you wouldn't get any pictures. Film makes it possible to capture the images you want. It produces the final results of your work —a combination of your visual thought and the mechanical working of the camera you use. Surprisingly, many beginning photographers fail to realize the versatility in film selection.

A prime example is the photographer who asked if I had any extra film she could purchase. I was photographing an air show, or at least walking around looking at the collection of airplanes. I had a camera in one hand and a medium-sized camera bag thrown over my right shoulder. Apparently I looked like I knew what I was doing and would be the type of photographer to carry plenty of extra film. She asked if I had any film she could buy.

I asked, "What kind?"

She said, "Kodak."

I raised my eyebrows a bit and asked, "What size?"

She blushed a bit, then said, "35mm."

Finally we were getting somewhere. I had the size and specific brand she had asked for, but I still needed a little more information. "Black-and-white or color?" I questioned.

"Color," she responded.

"Slide or print film?" I asked her patiently.

She smiled. "Print film."

"I have some Kodacolor 400 I can let you have," I said graciously.

"Oh no! I only use 100 film."

To make a short story of this, she didn't like the film I had to offer. She had become accustomed to using one film and that's all she was willing to put in her camera. I'm sure there are many photographers who learn on one film and use it regularly, without running the risk of trying anything different.

There's nothing wrong with using one type of film. If it works well for every type of photographic situation you come across, then fine and dandy. If it doesn't, you should be aware of the different types of film available.

Negative, Slide, Print or All Three?

Everyone understands the difference between color and black-and-white films. To take it a step further, there are color films for prints, color films for transparencies (or slides) and there are color films that self-develop into instant prints without producing a negative. There are black-and-white films that produce instant prints and those that produce negatives which can be converted into black-and-white prints.

Depending on the film you use, you can obtain more than just a print or a slide. If you were to use color transparency film (names like Ekta*chrome,* Koda*chrome,* Fuji*chrome,* and Agfa*chrome*) your final product, after processing, is a positive image the size of the film or film back you use. That positive film image can be transformed into an internegative which can be used to produce color prints of various sizes. The transparency can also be used to produce prints without the use of an internegative.

Negative-producing color films (names like Koda*color,* Fuji*color,* and Agfa*color*) can produce color prints and black-and-white prints, as well as slide-size transparencies.

The instant films from Kodak and Polaroid produce small pictures, but the pictures can be

Film isn't an accessory; without it there wouldn't be any pictures. This is an exposed and processed roll of 35mm Kodacolor II. The negative is then converted into a color print. Photo courtesy the Eastman Kodak Company.

used to produce enlargement prints or even slides.

Whatever form you would like for your final picture, whether print or slide, it can somehow be produced. It might take the help of a custom photographic lab, but it can be done.

One problem—not all films are available in every size. Kodachrome 25 is made for 35mm cameras only. You can't buy it for pocket, medium-format or view cameras. So you do have

some limitations on the type of film you can use, depending on the camera you own.

Let's take a look at film characteristics in general. What actually makes one film different from another and how can the differences be advantageous or disadvantageous?

Film Speed

In Chapter II, I mentioned lens speed (one lens can be faster than another). The same thing can be said of various photographic films; one can be faster than the other. Lens speed is related to maximum aperture of f/stop. Film speed is related to the film's sensitivity to light. The more sensitive the film is to light, the faster it is.

Each sheet, roll or cartridge of film has an ASA rating. The ASA stands for the American Standards Association. (The letters ASA aren't important, because the system is changing to ISO ratings, ISO being the abbreviation for International Standards Organization.) Although ASA will gradually be changed to ISO, the film-speed rating number that follows the letters will remain the same. A film rated ASA 400 will change to ISO 400. There's no major change, so it's nothing to worry about.

The number that follows the letters ASA or ISO is important. The larger the number, the faster or more sensitive the film will be to light. A film number with ASA (ISO) 400 is more sensitive to light than a film with an ASA (ISO) number of 100.

The ASA, soon to be ISO, rating is usually printed with a DIN number. DIN is an abbreviation for Deutsche Industrie Norm, which is the German Standards Organization. It's just another way of rating film speed. A plus 3° in the DIN rating is used for doubling film speed. Plus-X black-and-white film has a DIN of 22 and Tri-X has a DIN of 27, which means the Tri-X is not quite three times as fast as the Plus-X.

Film used to have ratings such as the following for Tri-X: ASA 400/27 DIN. Using the new rating system, it will look like this: ISO 400/27°. Don't let it confuse you; just rely on the old ASA number for judging film speed.

Which is better? Before we decide, let's put a brand name with the film ratings. ASA (ISO) 400 is for Kodacolor 400 and ASA (ISO) 100 is

These two rolls of Tri-X black-and-white film show the old ASA 400 and 27 DIN ratings. The new package on the left includes the ISO 400/27° rating that will eventually replace ASA and DIN.

for Kodacolor II, both manufactured by the Eastman Kodak Company and both readily-available films that produce a negative.

The first thing to find out is what sizes the films come in. The Kodacolor II is manufactured and sold in 110 format for pocket cameras, in 35mm, and in 126 cartridges for instamatics and a few other film sizes including 120, 127, and 620.

The Kodacolor 400 is sold in three film sizes only: 110, 35mm and 120. Right away, depending on the camera you own and use, you might be able to decide which film is best for you—the one that fits your camera.

Suppose you own a 35mm camera, which means you can choose either of the two films. Before you decide, you need to think about the subject or material you plan to photograph. If the subject is going to be in dim light and you plan to take the picture without the aid of a flash, you would need to choose the faster film, Kodacolor 400. If you are taking pictures outside under bright sunlight you might want to use the fast film if you're shooting fast-moving objects. The 400 rating will allow you to use faster shutter speeds or smaller apertures. Kodacolor II can be used indoors with flash or it can be used outside if you're not worried about stopping extra-fast action or needing small apertures for increased depth-of-field (area of sharp focus).

Both films produce negatives which are converted into color prints when the film is processed. The final size of the print might also be a consideration in choosing a film. Faster film has more "grain" than slower films, and "grain" can be an important factor in film selection.

Film Grain

Graininess in film relates to the clumping of silver or dye particles in color and black-and-white films. The grain becomes more apparent as a slide or negative is enlarged by projection onto a screen or through enlargement on photographic paper to become a print. Besides the inherent characteristic in some films, graininess can become enhanced by overexposure of black-and-white negatives or underexposure of color negatives. Improper development can also alter film grain.

Depending on the subject matter, a relatively high degree of graininess can produce either a detrimental effect or a pleasing, or at least interesting one, on some transparencies or prints. If your photographic subject requires the use of faster films, then you will have to tolerate the grain characteristics of some films.

Color Balance

Another consideration in choosing the film you plan to use in your camera is the color balance. You don't need to worry about it when you take pictures using black-and-white films, since there is no color. However, color films are balanced for various types of light. (See Chapter VI for artificial lighting variations.)

Most films are balanced for daylight. These films can be used with direct or reflected sunlight, some flashbulbs and flash cubes, and all electronic flash. All other light sources, like fluorescent bulbs and incandescent bulbs, will alter the color of the film and will deviate from natural or lifelike color. (Color correction filters can be used to balance film to various lighting as discussed in Chapter II.)

Some films are balanced for tungsten lighting, the light produced by common household light bulbs (incandescent lighting). If the film is used with daylight without a correction filter, the pictures will have an overall blue cast. As with most films, color correction filters can be used to balance tungsten film with an alternate light source such as flash or daylight. Keep in mind that when you add a filter you are reducing the amount of light striking the film, so you're actually reducing the speed or ASA (ISO) number.

There's more than one type of tungsten lighting. It depends on the light's Kelvin rating, which can be 3200 or 3400 degrees Kelvin. (See

Chapter VI.) There are two types of film available for these two light sources. One is called Type A, to be used with light sources that produce 3400 Kelvin; the other is Type B, which can be used with 3200 Kelvin light sources. Either film can be used with alternate sources of light, providing a color correction filter is used.

Grain, film speed, light (color) balance, and type of film, whether negative or transparency, are all things you must consider before you load your camera and start taking pictures. If you don't give these elements some consideration you may end up with very unsatisfying photographic results.

Color or Black-and-White Film?

Choosing between color or black-and-white film isn't difficult. You want either one or the other, and on occasion you may want both. I would assume that color film is the most popular film because people are used to seeing in color. They can accept color as real, whereas "living color" converted to black-and-white may lack vividness and personal appeal.

Before you decide to shun black-and-white film altogether, let me tell you one of the finer points of black-and-white film. It's a fine tool for learning photography. First, it's less expensive than color film, and if you're a do-it-yourselfer, you can quickly learn to process your own film and make your own black-and-white prints.

Second, in my own opinion, you learn more about composition and lighting when you use black-and-white films. You don't have bright yellows, reds, greens and blues to help hold your photograph together. If you don't make the best use of natural or added light you can end up with a monotone, rather than a graduated scale of black-and-white shades.

It's a lot easier to shoot a vendor holding a handful of colorful helium-filled balloons with color film than it is to do it with black-and-white. The color combination of the balloons can save the picture, but with black-and-white you don't have the colors to add impact. You have to

imagine the colors, or at least take the picture in such a way that the viewer can "sense the colors." Sometimes it's a difficult task.

Black-and-white films certainly have their place in the photographic world, as do the color films. With the color films you have to choose between shooting negatives and shooting transparencies or the very popular slide, which is nothing more than a transparency mounted in some sort of cardboard or plastic holder.

Slides are less expensive than negative-to-print films. With slides you don't have to pay for the processing of prints. You do have to invest in some sort of viewer and, preferably, a slide projector if you want more than one person to view the slides at a single time.

Very seldom are all the pictures you take on a single roll of film going to be good, and I mean really good, capable of stimulating a viewer's emotions. With slides or transparencies you can weed out the ones that are not quite up to par and have prints made of the best ones.

If you don't want to bother with slides, then choose a film that produces negatives. Generally you're allowed a little more room for exposure error. If the film is a little over- or underexposed, a good photographic lab can still produce a pleasing print. The same goes for color correction. Some modification in color can be done when the negative is being transformed into a print.

Push Processing

Some films can be "pushed" by altering the film speed, allowing you to get a faster shutter speed or a small aperture. Generally you'll alter a film's speed by one f/stop or one shutter speed. When the film speed is doubled, development of the film has to be changed.

Kodak Ektachrome 200 or Ektachrome 160 (tungsten) can be doubled in speed to 400 or 320, which will give you an additional f/stop or faster shutter speed if needed. The whole roll of film should be exposed at that new film speed

and then processed. Kodak offers special mailers for sending the film to their labs for the proper processing.

Black-and-white films rated at 400 or even Kodak Ektachrome 400 can be pushed beyond a doubling of the ASA (ISO) number. Tri-X can be pushed all the way to 3200, with a noticeable change in film grain and special developers required for the processing. Ektachrome 400 can be pushed as high as 1600 with "adequate results." However, all films cannot be pushed this far. Fujichrome 400 cannot be pushed at all if you want tolerable results. Experimentation with films and processing is the key to getting desired results when you feel pushing a film is the only way to get the pictures you want.

This creative photo was originally taken on Kodak Tri-X film. The image was then transferred onto 4″×5″ Kodalith, which was transferred onto Kodalith again to produce a negative. Finally all the background was painted out and a print was made.

What Brand of Film to Use?

I think photographic film is a prime example of how well advertising works. You ask a beginning photographer whose film he uses and the answer will invariably be Kodak. Kodak produces a fine line of films, cameras and other photographic accessories. They sell a bunch year in and year out and use a good deal of their profit for advertising. You see it on television, in photographic magazines, and in the publications that have mass market appeal. Everyone, sooner or later, is going to come across an advertisement for Eastman Kodak films and products.

Believe it or not, there are other film manufacturers besides Kodak. A few of these are: Ilford, Fuji, Agfa, H & W, 3M Company and Polaroid. Of course, some of these film manufacturers specialize. Both Ilford and H & W make black-and-white films only.

Fuji offers color film for both slides and transparencies in limited film sizes. Agfa manufactures both color and black-and-white films. There's an Agfapan 100 and 400 for black-and-white, and Agfacolor for negatives. There are three Agfachromes with various ASA (ISO) ratings for transparencies.

The problem with these films is the limited format selection and possible processing requirements from specific labs. Kodak film can be processed by Kodak Labs or it can be processed at the many independent labs across the country. All you have to do is walk to your nearest drugstore, drop off your film, and in a couple of days you'll have your prints or transparencies back.

Agfa color films come with prepaid mailers, and you have to send them to a lab set up for developing the film. Some individuals may find this inconvenient. Eastman Kodak offers prepaid processing mailers for their films too. You purchase the mailer from a photo supply retailer, fill out the mailing address, add postage and your return address, drop in the exposed roll of film and ship it off to the nearest Kodak processing lab. Depending on the lab you mail the film to, you'll get your processed transparencies or prints

Recognize any of these brands of film? The 3M Company is also the largest producer of private-label color film in the world. In the United States alone, the company has its film packaged under 45 different labels. Photo courtesy the 3M Company.

The 3M Company is manufacturing a limited line of color film and packaging it under their own label. Photo courtesy the 3M Company.

A small assortment of some of the many 35mm films available from the Eastman Kodak Company.

back in about a week. You never have to leave your home. What could be more convenient?

The prepaid mailers are practical for use when you are traveling. As you take pictures on your trip, you can mail the exposed film from wherever you are; by the time you return home from your travels, all your developed film will be waiting for you.

Specialty Films

Until now I've been writing about the common black-and-white and color films. If you have special photographic problems or would like to try something different, Kodak has the film. Again, not all films are made in every camera format, so you need to know what sizes are made for your camera. The widest selection of photographic films is available for use with the popular 35mm camera.

Kodak Royal-X Pan and Recording Film 2475 are two very fast black-and-white films. The Royal-X has an ASA (ISO) rating of 1250. It's made for 120-format cameras only. Recording film 2475 is another fast black-and-white film with a speed of 1000. It's manufactured for 35mm cameras. Both are grainy, compared to conventional, slower speed black-and-white films.

Kodak High Speed Infrared film can produce some interesting results because it's sensitive to infrared radiation. The strange results produced by this unique black-and-white film are fun to see, but I don't think it's a film you want to use for everyday work. The film is available in 35mm cartridges and must be used with a filter.

Ektachrome Infrared film, which verges on the bizarre, can produce pleasing results, creating unnatural colors depending on the filter used. Normally green foliage can produce red, white or yellow colors, creating a visually new environment. It's available in 35mm format.

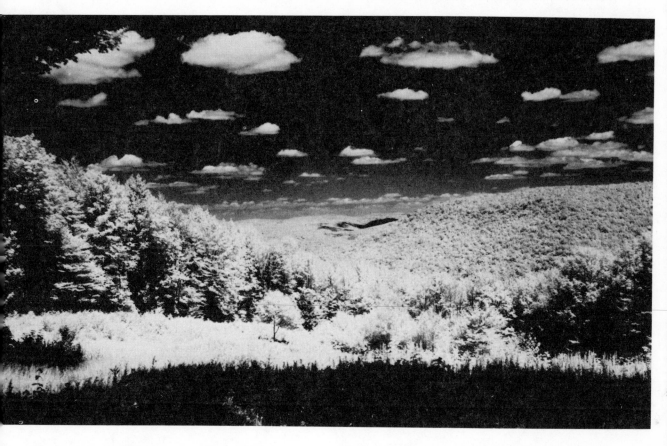

These two photos were taken with different films. One was taken with normal black-and-white film without the use of a filter, while the other was taken with black-and-white infrared film from Kodak with a red filter. Copyright Eastman Kodak Company, 1980.

Many of the Kodak films have the term "Professional" following the name of the film. These films require more care in exposure, handling and storage than the mass consumer films. The term "Professional" doesn't mean the beginning photographer can't give the films a try to see if they fit his needs.

Exposure Control

All films require the correct amount of light striking them to produce a proper exposure. Today, most cameras are automatic or have built-in light meters that act as guides for correct exposure. The final judge of exposure is the photographer, who might like his transparencies or prints a little darker or lighter than normal. Whatever the case, you must tell the camera's meter or mechanisms which film you are using by setting the ASA (ISO) number. With some of the less expensive models, which have limited exposure control, you can't use the faster films having 200 or 400 light sensitivity ratings.

Each roll of film comes with an instruction sheet, which gives you an idea of the proper exposure under various lighting conditions. In most situations, by using the normal combination of shutter speed and aperture (f/stop) the film will produce a properly exposed negative or transparency.

For the most part, if your camera has a light meter, if it's working correctly, and if you use it according to the instruction manual supplied with your camera, you shouldn't have any problems.

Light Meters

A backup method for judging exposure is the use of a hand-held light meter. There are many to choose from, varying from the inexpensive to the costly.

All meters have one thing in common—they have some sort of light-sensitive cell built into them. Some require a power supply from a battery while others don't. You set the meter so it knows what type of film speed is required, then take a light reading, and the meter will give you a series of shutter speeds and aperture combinations for correct exposure.

Basically there are two types of meters. One will take an *incident-light* reading and the other will take a *reflected-light* measurement. The difference is simple: an incident-light meter measures the amount of light striking the subject while a reflected-light meter measures the amount bouncing off the subject. When used properly both meters will give you the correct or desired film exposure.

Not all lighting situations are the same, and some can actually fool a light meter. A prime example is a back-lighted subject, such as a person with the sun behind his back or head. If you were to use a reflected-light meter, which is the type built into most cameras, you would end up with an underexposed main subject, the person. The meter would read the bright area behind the subject, giving you directions to expose for that particular area. However, the subject's face, pointing away from the sun, would be in the shade.

To obtain the correct exposure you should move in close and meter off the person's face, which is in the shadow. Once the exposure is set, step back and take the picture. Some of the newer, automatic cameras have a little button you can push which automatically compensates for unusual lighting situations by an f/stop or two.

At first glance the dials and numbers can scare the beginning photographer into thinking that light meters are impossible to use. However, once you understand how to use them, they can guarantee proper film exposure.

camera has. You can find out by reading your instruction manual or asking your local photo retailer. The built-in light meters can vary. Some are geared for center metering, using the central subject as the guide for exposure. Others may be bottom-weighted, using the center of the picture and below as the exposure guide. Finally, there are those that take everything in the frame as a guide, and some that offer spot metering.

Depending on the meter's characteristics, you can learn to compensate for "tricky lighting situations." You'll learn to move in close for backlighted subjects, or aim the camera toward the ground when you're shooting landscapes and the sky's field of light is a dominant force acting on the camera's meter. Understanding your photographic equipment is a major step toward taking properly exposed pictures.

This white plastic cap converts the meter from reflected- to incident-light reading.

Other "tricky situations" include vast amounts of sky, snow or other light- or dark-colored objects. You're not as apt to have the same problems with an incident light meter because it measures the light striking the subject, rather than light bouncing off. Many of the hand-held meters offer both reflective and incident readings by the use of various attachments.

The majority of hand-held light meters cover, or read, a fairly large area with an average of 30 degrees, while some are called spot meters. The spot meters measure a very small area, maybe as little as one degree, giving a precise reading of one area. To get the correct exposure you may have to take several spot readings and then average them. Some of the newest spot meters have zoom capabilities so you can vary the area you meter.

As a photographer you should be aware of what sort of weighted metering your particular

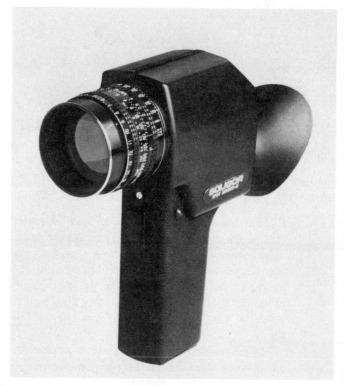

The Soligor Spot Sensor uses a 100mm lens. The 1 degree being measured by the meter is clearly marked in the center of the viewfinder. The unit has a built-in battery tester. Photo courtesy Soligor; AIC Photo, Inc.

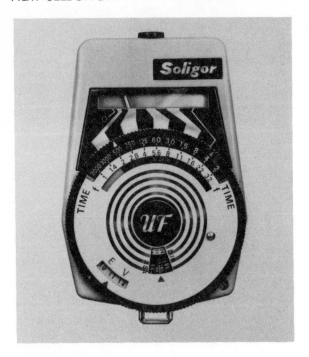

An ultra-thin reflective, hand-held meter from Soligor. Photo courtesy Soligor; AIC Photo, Inc.

Light-Meter Accessories

If your camera has a reliable built-in meter, there's no need to invest in a hand-held meter unless you like the idea of having a backup system. Depending on how much money you wish to spend and the sophistication of your photographic work, you can invest in a simple light meter or you can start a system that offers accessories.

The accessory list may include a *microscope adapter,* an attachment for *copying,* a *flash exposure meter* and a *variable angle spot-meter.* Whatever you think you might need to give you the film exposure you want, there should be a meter and accessory to fit the photographic situation.

Gray Card

To help you obtain the correct exposure, you might want to invest in a package of Kodak 8″×10″ *Neutral Test Cards.* Each of the four cards has one white side, with a 90 percent light reflectance. The opposite side of the card is gray, with 18 percent reflectance.

The vast majority of light meters are calibrated, using a scene with 18 percent reflectance. Thus, an average scene has an 18 percent light reflectance. These cards can be used to help you get the right exposure when you are using a reflected-light meter. You use the gray card as a source for metering. You have to get in close enough to meter off the 18 percent gray card, making sure the meter's shadow, or your own, doesn't fall on the card.

For best results, the card should be placed near the subject, with the same light striking the card that strikes the subject to be photographed. If your subject is in the shade, the card should be in the shade. If your subject is in full sun, your card should be in full sun, with no harsh reflections bouncing off the card. If there are, change the angle of the card slightly.

The final exposure reading will give you the average reflectance for the scene and the generally accepted exposure combination: shutter speed and f/stop. The Gray Card should be used for scenes with tricky subjects, such as too much white, which can trick the meter into the wrong exposure.

The white side of the card is used for dimly lit situations where it's difficult to read the meter. You take a meter reading off the white side and then divide the exposure by five, since 90 is equal to 5 times 18. Or, you can divide the ASA (ISO) number of your film by 5, using the new film speed as the meter's guide for the reading off the white card. Another route is to use the regular film speed setting, then divide the final shutter speed reading by 5 and set the camera to the nearest number and take the picture. If you were using ASA (ISO) 400 film you would set your meter to ASA (ISO) 80. Or you could take

the 400 reading, which might be 1/60 at f/4, and then divide 1/60 by 5; you would have to adjust the exposure to 1/8 or 1/15 at f/4.

Film Accessories

There are a limited number of film-related accessories to choose from, which may be nothing more than a small film-carrying device that attaches to the strap of your camera. You might want to purchase a plastic *film tube* that can hold several rolls of 35mm or 120 film. You remove the new film from the box it comes in and slip it into the tube. Supposedly it will take less room in your camera bag, plus you can see what film you need. The storage device saves you from cluttering your camera bag with empty film boxes and the film's data sheets. Another device for 35mm film can be clipped to your belt or pocket and actually dispenses the film as you need it.

If you travel by air regularly, you might want to invest in a *protective pouch,* which guards against X rays. X-ray machines are common in

A package of neutral test cards, showing the white and 18-percent gray sides. They are used to help you get precise light metering. Photo courtesy the Eastman Kodak Company.

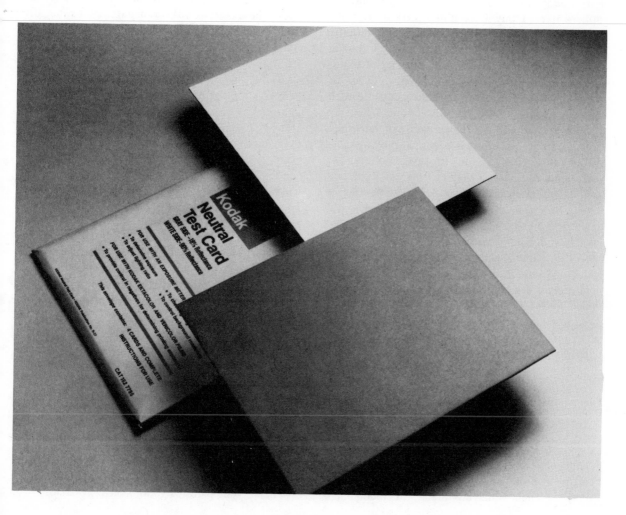

airports, and accumulative rays can fog your film. However, if you have to pass through only one or two airports I wouldn't worry about it. You can also request the attendant to manually inspect your camera equipment instead of running it through the X-ray machine.

Changing bags might be useful if you have a camera that has a tendency to jam film or if you want to load sheet film. It's nothing more than a lightproof material with sleeves for your hands. The film is kept in total darkness while you either change it, load it, or unjam a mechanism. Kodak black-and-white infrared film is supposed to be loaded in total darkness, so if you plan to shoot more than one roll during a photo excursion you might want to invest in a changing bag.

A final film accessory for 35mm users is a *bulk film loader* and *cassettes*. Some avid photographers like to buy bulk film in 100-foot rolls. It's less expensive than buying individually loaded film cassettes. Once the film is loaded into the device you can put any number of exposures into each cassette—ten, twenty, thirty or thirty-six. Make sure you label each cassette with the proper ASA (ISO) and film name. When the film is exposed and developed you can reuse the cassettes until the end seals begin to show wear.

Bulk film enables you to save money, but you'll find you have a tendency to get scratched film. For a while you'll wonder if something is wrong with your camera, and then one day it'll dawn on you that the scratches are coming from your bulk loader. Extreme care must be taken to keep the loader clean and free of dust and dirt, which will scratch the film.

(Filters are actually a film accessory, but they attach to the front of the lens, so I've included them in Chapter II. Various film holders are also accessories, but since they attach to the camera's body, I've included them in Chapter III.)

Instant Films

At the present only two manufacturers offer instant print-producing films: Eastman Kodak and Polaroid. Their films are made for their mass-market-appeal cameras. However, Polaroid sells many films for professional photographers, including an unbelievable 8×10 print-producing film using a special Polaroid print processor. An 8"×10" view camera is needed to use the film. Polaroid also manufactures sheet film for use with 4"×5" cameras or with any camera that will accept a 4"×5" film back. Another film of interest from Polaroid is a black-and-white print- and negative-producing film. You can use the negative to make additional black-and-white prints by the conventional method.

Professional photographers who use instant print films use them as a means of checking composition and lighting of their subjects. They can take a picture using the instant film and then, once it develops, look at the print to see if they have the results they want. If so, they can load the camera with transparency or negative film and take the picture, being fairly sure that the results will be exactly what they need.

In Summary

Film is the means to carry out your photographic endeavors. If you can see a subject or even visualize it in your mind, you should be able to reproduce the subject on film, whether it be in color or black-and-white.

Usually it's easier to look through a camera's viewfinder and see the subject. By moving in close or changing the lens or angle of the camera, you can manipulate the composition or placement of the subject. Composition is one control; exposure is another. You have the choice to overexpose, underexpose, or expose the film according to the manufacturer's guidelines. You can add color or alter color by use of filters.

Capturing or altering part of life on film is what makes photography so interesting. It's a creative tool that is seldom, if ever, totally understood. Each picture you take can be a lesson in photography, mixing both good and bad elements together. You'll have to be the judge of what elements—exposure, composition, subject—make your pictures good, average or bad.

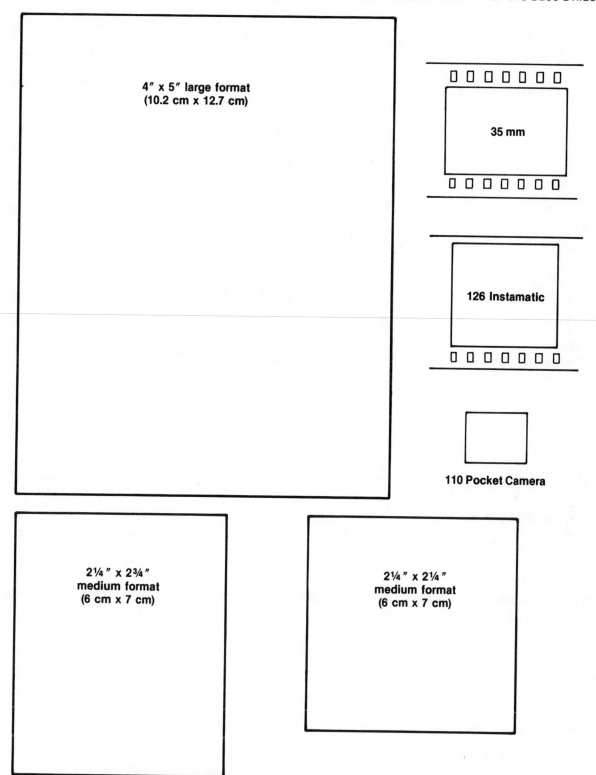

Fig. 3. Actual-size film comparisons.

Film Guide

BLACK-AND-WHITE

AGFA Films:

Agfapan 25	ASA 25	Available in 35mm and 120 roll film sizes.
Agfapan 100	ASA 100	Available in 35mm and 120 roll film sizes.
Agfapan 400	ASA 400	Available in 35mm and 120 roll film sizes.

H & W Control Films:

VTE Pan	ASA 50	Available in 35mm and some roll film sizes.

Ilford Films:

HP5	ASA 400	Available in 35mm, a 72-exposure cassette for 35mm cameras with winder, and 120 roll film sizes.
HP4	ASA 400	Available in 35mm, 120 roll and sheet film.
FP4	ASA 125	Available in 35mm, 120 roll and sheet film.
Pan F	ASA 50	Available in 35mm and 120 roll film sizes.

Eastman Kodak Films:

Verichrome Pan	ASA 125	Available in 110, 120, 126, 127 and 620 sizes.
Plus-X	ASA 125	Available in 35mm and bulk rolls.
Plus-X Professional	ASA 125	Available in 120 and 220 rolls.
Plus-X Professional ⌗4147	ASA 125	Available in sheet film sizes.
Panatomic-X	ASA 32	Available in 35mm and 120 roll film.
Tri-X Pan	ASA 400	Available in 35mm, 120 rolls and 126.
Tri-X Pan Professional	ASA 320	Available in 120 rolls. Tri-X Pan Professional 4164 available in sheet film sizes.

Specialty Kodak Black-and-White Films:

High Speed Infrared 2481	ASA to be determined by the user.	Available in 35mm, 20-exposure roll.
High Speed Infrared 4143		Available in 4"×5" sheet film size.

Royal-X Pan	ASA 1250	
2475 Recording Film	ASA 1000	Available in 120 roll size and 4"×5" sheet film.
	or higher	Available in 35mm.

The above are many of Kodak's black-and-white films. There are others for special application and sheet film sizes. Many of the films mentioned can be purchased in bulk roll lengths.

Polaroid Corporation Films:

Type 87	ASA 3000	
Type 107	ASA 3000	Available for various
Type 665	ASA 100	models of Polaroid
Type 667	ASA 3000	instant cameras.

Type 51, high contrast	ASA 200	
Polapan Type 52	ASA 400	Available in
Type 55 P/N (positive & negative)	ASA 50	4"×5" film packets.
Type 57	ASA 3000	

COLOR FILMS

AGFA Films:

Agfachrome 100	ASA 100	Available in 35mm.
Agfachrome 64	ASA 64	Available in 35mm.
Agfachrome CT-18	ASA 50	Available in 120.

Fuji Photo Films:

Fujicolor F-II	ASA 100	Available in 35mm, 126, 110 and 120.
Fujicolor F-II	ASA 400	Available in 35mm, 110 and 120.
Fujichrome RD-100	ASA 100	Available in 35mm and 120.
Fujichrome 400	ASA 400	Available in 35mm.

Eastman Kodak Films:

Kodacolor II	ASA 100	Available in 110, 126, 127, 35mm and 620.
Kodacolor 400	ASA 400	Available in 110, 35mm and 120.

Vericolor II		
Professional Type S	ASA 100	Available in 35mm, 120 and 620.
Vericolor II		
Professional 4107		
Type S	ASA 100	Available in sheet film sizes.
Vericolor II		
Professional Type L	ASA 80	For tungsten lighting; available in 120.
Kodachrome 25	ASA 25	Available in 35mm.
Kodachrome 64	ASA 64	Available in 110, 126 and 35mm.
Ektachrome 400	ASA 400	Available in 35mm and 120.
Ektachrome 200	ASA 200	Available in 126 and 35mm.
Ektachrome 160	ASA 160	Available in 35mm for tungsten lighting.
Ektachrome 64	ASA 64	Available in 110, 126, 127 and 35mm.
Ektachrome 200		
Professional	ASA 200	Available in 35mm, 120 and bulk rolls.
Ektachrome 160		
Professional	ASA 160	Available in 35mm, 120 and bulk rolls.
Ektachrome 64		
Professional	ASA 64	Available in 35mm, 120, sheets and bulk roll.
Ektachrome 50		
Professional	ASA 50	Available in 35mm and 120; for tungsten lighting.
Ektachrome 6118		
Professional	ASA 50	Available in sheet film sizes.
Ektachrome Infrared	ASA to be decided by photographer	Available in 35mm; 20 exposures.

3M Company Films:

Color Slide 100	ASA 100	Available in 35mm.
Color Slide 400	ASA 400	Available in 35mm.
Color Print	ASA 100	Available in 110 and 35mm.
Color Print High Speed	ASA 400	Available in 35mm.

SELF-PROCESSING FILMS

Eastman Kodak Company:

Kodak Instant Print Film	For Kodak Instant Cameras.
Instant Film Back	For use with 4"×5" Graflok back.

Polaroid Corporation:

Polacolor 2, Type 108	Super Shooter, 100–400 series cameras,
Polacolor 2, Type 668	Reporter, MinuteMaker, Model 195 and Polaroid film backs.
Polacolor 2, Type 88	Super Shooter, Reporter and MinuteMaker Polaroid cameras.
Polacolor 2, Type 58	$4'' \times 5''$.
Polacolor 2, Type 808	$8'' \times 10''$ with Polaroid processor.
SX-70 Land Film	SX-70 and Pronto Cameras.
Time-Zero Supercolor	SX-70 and Pronto Cameras.

The previous list of films is by no means complete. Many specialty films are made by the Eastman Kodak Company and the Polaroid Corporation. The film listing is to give you a general idea of what's available.

Chapter V

Camera Protection: Cleaning, Storage and Equipment Holders

All the photographic equipment you own is an investment and, as with all investments, care should be taken to protect them. You may think I'm contradicting myself because, in the first chapter of this book, I wrote, "Cameras are tools, not jewels," and said that they should be used. I'm not reversing myself, though—I'm just pointing out that tools deserve care. You're not going to leave them out in the rain, nor are you purposely going to drop them on the ground. If you do, your tools aren't going to work very well.

With reasonable care (barring any unforeseen catastrophe) and occasional maintenance by a qualified camera repair person, a camera should last indefinitely. Of course, the unforeseen does happen. I once watched a photographer drive down the road with his $1,500 worth of camera equipment sitting on top of his car's roof. Although I felt horrified and subsequently sympathetic, there was nothing I could do except watch it bounce off the trunk of his car and onto the asphalt pavement of the road. It wasn't a freak accident where no major damage was done to the camera. On the contrary, it was ruined. I like to think that things like that don't happen, but they

do, and I can only hope it happens to the other guy.

If you're lucky, you'll never lose or break any equipment by careless handling. Once in a while the unusual does happen, but you can chalk it up to experience. I've had two strange occurrences while taking pictures. Both were my fault and both happened when I was on a photographic assignment.

On one occasion I was using an old model Nikon which had a camera back that came completely off the camera when you changed the film. I was busy taking pictures and had just completed a roll of film. There were quite a few people watching me take the pictures when suddenly the back dropped off the camera. So much for the roll of exposed film and for looking professional.

The other occurrence took place when I was wearing a coat and tie. I had loaded the camera with film and closed the back. Every time I raised the camera to take a picture, my tie rose too. I had wedged the tip of the tie in the camera back. I had to use a screwdriver to get the tie and camera back separated. Needless to say, now I never wear ties when I'm taking pictures.

Lens Protection

A scratched or dirt-covered lens is going to affect the quality of your photography, so care must be taken to give the lens as much protection as possible. There are a number of ways to do it.

If you have a lens that's not in use and not attached to your camera, it should have its front and rear glass elements covered with a protective lens cap. When you purchased the lens, the manufacturer should have supplied the protective caps. The rear cap may be a slip-on, or it may be made to fit the mount method of the lens, such as bayonet or screw-on.

The front lens cap can be screw-on, slip-on or a squeeze, spring-loaded type. The screw-on is good because it will stay in place once it's attached. The deficiency of a screw-on lens cap is the amount of time it takes to get it off. The slip-on caps, if they don't fit snugly, slip off. The squeeze type are quick to put on and take off, but some do not stay on the front of the lens as well as they could. If the spring-held button is struck against something, like the edge of a camera bag, the cap will pop off.

Sooner or later you'll lose a front or rear lens cap. Either it's going to fall off, or you'll be in a hurry and take the caps off, laying them on the ground and forgetting where you put them. Be grateful that front and rear lens caps are not the most expensive accessories you can buy.

Quite a few manufacturers have come up with methods to help the photographer keep from losing the front lens cap. They range from flip-up to string-along caps. You, as a beginning photographer, might want to try one of these methods.

The type that has a connecting cord from the camera body to the lens cap bothers me when the cord dangles from the side of my camera. The flip-up type interferes with my operation of

A set of Olympus lens caps, front and rear, plus a body cap to keep dust from entering the camera when a lens is not attached.

the lens. But, if you're prone to losing lens caps, one of these methods may be of use to you as a photographer.

For added protection for the lenses not in use, you can buy hard or soft cases in which to store them. Once again, many manufacturers supply a lens case when you purchase their lenses. If not, several companies produce cases to fit just about every lens made.

A padded, hard case will offer more protection to a lens if it's dropped accidentally than a soft case will. Sima manufactures a soft case with built-in pockets you can fill with air before sealing the case. As long as the pockets hold air, they offer protection for the lens.

When you're actually taking pictures, the best place for a lens case is at home in a drawer. Far too much time can be wasted taking the lens out of the case and then putting it back in the case when you're done with the lens. If you do want a little extra protection for your lens while it's in your camera bag, wrap it in a soft, lint-free cloth or put it in a clean, heavy sweat sock.

I have seen a number of newspaper photographers with lens cases worn around their necks. The cases are for extra-long telephoto or zoom lenses and the method seems to work very well for them.

Many lenses come with cases when they are purchased. Olympus has hard cases for their lenses, and provides an indication of which lens is in the case, making it convenient for the photographer to find the correct lens.

A lens mounted to the camera body needs a different type of protection than one placed in storage or resting in the bottom of a camera bag. The rear element is protected by the camera, but the front element is exposed to all sorts of photographic hazards. When the camera is not in use, it's best to keep the lens cap on.

However, if you own a camera that doesn't have through-the-lens viewing, you have to remember to take the lens cap off before using the camera. There are thousands of photographers who have taken picture after picture only to find out that they had forgotten to take the lens cap off. Please, as a beginning photographer, try not to make the same mistake. Always, before you take a picture, make sure the front lens is unobstructed by dirt, grease or the lens cap.

A filter is far less expensive than a lens. If a filter gets scratched or broken it can be replaced for a few dollars. A new lens can cost $100 or more. Every lens I own has either a UV (ultravi-

olet) or skylight filter covering the front element at all times. The filters' effects on my pictures are minimal compared to the lens protection they offer. When I purchase a lens I also buy a protective filter and attach it as soon as I can. If by chance the filter eventually becomes scratched or damaged, I replace it, being thankful that it wasn't the lens I had to replace.

Rubber lens hoods can also offer some protection. They attach to the front of the lens just as a filter would. Of course, you can purchase metal lens hoods too, but metal doesn't absorb the shock of being struck like a shade made of rubber would. I use a rubber lens shade when I'm in a photographic situation that requires my hiking to photograph subjects in rough terrain or anywhere I feel there's a chance I can bang the lens of my camera against a hard object. If I'm

A selection of lens cases from Vivitar to fit a wide assortment of various-size lenses. Photo courtesy the Vivitar Corporation.

shooting interiors, where the camera spends most of its time on a tripod and there are no unwanted reflections to worry about, I don't use a protective lens shade.

I cannot emphasize enough what a little protection to a lens is worth. Until you've had to replace a lens you may not realize the importance of this, but if you ever damage a lens in a way that could have been avoided by using protective filters and lens shades, you'll quickly learn their value as protective devices.

Lens Cleaning

Even if you don't use your lenses as much as you'd like to, they're going to get dirty. There's so much lint, dirt and dust in the air, some is bound to land on the lens. When it looks truly dirty it will need to be cleaned.

Cleaning the actual lens, not the front and rear elements, isn't difficult. A soft brush for getting into the nooks and crannies of the lens is useful. Brush the dirt loose. When the dirt is free, a soft, clean cloth can be used to wipe the entire barrel of the lens.

The elements of the lens need special accessories for cleaning if you don't want to cause any damage. If you have a protective filter on the front of the lens and you started with a clean front element, it should still be clean. If not, you're going to have to take the filter off and clean the lens.

Get rid of the big particles of dirt and dust by blowing them off the lens; you can purchase a combination blower and brush from your photo retailer. If you can see faint fingerprints or small smears of some sort, you'll have to clean the lens with special tissue you buy at your camera store. Do not use regular tissue for lens cleaning, because it's not a fine enough grade. Regular tissue can cause scratches. Your local camera store will sell small packages of lens cleaning tissue. When you buy the tissue, pick up a small bottle of lens cleaning fluid as well.

After you place a drop of fluid on a crumpled piece of the tissue, you gently clean the lens in a circular motion until the fingerprints and smears

are gone. If necessary, the same thing is done to the rear element of the lens, using a clean piece of tissue.

Before you replace the protective filter, if you're using one, you'll need to blow away any dust and lint that have accumulated on it. Use a blower brush or a can of compressed air, not your breath, which will do nothing more than add moisture to the front of the lens. If it's still dirty, use a new sheet of lens cleaning tissue and a drop of fluid to remove fingerprints and smears from the filter. Replace the filter, then the lens cap, and you're ready for your next photographic adventure.

Cleaning fluid for lenses helps pick up the extra-fine dust and remove fingerprints or smudges. A small bottle of the fluid should last a very long time. Photo courtesy the Eastman Kodak Company.

Your local photo dealer should have a display similar to the one illustrated here. This lens-cleaning paper is extra fine to prevent scratching your valuable lenses. Photo courtesy the Eastman Kodak Company.

A small brush should be used to brush away any large particles of dust or dirt on the lens before you clean it with lens tissue.

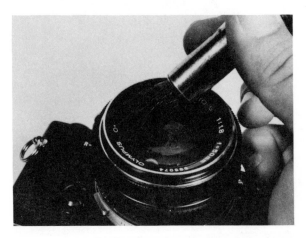

Camera Body Protection

A camera body, like a lens, needs some sort of protection. When a lens is not attached to the camera, the opening where the lens would go needs to be covered with a body cap. Like a lens cap, it may screw on, slip on, or match the camera's lens-mounting method. The protective body cap will keep unnecessary dust from getting inside the camera when it's not in use.

Most camera manufacturers sell either hard or soft "ever-ready" cases to fit both the camera body and normal lenses. They offer protection when the camera is being transported or stored. These cases are nothing more than protective sheaths which wrap around the camera. I've never owned one. Instead, I keep my cameras in some sort of gadget bag, because having a case around the camera can be bothersome except when it's actually used for storing a camera.

If you've ever taken pictures with a case on the camera you'll know the problems they can cause. First, the front portion of the case has to be taken off or it dangles beneath the camera. If you have an accessory lens on the camera, such as a telephoto, you can't use the front portion of the case because it won't fit. What do you do with the case? Leave it at home or in the car. Don't take it with you when you're taking pictures.

The other portion of the "ever-ready" camera case goes on the bottom of the camera. ("Ever-ready" is really a misnomer, because the cases are not ever as ready as they could be.) Often, it's held in place by a retaining screw that goes into the tripod socket. There is one problem with this design. If you need to change film in a hurry, you're out of luck. The case has to be taken off the camera to open the camera film back. Certainly, not all "ever-ready" cases are this bothersome, but many of them are.

The cases do serve the function of protecting your camera when it's being stored or transported. However, I recommend that you take the case entirely off the camera and leave it in a safe place when the camera is being used.

An Olympus Ever-ready case to protect the camera from damage. The front of the case must be removed before the camera can be easily operated. Photo courtesy the Olympus Corporation.

The Safari camera case is capable of holding a 35mm camera with a telephoto lens. Photo courtesy Safari Camera Case, Inc.

There is an "ever-ready" case which has a different design than most. It's the Safari™ single-lens reflex modular camera case, which can be carried over the shoulder with a strap or attached to a belt. Its modular design makes it possible to carry a camera with a lens up to 300mm, by adding extension tubes to fit the lens you use.

Camera Body Cleaning

Your camera will get dirty, and when it does you'll need to clean it. As with the lens, a soft brush can be used to loosen dirt and dust from the crevices and hard-to-reach areas. Then a soft, lint-free cloth can be used to wipe it away. The viewfinder can be cleaned with a piece of lens tissue and a drop of lens cleaning fluid. If the viewfinder is very small, a cotton swab stick can be used in place of the tissue.

The only other area of the camera I clean, other than the exterior, is the film plane. If there are small dirt particles on the pressure plate they can scratch the film every time it's advanced. A soft brush or a blower can be used to clean the area.

Small camera viewfinders can be cleaned by using a cotton-covered swab stick instead of lens-cleaning tissue.

As far as the interior of the camera goes, I leave it alone. If it gets really dirty I take it to a camera repair shop, or I send it to an authorized repairman to have it cleaned.

If you use interchangeable focusing screens or viewfinders you will need to carefully brush away the dirt and dust that accumulates on them.

When you store a camera for an extended period of time, you should remove any batteries from the equipment. However, don't forget to replace them before you use the camera. You might also want to click the shutter before you put the camera away; this takes the pressure off the shutter's spring.

As you accumulate hours of usage on your equipment, you may eventually discover that the pictures you're taking aren't exactly right in exposure; something may be wrong. Shutter speeds can change and mechanisms jam. First, before you panic, make sure that any batteries you are using are in good working order. If that's not the problem, you're going to have to take your camera in for a physical.

Your photo retailer may recommend a local camera repair person. The other alternative is to check your camera's warranty card to see where the manufacturer has a service station. It doesn't hurt to get an estimate on the repairs before you commit yourself to getting it fixed. You may find it less expensive to trade in the old model on a newer one.

Camera Cases and Bags

Once you've accumulated all the camera equipment and accessories you know you're going to need, you'll have to find a way to store and carry them. Well, there are hundreds of camera cases and bags to choose from. The problem is to find one that holds all your equipment and is convenient to use. While you're looking, you might want to whistle or hum "To Dream the Impossible Dream." Finding the right bag is no easy task.

Camera Cases

When I use the term *case,* I'm referring to the equipment holders shaped like a suitcase. They may be made of aluminum, or their construction may consist of cardboard or wood frame covered with vinyl or leather. Some are made of fiber glass or plastic.

Inside you'll find a protective foam liner, which may be precut or solid; if it's solid, you'll have to cut it yourself to fit your equipment. These cases serve their purpose. They work fine for camera and accessory storage. They are good for camera transportation, because the foam holds the equipment in place and helps to absorb any shock the case might receive during its trip.

Finally, the case is excellent for single-location photography, when you're taking all of your pictures in one place without moving around. If you try to use the case for any other type of photography situation, such as shooting a sporting event or when you're hiking, you'll be thoroughly disappointed.

You cannot carry a suitcase-type camera carrier and take pictures at the same time. If you need an accessory from the case, you have to set it on the ground, open it, remove the accessory you want, then close the case. While you are actually using the camera to take pictures, you have to leave the case sitting somewhere. While it's sitting and you're concentrating on the pictures you're taking, someone can walk off with it.

The cases are attractive, and they work well in some photographic situations, but not all. Realize the suitcase-type carrier's limitations before you buy one, because if you don't, you'll have to purchase another case that has practical field use.

Camera Bags

Selecting a camera bag is very similar to accepting a blind date. You won't know until you see it and spend a little time with it whether it's great fun or a total disaster. Only when you've actually

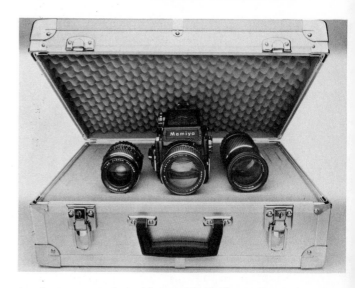

An aluminum case for a Mamiya M645. The protective foam is precut and ready to be removed for camera and accessories. Photo courtesy Bell & Howell/ Mamiya Company.

This sturdy aluminum case uses padded partitions instead of a foam insert. Photo courtesy Fiberbilt Photo Products.

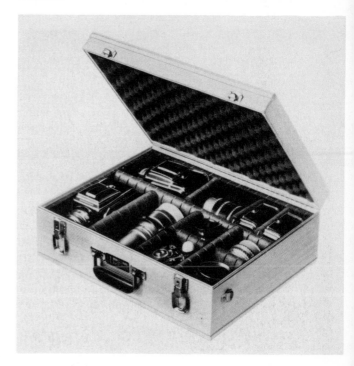

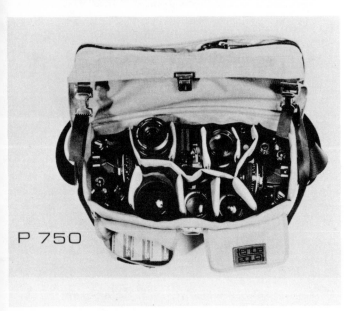

P 750

A Tenba soft-case packet with camera equipment. Note the easy access to film, cameras, lenses and accessories. Photo courtesy Tenba.

ally know because I'm still searching. I've had to settle for a regular bag and strap. Everything rolls together and I have to shuffle equipment when I'm looking for an accessory. After I use this system for a while, my equipment begins to look a little ragged, but I generally get the pictures I want.

You might think the answer is two camera bags. No, that won't work either, unless you're shooting in one spot. Try to visualize how difficult it would be to have two bags, a camera, and possibly a tripod hanging over your shoulder. It would be an interesting study in coordination, but you'd have nothing but trouble trying to get organized, even to take a single picture.

The bag you select has to be geared to the amount of camera equipment you own. If the only equipment you use is a camera, one lens,

placed all your necessary equipment in the bag and gone out to take pictures, reaching in for equipment as you need it, will you know how good the bag is.

The ideal bag holds all your camera equipment and accessories within easy reach. You want to be able to open the bag, reach in and, without having to take everything out of the bag, get the accessory you need.

There are literally hundreds of bags to choose from. Some are nothing more than a bag with a shoulder strap. Everything rolls around together in the bag. Other bags may have different compartments to hold the various equipment, such as one compartment for a camera body, one for a lens, and another for film and filters. Then there are bags with a top and bottom compartment. The only way to get to the bottom portion of the bag is to take everything out of the top compartment. When you do find what you need, you have to put everything back into the top of the bag. By the time you've done all of this, the picture you wanted to take has walked off or died as the sun went down.

So what's the ideal bag? Candidly, I don't re-

A small over-the-shoulder camera case from Tenba, for limited equipment transportation. Photo courtesy Tenba.

and a filter or two, you don't even need a bag. If you plan to carry a camera, several lenses, filters, a flash unit, a cable release, lens cleaning equipment, a viewfinder, and a good supply of film, you'll need a bag that will hold everything you think you're going to need. A shoulder bag with one large compartment and several pockets on the side may work just fine. The only way to know is to try.

It's possible that a two-layered case will work if you keep accessories you need once in a while on the bottom shelf. Cases and bags are not the only methods for carting around cameras and accessories, and maybe one of the alternative carry-all systems will work better for you.

A backpack for a Tenba camera case for easy carrying when hiking. Photo courtesy Tenba.

Vests and Backpacks

Some manufacturers specialize in unique carry-all systems. One example is merchandise made by Focus Photographic Outfitters. Their field cases and travel cases are designed for both hand carrying and over-the-shoulder transporting. Some of the smaller bags can be converted for backpack use.

Another unique carry system is a photographer's vest. The vest has a total of seven pockets, which should offer plenty of room to hold a complete line of picture-taking accessories.

Tenba, a Tibetan word for strong, unshakable and reliable, is the name of another manufacturer which produces a complete line of heavy-duty and versatile camera bags. Accessories are available for waist-belt or backpack-harness carrying.

Another system is nothing more than an oversized money belt which is worn around the waist. There are several zippered pockets to hold film, filters, and other accessories.

You'll need to decide what sort of material the camera bags, cases, etc., should be made of. Some are vinyl, leather, canvas, or nylon. If you like to search for pictures of elusive rainbows, you had better make sure your camera bag is water repellent or waterproof.

Small Cameras, Small Cases

For the camera owner who doesn't have a wide selection of accessories to choose from, other than flash and filters, a number of pocket pouches are made. Some may hold just a camera to offer limited protection. Others may be large enough to hold a camera, a flash attachment and extra film. The smaller pouches may attach to a belt, fit in a coat pocket, or have a shoulder strap. There's a case to fit your specific photographic needs.

Accessory Protection

Glass filters need some sort of protection when they are not in use. The easiest method is to keep them in the package they came in. How-

ever, if you have a number of filters, they can take up quite a bit of room in your accessory bag.

Some manufacturers make small pouches that hold up to six filters. When you need a filter, you pull the pouch from your camera bag, pull out the filter you need and attach it to the front of your lens.

Another method, if all your filters are the same size, is the use of stacker caps. You screw all your filters together and then attach a stacker cap to each end, sealing the filters inside and protecting them from dust and dirt. When you need a filter, you read the filter's retaining ring to see which is which. Then unscrew the filter from the rest and you're ready to go.

Vivitar filters are packaged in a Reddi-Pouch,tm which can be combined with the op-tional Reddi-Pouch binder that's capable of storing three Vivitar filters.

Some manufacturers also make special carrying cases for tripods. The cases will hold a tripod and make it easier to carry by featuring a hand or shoulder strap. Some feature both. Tripods can be one of the most cumbersome pieces of equipment you own. If a case will make it easier to handle, by all means invest in one or make your own as described in Chapter VIII. Tripods are not quick-to-use equipment, and a carry bag won't slow you down as would lens and "ever-ready" cases.

A filter pouch is capable of holding six filters, or you can leave your filters in the protective packages in which they were purchased.

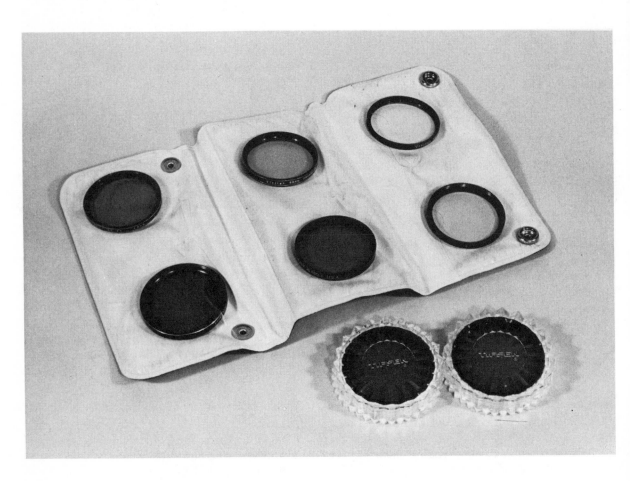

You can also buy small bags or pouches to fit inside your case or bag. You might want one to hold a flash, one for film and so on. Keep in mind that you'll be reducing access to your equipment when you have to open the bag to pull out a bag which in turn has to be opened to reach the accessory. If time isn't important and you want the added equipment protection, the accessory bag within an accessory bag might be worthwhile.

If you have a number of accessory lenses in your camera bag and they look similar, there's an easy way to speed up accessibility. Label the lens caps, using masking tape or a label gun. Then all you have to do is look at the lens cap to know which lens you want. It's quicker than picking up each lens and taking the lens cap off to see if you have the right one.

Convenience, comfort and reliability are the three keys to a quality equipment bag. Putting the three together may take some trial and error.

Vivitar filters are sold in a Reddi-Pouch.™ An optional Reddi-Pouch Binder can be purchased to hold three filters. Photo courtesy the Vivitar Corporation.

Think Before You Buy

Every photographer works differently. Some are quick-composition-and-shooting specialists. Others are slow, carefully composing and exposing each photograph they take. One may rely on a number of accessories to get the pictures he wants while another needs only one lens and camera for all of the pictures he takes. Both photographers, with their various techniques and equipment, may get good pictures.

A quality camera case or bag is a vital accessory to the photographer. Choosing the right bag is a difficult but personal endeavor. Only you, as a photographer, know how to get the optimum performance from your equipment. If it doesn't bother you to haul around an aluminum or fiber glass suitcase when you take pictures, then that may very well be the system you need.

If your photographic environment consists of climbing high mountains or chasing an elusive bird, you may need the mobility of a vest or backpack camera-carrying system.

Ideally, you may use two systems, one for single-location or studio photography and another for fieldwork. Again, it all depends on your photographic style and the number of camera accessories you use on a regular basis. Shop and compare bags, or ask other photographers what they have found to be the best method in equipment storage, transportation and field use. You'll be surprised how varied the answers will be.

Chapter VI

Artificial Lighting and Lighting Accessories

Light, whether produced by the sun or by some artificial means—flash, fluorescent lights, photo floods, etc.—is as important to your pictures as the camera and film are. Without some type of light source you would not be able to produce photographic images.

Natural light produced by the sun is by far the easiest to work with. Available artificial light produced by various light sources, such as table lamps and ceiling fixtures, will work well with some films, especially the fast black-and-white or color.

However, there's more to lighting than sunshine and what's produced to light our homes. It is "controlled lighting" that puts the photographer in the driver's seat. Once you know how to use controlled light, you are able to put the light where you want it. If you understand a few fundamentals, you'll keep to the road. If you don't, you might find yourself bouncing off a brick wall every now and then, producing pictures that are far from good.

This chapter will act as a basic "driving school" to help you learn a little bit about controlled lighting. In all honesty, the best way to learn, if you have the time and patience, is to go out and hit a few walls. I like to think we all learn from our mistakes, and by playing with lighting you can begin to see what may or may not be right when using controlled light.

By knowing the basic principles of proper lighting or by altering the rules to fit your needs, lighting can be used as a creative tool. What's right for one photographer may not be as good for another. Controlled lighting is determined by how you look at the subjects you photograph and by the results you want—results other people, as well as yourself, will think are pleasing.

The most common controlled lighting method is some sort of flash; this can be electronic, cubes, flipflash or bulbs.

Flash

When your photography calls for a dash of light, use flash. Visually, flash does look like a dash of light, but it's more than a dash; it can be harsh and almost obtrusive, depending on how it's used.

Beginning photographers rely on flash because it's relatively inexpensive and because all cameras offer some sort of flash-to-camera attachment. For the less expensive cameras like the Instamatics and some 110's, it may be nothing more than a coupling device for flashcubes or flipflash.

More and more cameras are being built with flash incorporated into the camera. Some cam-

116

eras are designed with a special flash attachment which costs extra, but when it's attached to the camera it looks like an integral part of the system, making it difficult to visually perceive the two parts as separate.

Cubes, bulbs and flipflash are easy and relatively inexpensive ways to get introduced to flash. But why invest in a device that gives you one, four or eight flashes, only to be tossed in the nearest trash container when the bulbs are used up? Electronic flash, which uses a battery power source and recycles in a matter of seconds with fresh batteries, is reliable and well worth the investment. You don't have to worry about running out of flash power after a single roll of film is used. Some electronic units will give you 100 or more bursts of light with a single set of batteries. As electrical power diminishes, the recycle time for the unit to build up energy for another burst of light increases. Instead of two seconds between flashes, it may take fifteen seconds before the flash will be ready to fire.

Understanding Flash

There's nothing wrong with using flash when there's a need. Some of the less expensive cameras having limited exposure control, if any, rely heavily on flash whenever the camera is used in lighting situations other than natural, outdoor, sun-provided light. You'll have to live with the problem because it came with the camera.

Artificially produced light from flash has a weakness. It dissipates and gets weaker the further it gets from the source (the flash unit). A

Some cameras have built-in flash units while others have accessory flashes that can be attached to the camera. When this A11 electronic flash is attached to the Olympus XA camera, it looks like an integral part of the unit. Photo courtesy the Olympus Corporation.

subject five feet from the flash unit will receive more light than a subject ten feet from the unit. The camera's f/stop will have to compensate for this light variation.

Another electronic flash consideration is the speed of the dash of light. If you blink while the unit is being fired, there's a good chance you'll miss it. It can be 1/1000 of a second or faster. These extremely fast flash durations are quite capable of stopping or freezing action and are very important for some types of photography. The flashbulbs or cubes are considerably slower in duration and may not work in stopping all action.

Both bulb and electronic flash can vary in the amount of light they produce, depending on their power, BCPS (beam candle power seconds) or guide number. The more light the flashbulb or unit is capable of producing, the more you'll probably have to pay for it.

Flash Synchronization

The shutters of a camera can vary, and some may be built into the lens rather than the camera. Whatever the case, it takes a certain amount of time for these shutters to open, and the secret is to have them open when the flash puts forth its burst of light. Your camera manual will give you instructions for use with electronic flash. It may state that flash can only be used at 1/60th of a second or slower, or it may allow flash use with any shutter speed if the shutter is built into the lens.

You can always tell when your shutter speed is incorrect for use with the flash—but, unfortunately, you'll find out after the pictures have been taken and the slides or prints are processed. If you were using the right amount of light, enough to expose the film correctly, but the shutter speed was too fast for synchronization with the flash, you'll get a picture with a portion of it incorrectly exposed. The portion of the film incorrectly exposed will vary with the speed of the shutter. This happens because you failed to understand the correct shutter-flash combination,

or more likely because you became so involved with your photography you forgot to adjust shutter speed. It's one of those walls you can run into while learning about controlled lighting.

Just the opposite can also happen when using flash. You might use a shutter speed that's too slow, producing unexpected results. What happens is that the flash goes off, exposing the film; then the shutter remains open, allowing any remaining available light to expose the film. Your final picture will have a sharp image—plus, if the subject was moving, a blurred, ghostly image.

Your camera needs to be set so that it works with the flash being used. It may have a hole for the flash relay cord with an X, an FP, or even an M setting. The X setting is to be used with electronic flash. The M or FP setting is to be used

Some cameras have a socket to hold the flash relay cord. If so, it might have a choice of settings. The X is for electronic flash while the FP is for bulbs.

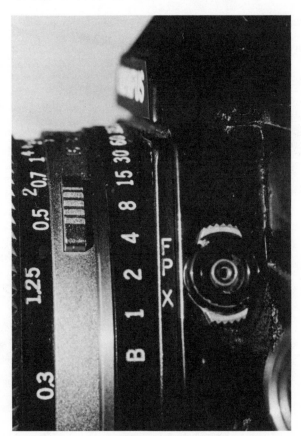

with various types of flashbulbs. You have a choice of blue-colored bulbs for daylight films or clear bulbs for use with tungsten film. The bulbs can be classified as F, fast; MF, medium fast; M for medium; and S for slow. These ratings refer to the bulbs' ability to reach maximum light output.

Flash-to-Camera Connection

There are a couple of ways to connect the flash to the camera. One is by using a hot shoe. This is a little mounting bracket attachable or built into the camera. The base of the electronic flash slides into place and an electrical connection is made.

Some flash shoes are not "hot." There's no connection made to the camera, so a PC cord is used from flash to camera. This is nothing more than a short or long cord with a fitting that slides into a PC socket or hole. There may be a flash-setting device on the PC socket for X, FP, or possibly M. If you're using electronic flash you use the X setting. If you plan to use a flashbulb system, check your camera's manual for the proper setting; if you only have the FP, then use that for flashbulbs.

So far all I've mentioned is flash-to-camera connection. The flash unit is attached to the camera. It may be on the side of the camera if it has a built-in flash, or it may be somewhere on top of the camera, especially if it's a 35mm.

This type of connection works because it's convenient. Your camera and flash act as one unit. However, the placement of the flash unit can drastically alter the effect it has on the subject. If the subject you are photographing has a light-colored wall directly behind it, you'll quickly see what I mean. The directional light produced by flash can produce harsh shadows.

If the flash is pointed directly at the subject, little shadow will show up. If the flash is off to the right or left of the camera, a harsh shadow may appear on either side of the subject. If you were to shoot your subject from a very low angle you could produce large shadows behind the subject.

This is a hot shoe, which connects the flash to the camera without the need for a relay cord. The flash slides into place. All you have to do is turn the flash on when you're ready to use it.

This Olympus OM-2 camera and flash attachment is ready for picture-taking. The combination is fully automatic, with the camera controlling the flash's light output. Photo courtesy the Olympus Corporation.

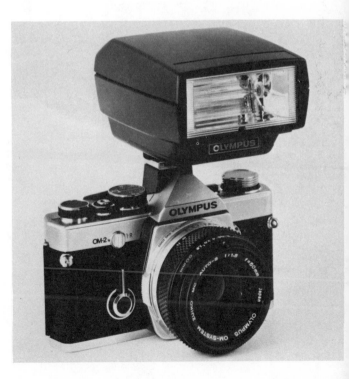

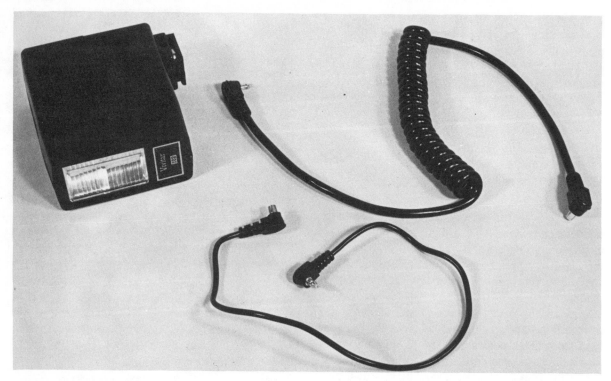

A flash unit with a choice of two relay cords. If the flash is to be mounted to the camera, the short relay cord can be used. The longer cord is for using the flash at a distance from the camera.

This unique relay cord connects the electronic flash to the hot shoe receptacle rather than the PC hole. Photo courtesy the Olympus Corporation.

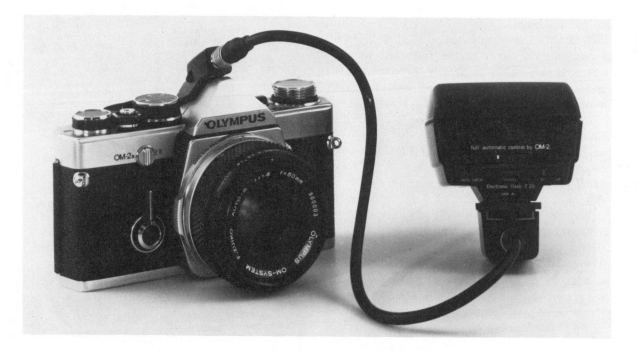

The major problem with flash is that it's not a constant light source. You don't have a chance to see the shadows until you get your exposed film processed. Then they show up as big as life. You might say, "Gee, but I like those shadows."

I think that if you were to shoot a subject twice, once with and once without the shadows, you'd find the latter much more pleasing. Those shadows, no matter what size, can be very distracting to the viewer. They can reduce the impact of a photograph and its visual appeal.

The best way to avoid the shadow is to make sure your subjects don't have backgrounds directly behind them. Realistically, this isn't possible, however, because you'll miss a lot of the pictures you want to take.

The ideal way to find out how to avoid shadows with your camera/flash combination is to shoot a roll of film and experiment with the various camera angles to see which, if any, produce a minimum of subject shadow. It's not an easy task, but it is well worth the effort. Think of it as like learning how to parallel-park a car. Remember, artificial lighting puts you in the driver's seat, and you have the control, but to become good at it you have to practice.

Flash Brackets

There are all sorts of flash brackets that mount to the camera available from various manufacturers. Some are nothing more than *straight brackets* which attach to the tripod socket at the bottom of the camera. A flash shoe is attached to the bracket to hold the flash unit. You need a PC cord to join flash to camera.

A flash bracket with a cable release for tripping the shutter and a tilting head for bounce or direct flash. Photo courtesy Soligor; AIC Photo, Inc.

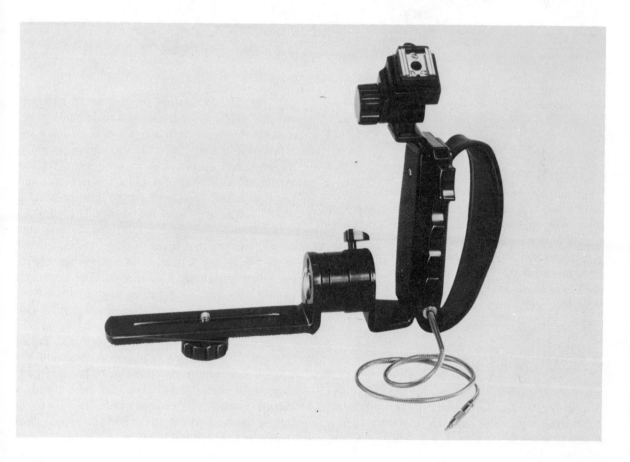

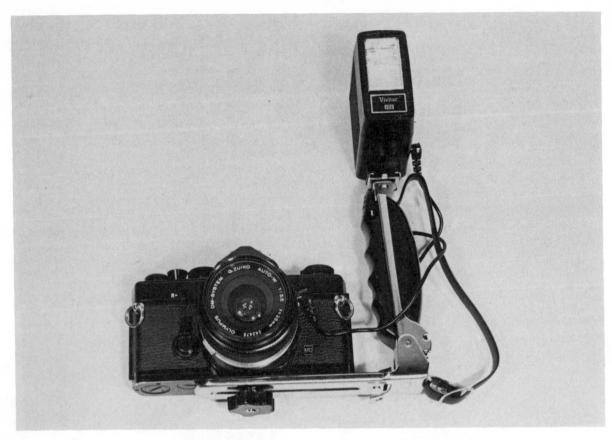

This tilting bracket gets the flash away from the camera. Note PC cord connection from flash unit to camera.

A more elaborate flash bracket will have a handle with a shoe on top of the handle. Some of these *right-angle brackets* will have a shutter-release button with a built-in cable release.

Brackets are available for using two electronic flash units on the same camera. Whatever you need in order to attach a flash unit to a camera is available from one or more manufacturers.

Bounce Flash Adapters

A pleasing way to use flash without producing harsh shadows is to bounce the light off a ceiling, a wall or even the floor if it is capable of reflect-ing light. If you do this you'll have to compen-sate for exposure, because you're increasing the distance the light has to travel.

Some flash units have built-in tilting heads so the flash can be directed up or down. The less expensive units may not offer this feature, and you might have to hand-hold the unit, pointing it toward the ceiling to get the bounce flash effect.

Hand-holding a flash and trying to hold the camera in the other hand reduces stability. Don't worry; there are a number of accessories availa-ble which attach to a flash shoe. The accessory enables the flash unit to be angled upward or sideways or down, depending on the manufac-turer.

The Fujica Auto Strobo 300X offers a unique fill-light system for bounce lighting. The unit has a small flash tube beneath the main head. It's au-tomatically turned on when the flash head is turned upward for bounce flash. Its low light output is used to fill in any shadow area pro-duced by the bounced lighting.

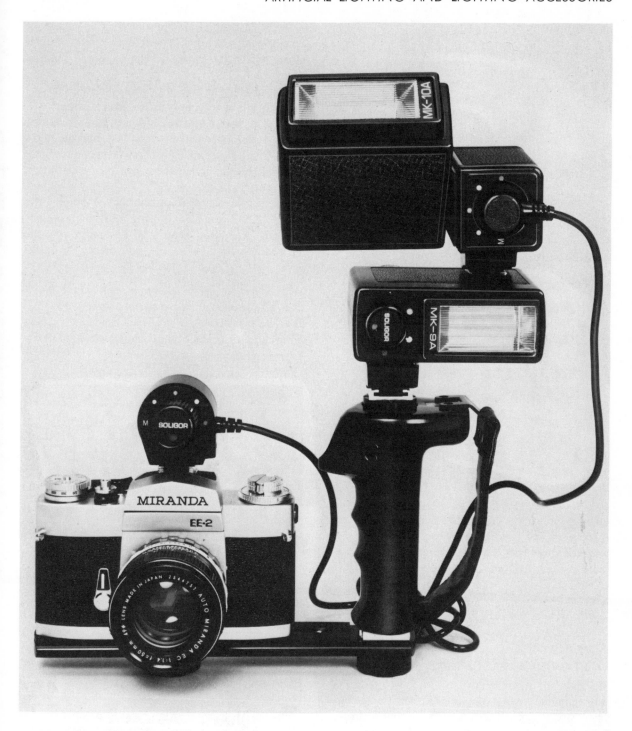

Flash bracket, two flash units and a light sensor on top of the 35mm camera give this setup both direct and bounce flash with automatic control. Photo courtesy Soligor; AIC Photo, Inc.

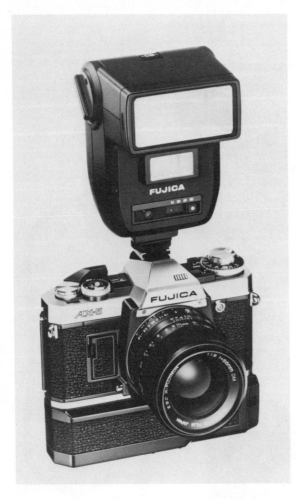

Some flash units are now offering a variety of accessories, making it possible to create special effects that get the most from a single lighting unit.

You're going to have to choose between an automatic or a nonautomatic flash. Either will work, but unless you really know how it works, the nonautomatic will produce less consistent results. Every burst of light from the nonautomatic unit will be the same; there will be no variation in its output.

Control of the unit is done by changing the f/stop of the camera, allowing more or less light to strike the film. There's a dial built into the flash which may be on the side or on the back.

This nonautomatic flash unit has a small dial on the back to guide the photographer in proper exposure. The ASA is set at 200, which means a picture could be taken using an f/stop at f/8 if the subject were at a distance of ten feet from the camera.

A Fujica camera with winder and flash. The small flash beneath the main head is turned on automatically when the larger flash is tilted upward for bounce light. Photo courtesy Fuji Photo Film.

Choosing an Electronic Flash Unit

Buying a flash unit is a lot like buying a car. There are all makes and models to choose from, plus choices in every price range, from the economical to the costly. What you own depends on how often you plan to use your flash unit and whether or not you plan to use it as a creative tool.

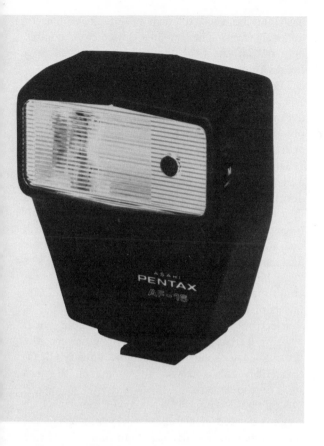

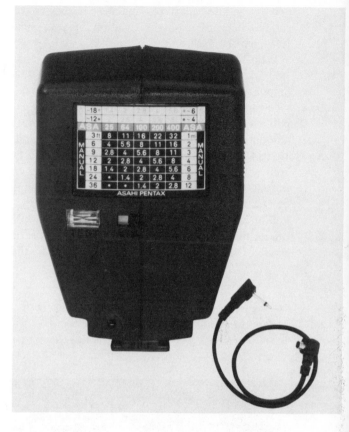

These front and rear photos of the AF-16 flash from Pentax show a manual exposure chart on the back and an electronic sensor on the front. Photos courtesy the Pentax Corporation.

You'll have to turn or slide the dial until the correct film ASA (ISO) number falls into place. Next, estimate how many feet there are between the flash and the subject you plan to capture on film. This is for use with direct flash, when the unit is pointed at the subject. Don't try to use the exposure dial if you plan to bounce the light off a ceiling. If you do, make sure to compensate for the distance to the ceiling, then back down to the subject.

Basically, figuring bounce flash with a nonautomatic flash is strictly guesswork. With direct flash, the dial will have an f/stop number opposite the distance you decide is between flash and subject. That f/stop is what you're to use on your lens. Make sure your shutter speed is set for the proper flash synchronization.

When using a nonautomatic flash, it doesn't hurt to run a test roll using the exposure dial and making records of each picture. When the film is processed, study the amount of light striking the subject and decide if it's too much, too little, or right on the money. If the lighting is just the way you like it, then you don't have to worry about compensating for exposure. If it's too dark, you're going to have to open up the aperture a little more than the exposure guide states. If the pictures are too light, you'll have to close the aperture a little for correct exposure.

Automatic flash has a built-in light sensor just like a camera or a hand-held light meter. Instead of a consistent amount of light being produced, the light can be regulated, reducing the output. The light sensor can be built into the flash, or it can be a separate unit which may attach to the camera's flash shoe while the flash is hand-held or supported by a bracket of some sort.

To control the amount of light striking the film when you are using a nonautomatic flash,

you vary the aperture, making it bigger or smaller depending on the location of your subject from the flash unit.

With an automatic flash you may have a limited number of apertures to choose from. The amount of light is controlled by the sensing device rather than by the aperture. The unit is capable of turning off the flash when the correct amount reaches the sensing device. This variation in light allows you to use more than one f/stop setting, depending on the unit's maximum output. Some units allow for the lens's full range of f/stops.

For example, the Fujica Auto Strobo 300X offers three color-coded f/stops for automatic mode: f/11, f/5.6 and f/2.8. Set at f/2.8, the

Here a medium-format camera and Vivitar 365 flash unit are being used. The light sensor is mounted between the flash and the camera. Photo courtesy the Vivitar Corporation.

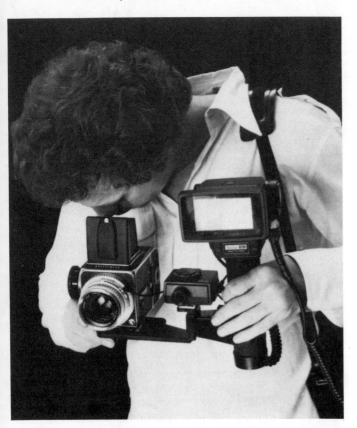

flash can be used on any subject from five to thirty-six feet. The sensing device will control light output. At f/11 the unit can be used in a range of about three feet to nine feet.

The Fujica Auto Strobo AZ can be used at any aperture setting, providing the subject doesn't reach beyond the light's maximum output. The exposure dial for the flash will give you aperture limitations.

The Rollei Beta 5 is a unique electronic flash unit that allows you to punch in ASA (ISO) and desired f/stop. Once the information is locked into the flash it automatically calculates the settings, giving you the maximum range for flash operation. The Beta 5 makes using electronic flash simple and precise. In addition, there's a wide range of accessories made for the unit, including a power pack that permits up to 2,000 bursts of light.

Electronic, automatic flash seems simple, but it is so in theory only. As with light meters, the sensing devices can be fooled by unusual situations; they can also vary depending on the lens used on the camera.

You're still going to have to do some work to make sure the electronic flash works correctly. Some adjustments will have to be made. You may have to use an adjustment on the light sensing device so it knows how much light is needed or which f/stop the lens is using. The only way to be sure how your flash equipment works is to read the instructions that come with it.

Guide Numbers for Flash

For most flash units a guide number is given. It may be listed in feet or meters. You don't have to worry about the guide number with automatic flash units, but you do if it's a nonautomatic. The guide number is given to help you judge proper exposure for each type of film. Let's look at the Pentax AF200S Electronic Flash, which has a guide number of 66 feet for ASA (ISO) 100 film. The 66 feet could be 20 meters. It has

a guide number of 130 feet with ASA (ISO) 400 film, which is equal to 40 meters.

You know the guide number for two films. Now you could figure an appropriate f/stop for your camera by using the formula: f/stop equals guide number divided by the distance from the flash to the subject. Make sure you don't try to divide a meter guide number by feet or a foot guide number by meters. If we were using film with a 100 ASA (ISO) and the subject were 16 feet away, we would come up with 4.1 as the f/stop. You've never seen a lens with a 4.1 f/stop, but there are some with 4.0, 3.5 or 5.6. Round off the number to the nearest f/stop. If we had ASA 400 film in the camera we would divide the 130 guide number by 16 and come up with f/8.1 or f/8 to round it off.

Let's try the figures using meters. Film is 100 ASA, subject is 16 feet (which can be converted to meters by dividing by 3.3), which gives us approximately 5 meters. Twenty meters divided by 5 meters gives us a 4.0 f/stop. The f/4 is very close to the f/stop we had already decided on. At 400 ASA, with a guide number of 40 meters, which is then divided by 5 meters, we get f/8. Right on the money.

Just because the manufacturer gives you a guide number doesn't mean you'll get the proper exposure. It will give you a "good" flash exposure, but it may not be the one you want. The best solution, before you rely heavily on a new electronic flash unit, is to test it to find out what kind of results you're going to get.

What happens if you don't want to use ASA 100 film with the guide number given? Well, I hope you know math. This takes some of the fun out of photography. Let's stay with the Pentax AF200S Flash unit and convert the 66 guide number for ASA (ISO) 100 film to ASA (ISO) 200 film. To get the new guide number, we have to take the old guide number and multiply it by the square root of the number obtained when the new film speed is divided by the old guide number's film speed.

In practice the formula is as follows:

$$\text{New guide number} = \text{old guide number} \times \sqrt{\frac{\text{New film speed}}{\text{Old guide number's film speed}}}$$

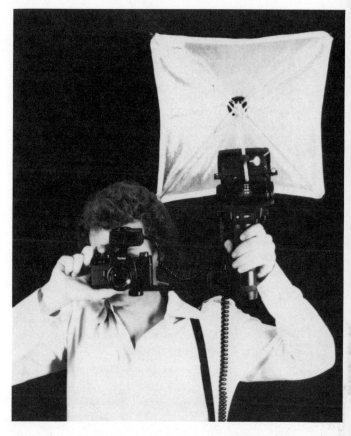

A Vivitar flash with bounce reflector is being used. The remote sensor is attached to a flash shoe on top of the camera. Photo courtesy the Vivitar Corporation.

Plugging in numbers now:

$$\text{New guide number} = 66 \times \sqrt{\frac{200}{100}}$$

$$\text{New guide number} = 66 \times 1.414$$

$$\text{New guide number} = 93.33$$

The new guide number is equal to about 93 feet. Now let's double check using the ASA (ISO) 400 film guide number:

$$\text{New guide number} = 130 \times \sqrt{\frac{200}{400}}$$

$$\text{New guide number} = 130 \times .7071$$

$$\text{New guide number} = 91.92$$

The new guide number is equal to about 93 feet. Bingo, you're in business if you like to play with numbers. Fortunately, charts can be found in various books that make it easy to convert new guide numbers, saving those of us who don't understand math from going crazy.

There are other formulas you might want to learn for using flash. They tell you how to figure multiple flash exposure and furnish other information you might need to know as you learn more and more about photography. The guide numbers are nice to know, but all electronic flash units have some sort of exposure dial to help you combine film and f/stop for proper exposure, helping to eliminate any confusion.

Flash is not foolproof. In fact, I see more bad photos taken with flash than with any other type of lighting. It takes experience to judge whether the flash should be aimed directly at the subject or bounced off the ceiling. Even with good judgment, there's no guarantee you're going to get the precise exposure needed.

Electronic Flash Systems

The least expensive flash units offer little besides a consistent burst of light. As you decide to spend more money the systems can become a little more complicated. The unit may have a light-sensing device plus a tilting head for bouncing the flash off a reflective surface. For the most part, the power for the electronic flash is supplied by a few batteries tucked away inside the unit.

Some systems allow for direct use of power from household current, or there may be an al-

The Vivitar 365 Flash System—remote power source, a light sensor, filters, a reflector, a battery recharger and flash brackets—is a complete system for many of your artificial lighting needs. Photo courtesy the Vivitar Corporation.

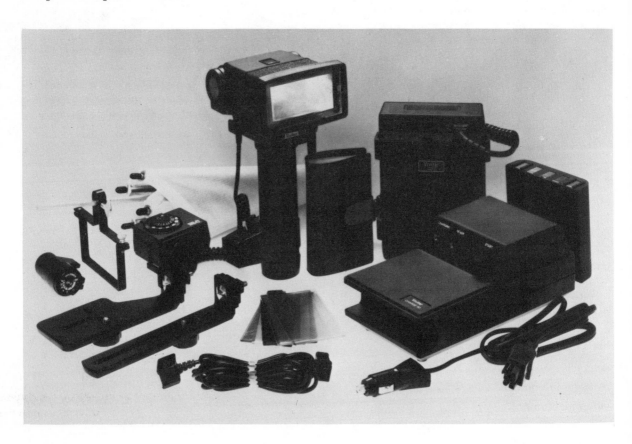

ternate power source that can be carried over the shoulder or attached to a belt. The flash may even have an extension handle that holds a number of batteries.

Some systems offer zoom flash, enabling the angle of light to match the angle of view offered by various lenses. Other units have attachable screens or lenses which go over the light source and alter the angle of light. Colored neutral density filters, diffusing screens, bounce reflectors and other accessories help round out the complete flash system.

Flash Accessories

There are some accessories you can combine with your flash unit to get more out of it. A *slave unit* may be needed if you plan to use two or more flash systems without running a relay or PC cord between them. The slave is a light-sensitive cell that attaches to the second flash unit through the PC receptacle. When the flash on the camera goes off, the second flash with the slave unit fires almost simultaneously. You can use one, two or three flash units or as many as you want to get the lighting you desire.

A wide range of *PC cords,* in any length you need, are made to fit your electronic flash. Some come with straight cords; others are coiled and flexible.

Flash *diffusion screens* are also made to fit many electronic flash units to soften the harsh light they produce. (Chapter VIII describes an easy method for flash diffusion.) The diffusion screen may be a flexible sheet of plastic that bends around the flash head and is held in place by an elastic band. There are also some air-filled flash diffusion devices sold.

There's no doubt that flash can be a useful photographic tool. As already stated, none of the flash units are foolproof. The units with built-in light sensing devices can be tricked just like the light meters built into many cameras. It takes practice and repeated usage to understand a specific flash unit.

There are a number of electronic *flash light meters* made. They work in such a way that they

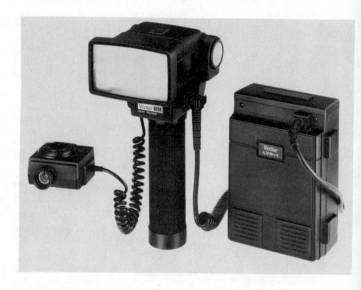

A Vivitar Zoom Flash with light sensor and remote power pack for an almost endless supply of light. Photo courtesy the Vivitar Corporation.

Special connecting cords for Olympus flash enable the photographer to use up to nine flash units. Somehow the idea of using nine flash units boggles the mind. However, as with this setup for three flash units connected to an OM-2, you don't have to worry about exposure control. Although the flash has built-in light sensors, the camera controls the light output. Totally automatic, the OM-2 camera and flash system should be one of the simplest to use. Photo courtesy the Olympus Corporation.

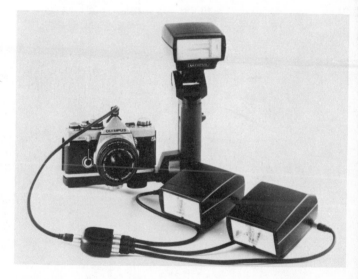

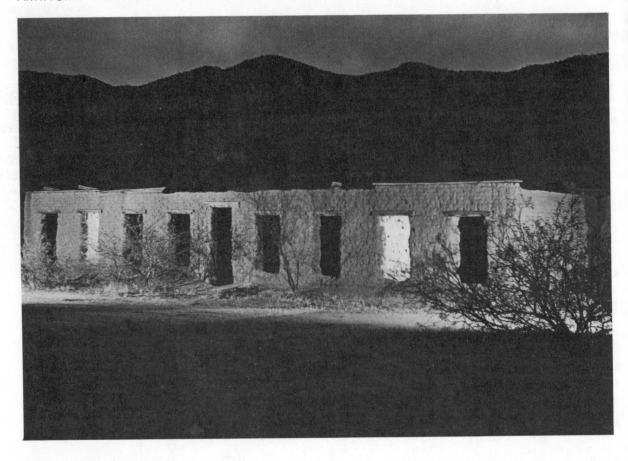

Here's an example of using creative flash. This old adobe building required four bursts of light to create a strange mood. The same flash was used for the entire picture. The process is called "painting with light." The front of the lens was covered between bursts of light; the shutter remained open.

can record the intensity of quick flash and then give the photographer an f/stop selection. They can be very useful when using more than one flash unit in studio work. However, make sure you're going to use flash on a regular basis before you decide to invest in a flash meter, which can be expensive.

You'll also be purchasing batteries if you decide to use flash on a regular basis. You have a choice of common zinc batteries or the longer-lasting alkaline or rechargeable type. The total number of flashes you get from each type of battery may differ. The advantage of rechargeable is that you won't have to buy new ones every time they run low. You just plug them into a wall socket using a mini-charger. The energy output from rechargeable batteries may not last as long as a fresh set of alkaline batteries, but the beginning photographer isn't going to shoot so many flash-assisted pictures at a single time that the power won't last.

In this picture the flash was fired nine times and the person moved to each of the windows to be captured on the same piece of film eight times.

Photo Floods, an Alternate Light Source

The biggest problem with flash is that you can't see it. The flash goes off and it's over. You don't have a chance to actually see the results or the effect it will have on the subject. With alternate light sources such as photo floods and light stands, at least you can see what you're getting. If you don't like the lighting you can move the lights, add lights, or do whatever you need. That's a big advantage in getting high-quality controlled-lighting photographs.

The problem is that you can't go around setting up lights everywhere you go. If you're at a party and want to take pictures, you don't walk around strategically placing a light stand, bulb and reflector in every corner of the room. People

131

This ultra-cool 1,000-watt studio light helps you to control your artificial lighting situations. Photo courtesy the Smith-Victor Corporation.

By using light stands and constant sources of light, you can set up studio-type shots to create any type of image you want.

will think you're nuts! For some types of pictures, photo floods can't be beat. If you plan to shoot some family portraits or just want to play around with shooting still lifes (fruit bowls, flower arrangements, etc.) you may want to invest in flood lights, reflectors and possibly some light stands. They will certainly help you learn the true value of controlled lighting.

Color Balance

Various films are balanced for a specific type of light. For outside it's called daylight; for inside it might be tungsten light. Daylight isn't going to vary drastically, while artificial light sources can. Light sources are rated by Kelvin temperature. Daylight is about 6000 degrees Kelvin, but it can vary from the time the sun comes up until it sets in the West. The variation is sometimes desired, and many photographers like to shoot color film early in the morning or late in the afternoon when the Kelvin temperature is actually lower than 6000, giving a warm rendition leaning toward yellow and red colors.

Artificial lighting is much more critical than outdoor lighting. The wrong film with the lighting can create unpleasing distortions in color; it may be either too warm, with a red or yellow cast, or too cold, with a bluish cast. You need to know which light you are using and which film goes with it.

Outdoors, the film rating is daylight. Electronic flash is also balanced with daylight. Indoor lighting is tungsten, but there are variations in tungsten lighting temperatures. The rating can be either 3400 or 3200 Kelvin, depending on the bulbs you buy. These two ratings need two different films, which are called Type A and Type B. Type A film is for the lights with a 3400 temperature and Type B is for 3200 Kelvin.

Balancing film and light can be as critical as the photographer wants to make it. If you don't mind slight variations in color you'll have no problem. If you're a perfectionist, then you have to worry about voltage inconsistency, which can alter the Kelvin produced by a light source.

Voltage regulators are available for use with lighting equipment, but the beginning photographer shouldn't have to worry about investing in that type of equipment.

With black-and-white films you don't have to worry about color balance. There's no color to show, and you can get pleasing results no matter what type of light source you use.

Artificial Lighting Equipment

If you plan to do a lot of your photography with controlled lighting, the easiest route to go is to purchase a lighting system, available from a number of manufacturers. It will consist of a minimum of two light sources, light stands, and possibly a case in which to store and carry the equipment. The more diversified you want the lighting, the more you'll have to spend.

Light Sources

Your light source may be nothing more than a photo flood, or it can be a spotlight or quartz light. You need to know the Kelvin temperature produced by the light source you use. Is it 3200, 3400, 4800 degrees or somewhere in between? As long as you know the temperature you'll know which film or correction filters you'll need to use.

The light source may be nothing more than a bulb and reflector. However, the reflectors can vary in size, from 16-inch to 5-inch diameter. The size of the reflector can vary the light output, either directing it to a narrow area or allowing it to fill a large area.

Light sources also differ in the amount of wattage they produce. This is the light's intensity —the higher the wattage, the more light actually produced. More light is produced by a 500-watt bulb than by a 250-watt bulb. Wattage can be altered by the electrical current produced. If there isn't enough current reaching the light, the wattage will be reduced.

Reflectors, which can be nonreflective or

reflective in color, can alter the quality of the light, making it dull and diffused or sharp, almost harsh.

Quartz Lights vs. Incandescent Bulbs

Artificial lighting systems produce a great deal of heat. Some burn cooler than others, and the life of a light source can vary greatly.

A 3200 Kelvin photo flood may burn for only three hours before it's used up. During that time, the color temperature of the light may vary, being higher than 3200 when it's first turned on and gradually decreasing to 3200 or slightly lower.

Quartz lights last longer than regular bulbs and are more consistent in their color tempera-

ture. To give you an idea, I've listed the bulbs that can be used with the Smith-Victor SP-1 Pro 6″ 1000-Watt Quartz Focusing Spot Light.

NUMBER OF WATTS	COLOR TEMPERATURE	LIFE IN HOURS
750	3200	200
1000	3200	250
500	3200	50
750	3200	50
750	3350	12
1000	3350	12

The longer-life bulbs are quartz, with 200 and 250 hours of practical use.

Here's a set of three Smith-Victor quartz studio lights and a carrying case. Photo courtesy the Smith-Victor Corporation.

Light Stands

The least expensive method of mounting a light source is by using a spring-loaded clamp. You can attach the light source to a table, door, or whatever happens to be handy. Unfortunately, you'll find that what's handy isn't necessarily suitable for the proper lighting. That's when you have to turn to light stands of some sort.

Most stands are tripod type. They have three legs, which can be folded, and a telescoping center column so you can adjust the height of the light. The more expensive stands will have wheels on the base so you can easily move them.

The size of the light stand will depend on the size of your light source. If it's heavy, you want a sturdy stand to support the weight. If it's a small bulb/reflector combination, a lightweight stand will be adequate.

A reflector, light source, and stand is the basic lighting system, but there are a number of accessories available to help produce the type of lighting you want.

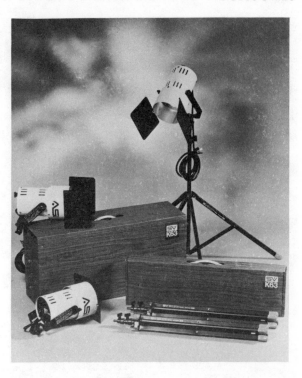

Quartz lights and barn doors with two cases—one for the lights and one for the stands. Photo courtesy the Smith-Victor Corporation.

Barn Doors

Some light sources will have barn doors built into the equipment; others will need the barn doors as an accessory. The barn doors act like movable flaps in front of the light source and help to control the light, directing it and preventing it from spilling over to cause lens flare near the camera.

They come in a number of sizes and are usually opaque and dark in color. They can be in combinations of two (2-leaf) or four (4-leaf) so every angle of the light is covered.

To improvise, barn doors can be made of heavy cardboard and taped to a light source or even hand-held in place while a picture is being taken.

Snoot

Snoots are cone-shaped accessories that fit over the front of the light source. They can vary in length and diameter to alter the circle of light they produce. Either a small circle or a broad circle of light can be produced using various snoots.

Diffusing Screens

Some light sources allow plastic diffusion screens to be clipped to the front rim of the reflector, softening the light. Besides the plastic diffusion screens, some lighting systems use fine screen or mesh as a type of diffusion system.

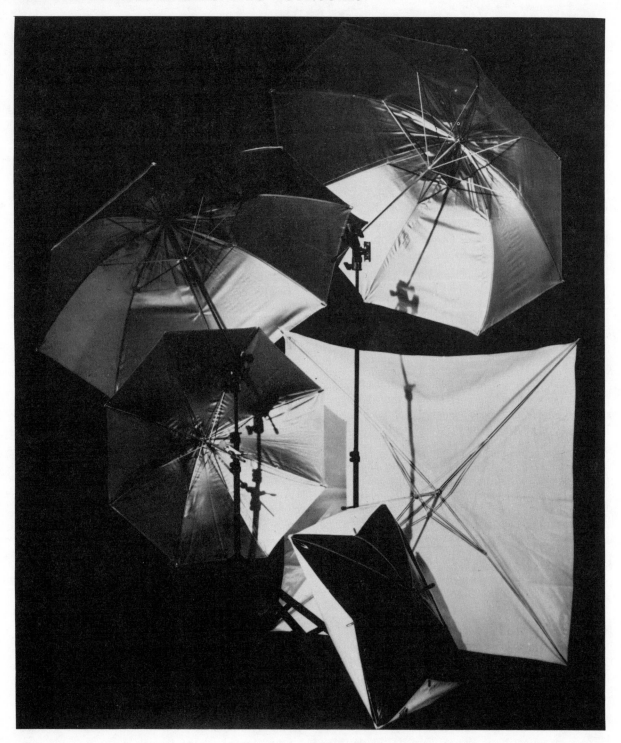

A selection of reflecting umbrellas from Smith-Victor called "Pair-a-sol." Photo courtesy the Smith-Victor Corporation.

Umbrellas

Very similar in appearance to what you would hold in your hand to protect yourself from the rain, photographic umbrellas are used to soften and direct light. All types are available, from shiny to translucent. Some are even made of a colored material to balance the light to a particular film.

There are a number of ways to use an umbrella, and you should know they can be used in conjunction with flash systems as well as with constant light sources.

Generally a photographic umbrella is used as a source to bounce light, much as you would use a ceiling or a white wall to bounce flash. It softens the light, helping to produce even lighting and reduce harsh shadows.

With umbrellas you have good control because you can move them fairly easily to where you need them. With this mobility you can use the umbrellas as reflectors for fill lighting. If you were photographing an object that had a slightly shaded side, you could position the umbrella near the object so the lighting would bounce off the umbrella and lighten the shaded area. The same thing can be done with sunlight outside when you're taking pictures and need reflected fill light.

Umbrellas generally fold up and can be fairly portable. Some are square in shape, while others form an octagon or hexagon, depending on the manufacturer. Small umbrellas are manufactured to be used with electronic flash.

Reflectasol reflectors with barn doors attached for directing or controlling light. Photo courtesy Larson Enterprises.

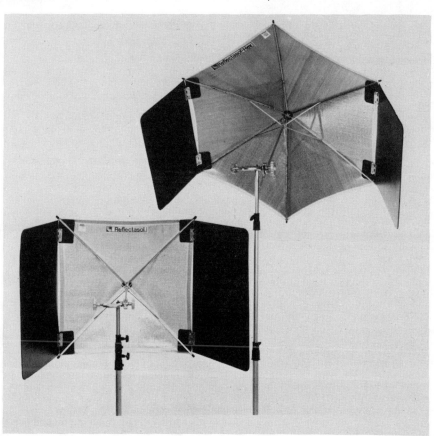

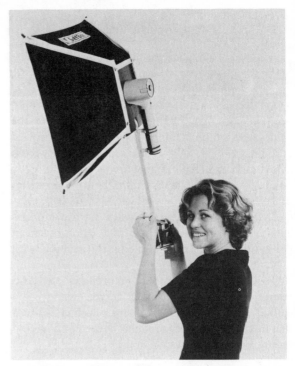

The Reflectasol Soff Box and camera brace for hand-held operation with a flash unit. Photo courtesy Larson Enterprises.

The Soff Box allows for alternate flash sources. The picture shows the Soff Box using a single-flash or a double-flash attachment. The Soff Box isn't an umbrella, but does soften the light of a flash unit and get rid of harsh shadows. Photo courtesy Larson Enterprises.

Reflectasol Carry-All for transporting equipment to the shooting location. Photo courtesy Larson Enterprises.

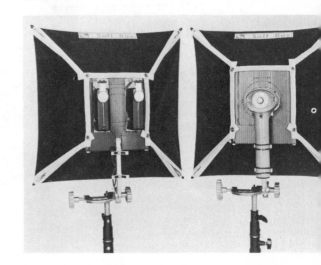

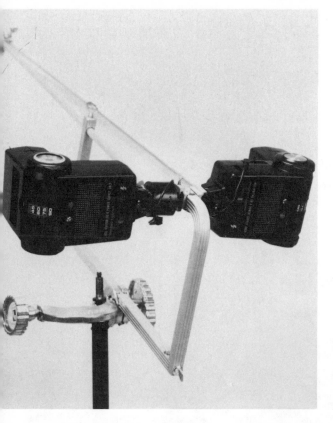

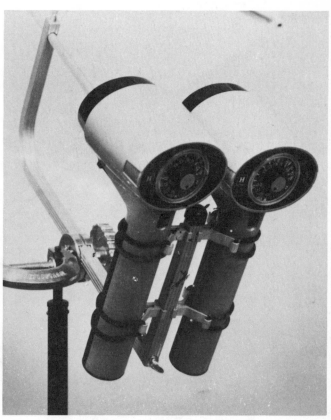

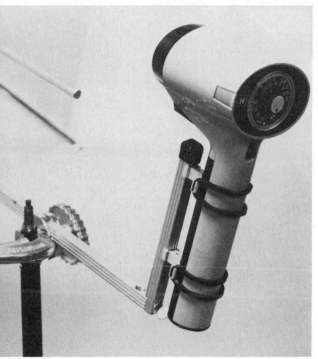

These three pictures illustrate how various flash equipment can be adjusted for umbrella use. One, two, or more electronic flash units can be used. Photos courtesy Larson Enterprises.

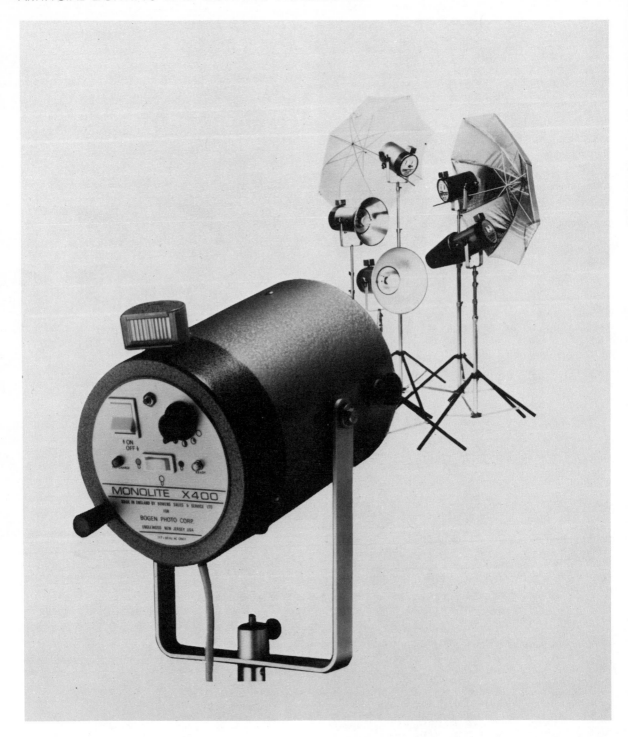

A Bogen Monolite flash unit with power control system built directly into the head of the unit. Photo courtesy Bogen Photo Corporation.

Strobe Units

Besides the constant light sources from bulbs and quartz lights, you can also purchase flash units which require a power supply that regulates the voltage. As with the electronic flash you use with your camera, you can't really see what you're getting until the picture is processed.

Some strobe units have modeling lights which put out a constant light source while you're arranging your lights. The lighting is rather dim, and the result is just to give you an idea of lighting direction and shadows.

The strobe units are more costly than the bulb reflector units and are generally used by professional photographers with studios. Depending on the system, some have separate power supplies for voltage regulation while others have them built directly into the flash unit.

This rotating clamp can be used to support metal or wooden poles for supporting lights or seamless paper. Photo courtesy the Brewster Corporation.

Controlled Lighting Accessories

Umbrellas, stands, reflectors, and diffusing screens can all be lighting accessories. They are the basics for producing the lighting you might need for various photographic subjects.

Other accessories include *filter holders* and *filters*. The filters may be for diffusion, light balancing, or special color effects.

You might want to invest in a special *light boom* which puts the light over the subject and away from the light stand. A special counterweight is added to keep the suspended light in position.

Extension poles are available for some light stands to give added height, say from nine feet to fourteen. Special *brackets* are available to attach two lights to a single stand or even to attach light units to ceilings or walls.

Some manufacturers make accessories for connecting a single pole from ceiling to floor with additional *clamps* for attaching light sources to the pole.

Other accessories include a *boom light* which attaches to a door and a *portable light stand* for attachment to tables, desks, or whatever is available. In short, whatever you might think you need to produce the controlled lighting you want should be available from one or more manufacturers. You might have to do a little research to find out who sells what; an easier method might be to talk to a knowledgeable photo equipment retailer.

Types of Lighting

The best way to understand the value of controlled light is to experiment with a constant source. Using floodlights, you can see the amount of area they cover. Spotlights direct a

beam of light, and some have built-in magnifiers to narrow the beam of light to a single point. It's difficult to have much control with a single light source, but when you have two or four sources you can begin to see the control and variations.

There are names given to a variety of lights which I'll discuss briefly, helping to give you an idea of what you can do to steer the light where you want it.

Front lighting is very similar to what you would get when you use electronic flash mounted on the camera. It's positioned directly in front of your subject. If it is positioned correctly, there should be a minimum of shadow produced.

Back lighting, as the name states, is achieved when the source is positioned directly behind your subject. It can be very effective in producing rim lighting, which can be seen when a glow or highlight appears around your subject. A good example is its use in portrait work to brighten the shoulders or hair of the person you're shooting. The same thing can be done using sunlight when the sun is positioned behind your subject.

Side lighting is off to the right or left of your subject. If only one side is subjected to side lighting, harsh shadows will be produced on the opposite side. If both sides of the subject are illuminated equally, the shadows are eliminated.

You can continue your lighting variations by having a *top light* or a *bottom light,* one being directly above the subject and another below.

The above lighting positions can be varied by having *semi-back light* and *semi-front light.* Think of it as looking at a map. North would be back light, south front light, and east and west side light. Then northwest and northeast would be semi-back lighting positions and the southwest and southeast would be positions for semi-front lighting.

Generally, when you're using controlled lighting you're trying to produce a natural lighting effect, as similar as you can make it to outdoor lighting. The object is to duplicate realism.

The first light you set up is generally what's called the *key light.* It's the dominant force in controlled lighting. It'll set the mood and get you on your way to illuminating the object you're photographing.

Once the key light is placed and turned on, you can place the other lights you plan to use. They could be used for *fill light.* This is the light used to brighten any shadows that have been caused by the key light source.

Another light is that which accents the subject you're photographing. This would produce a highlight or ring of light around the subject, helping to outline it or produce a halo effect.

That doesn't mean you can't be creative using unnatural lighting, providing it enhances the subject or produces the results you want. If you want to silhouette your subject, then by all means do it by placing all the light behind the subject, providing your background is clean. If you want your subject to have a harsh shadow on one side, then sidelight is what you need. With several light sources or even one, you have controlled lighting.

Using Timber-Topperstm and dowels, you have a clean background for shooting portraits. Note insert showing how a hole is drilled and then a wood dowel is added to support a pole and seamless paper. Photo courtesy the Brewster Corporation.

A round or a rectangular Timber-Toppertm makes it possible to build your own light and background supports from wood you buy at the local lumberyard. Photo courtesy the Brewster Corporation.

Studio Accessories

*Background*s can play an important role in your photography. If you shoot a lot of color you may want colorful backgrounds. The simplest route to go is to invest in seamless paper. These long rolls of paper can be purchased from photo retailers or from stores specializing in display merchandise.

However, seamless is not easy to work with

An instant studio in action, with three rolls of seamless paper to choose from. You'll have to locate your own models and swimwear. The bare feet help keep the seamless paper from getting dirty, so that it lasts longer. Photo courtesy the Brewster Corporation.

unless you have some better means of support than using masking tape and a blank wall. The floor should be hard and not carpeted or you'll end up tearing the paper. There are a number of seamless paper holders available, or you can even make your own as discussed in Chapter VIII.

The Brewster Corporation produces a number of seamless paper devices. One is a telescoping aluminum bar that can fit between walls from 6 feet 4 inches to 10 feet 6 inches. The seamless, which can be purchased in 52-inch and 107-inch widths, slides over the bar. You pull it down to use it. A portable seamless paper holder by Brewster uses a single ceiling-to-floor pole and has a pole that flips out for using 52-inch seamless paper.

Another clever device is Timber-Topper™ which slides over a piece of wood. There are two designs to choose from. One is rectangular and slips over a 2″×3″ piece of wood. The spring-loaded Timber-Topper lets you wedge the wood between the floor and ceiling. The other design is round and fits over a 1⅝″-diameter closet pole. Again, the spring inside the round Timber-Topper wedges the pole between ceiling and floor.

You can drill holes in the wood to put in supports for holding seamless paper, and you can even use the poles as devices for supporting your lighting systems. The Timber-Toppers are well worth the investment if you plan to use controlled lighting and clean backgrounds.

Other accessories you might need for studio work are some sort of chair for positioning people and making them comfortable while you take their pictures.

For photographing small objects you'll need some sort of table to work on. If you study the advertisements found in magazines using photographs, you will notice that some of the products have nice, even lighting, almost as if they were floating above the background. Chances are good that the product was photographed on a translucent material with a light source underneath.

Bogen sells a Technal Transi-table using a frosted acrylic for a flat surface and background. When you use color film the acrylic can be al-

tered in color by placing filters over the light source. Because units are expensive, it's unlikely that a beginning photographer would invest in this equipment, which would have limited use.

Reflectors, which can bounce light, may be needed for some of your photography. They may be nothing more than white or aluminum umbrellas, or they can be large white sheets of cardboard fastened to some sort of stand.

Dulling spray can be purchased in an aerosol can to be used on highly reflective objects such as silverware. These shiny objects may produce obtrusive "hot spots" if your light source is reflected off them. The dulling spray will reduce the shine and can be wiped off when you're finished with your photo session. Another problem with shiny or reflective objects is that sometimes the photographer and his equipment might show up in the picture. Most people won't catch the reflection unless it's really obvious.

A final accessory for studio work is a *rear projection screen.* The purpose of the screen is to project slides and use the slides as backgrounds for your subjects. Special screens are available to prevent the slide projector's light from showing up as a hot spot on the projected image. You want to make sure your controlled lighting doesn't interfere with the slide's image, so you need to have the screen far enough behind the subject and the lights angled away from the screen, using barn doors or light-blocking cardboard positioned between light and screen.

Front projection systems are available or can be devised using a projector and a mirror. Once you've made your first million from your photography you can add a *cobweb-making machine,* a *giant fan* for instant wind, *fog producers* and anything else you need to produce artificial lighting, backgrounds, and environment.

All of this synthetic photography is done by many professional photographers and certainly by the moviemakers in Hollywood. The beginner doesn't have to go to the extremes of building a set from scratch, but I do think it's necessary to know that such pictures are often thought of first and then developed into a setting to be captured on film.

Chapter VII

Accessories: Convenient and Specialized

By now you should have a pretty good idea of the diversity in photographic equipment and a basic understanding of how it can be used. The majority of items are practical and can be used in a number of photographic situations. The list of "tools" is not complete, however. There are a number of accessories that are specialized in their functions and are quite often expensive.

Chapter VII will give you an idea of what some of these specialized tools are. It doesn't mean you will ever need the equipment for your particular type of photography, but you never know for sure when you might want to try something different and will need such a specialized photographic tool. If you do, it might be nice to know there is equipment that can help you get the pictures you want.

Copy Stands

A great number of photographers find it important to copy various types of printed work. The material might be a photograph from a book, a blueprint, an old photo, or even a work of art. There are a number of ways to copy such work.

Copying it may be as simple as putting the camera on a tripod and shooting the object as it hangs on a wall. No matter how you do it, the important thing is to get good reproduction, whether it's a print or a transparency.

I had an interesting experience with a line drawing that was framed and hung on a wall. It was under regular picture glass, as opposed to non-glare, and it produced quite a few unwanted reflections. The owners of the drawing didn't want to take it off the wall to be copied, nor did they want it removed from the frame. I volunteered to try to copy the work.

The first advantage I had was the fact that the object was a line drawing. There wasn't any color to worry about, so I could use black-and-white film. I set the camera on a tripod and looked through the viewfinder. There were all types of reflections from various doors and windows; in addition, I could see both myself and the camera equipment being reflected off the glass that covered the art.

The drawing was hanging at the end of a long hallway, so I moved the camera to the end of the hall and then walked along, closing all the doors. By the time I finished it was very dark in the hall, but there was enough ambient light. I put a

long lens on the camera and checked for unwanted reflections. They were eliminated. I was far enough away from the glass so that neither my camera nor I was reflected in the glass. I took the pictures using very long exposures of up to one full minute. When I had finished shooting one roll of film, I crossed my fingers and told the owner I'd get back to him.

Surprisingly, the pictures came out better than I expected. If I had had to photograph the art in color, I would have had quite a bit of difficulty getting the results I wanted, though I'm sure it could have been done.

Most photographic copy work won't be as unusual as the case I just mentioned. You'll have the option of laying the work of art flat on the ground or on a table, and if necessary removing it from a frame and glass.

An example of a simple copy stand from Kodak with an Instamatic X-35F camera. Photo courtesy the Eastman Kodak Company.

One method for copying work was mentioned early in this book. If you own a tripod with a center column that can be reversed, you're in business. Reverse the column after extending the tripod's legs; then attach the camera to the tripod head, which will be located somewhere between the three legs. Then all you need are two lights to illuminate the object. That's the economical way of using equipment you might already own.

Another way is to invest in a *copy stand*. A simple one would be nothing more than a broad base and a column that supports the camera at various heights. You have to supply the light source.

A slightly more sophisticated and expensive copy stand would have two or even four lights incorporated into the unit. The lights should produce nice even illumination without any harsh reflections. (By placing polarizing sheets over the light sources and the camera lens, you can virtually get rid of all reflections.)

Copy stands can vary in size and should be large enough to securely support the camera you own. The base can be small or it can be very large. The height of the camera-supporting column can also vary in length. Depending on the size of work you copy and the reproduction ratio you want, you might have to use either a macro lens or extension tubes with your camera.

A copy stand is a useful photographic tool if you do a lot of copy work. If you don't, you're better off improvising, using available light sources and a tripod.

Slide Copiers

Bellows and slide copier equipment were briefly mentioned in Chapter III with camera body accessories. They will allow you to crop and copy slides, alter exposure, and create special effects.

Expensive and somewhat elaborate slide copiers are available. An example is the Bowens Illumitran. The unit allows for contrast control,

color balance, cropping, and much more. It uses a built-in flash that can be altered in intensity to help you get good reproduction from marginal transparencies.

Simpler, off-camera slide copiers are sold that use your flash unit and still offer limited color correction. These units hold the slide and illuminate it with a built-in light source for focusing. You can use the slide copier with a copy stand or a tripod. For extra-close focusing you might need to use extension tubes or a bellows system with your camera. Your flash unit will supply the light source for exposure.

Another system is the Spiratone Dupli-scopes.™ There are several models to choose from. They all have flat field optics and an adjustable slide stage with a special channel for adding filters. Spiratone also sells an exposure calibrated light system (ECLS System) which allows you to position your flash unit the right distance from the slide holder for proper exposure with daylight-balanced film.

Slide copiers are great for duplicating your favorite slides. They can also be used for altering exposure, cropping, and creating special effects by using filters or texturized screens. If you need to, you can make color or black-and-white negatives of your slides for conversion into prints.

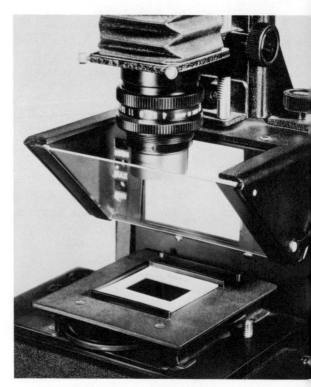

The Bowens Illumitran is one of the ultimates in slide copiers. The unit enables a wide range of functions for contrast, exposure and special effects control, along with cropping. The beginning photographer may not have the money or the need for such equipment, but it is available. Photo courtesy the Bogen Photo Corporation.

Ring Flash

A special flash unit that attaches to the front of the lens and uses a remote power source is the ring light or flash. As the name states, the flash is produced by a ring-shaped light.

The advantage to a ring flash over an ordinary unit is its soft, even illumination, which produces a minimum of shadows. Its output is generally low, so most are used for close-up work in medical or scientific fields.

Although many camera manufacturers make ring lights for their equipment, you have to pay a pretty penny for them. If you specialize in close-up work, a ring light might be worth the investment. If not, a standard flash unit or studio lighting will be more appropriate because of the versatility the equipment offers.

Remote Control Units

Cable releases, whether normal or electronic, get you away from the camera when you click the shutter. Another route is to purchase a remote control unit.

Half of the unit attaches to the camera and shutter mechanism of a winder or motor drive. It's the receiver. The other portion of the equipment is held in your hand and acts as the transmitter. When you push a button the camera fires a shot and the winder or motor drive will advance the film.

The Nikon SM-2 ring light is designed for macro work because of its low light output. The results are soft, even lighting. Photo courtesy Nikon, Inc.

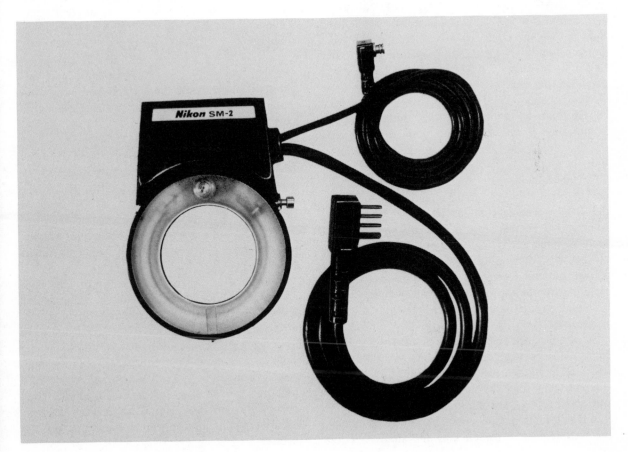

A transmitter and receiver from Nikon for using remote control on your photo equipment. Photo courtesy Nikon, Inc.

You have to make sure the proper exposure and focus is preset. Nikon offers two units for their equipment. One uses a frequency in the CB (citizen band) range and can operate from one to three cameras. It has a range of 2,300 feet, provided that there are no obstacles to interfere.

Another unique system from Nikon uses an infrared beam to fire one or two cameras. Maximum range is only 200 feet, compared to the 2,300 offered by the radio wave transmitting unit.

A remote control unit can be useful in a number of unique photographic situations. You can put the camera or cameras in places you don't want to be. For example, you might want to attach a camera to the nose of a hang glider, pointed back toward the flyer. If you want the picture but don't want to be the person to leap off a cliff or the top of a mountain, you can stay on solid ground and push the button of the transmitter.

A similar example would be attaching the camera to the front of a motorcycle that's entered in a motocross race. You can sit on the sidelines and pray that the driver doesn't wipe out and destroy your equipment.

Wildlife photography could be improved using the remote system for clicking the shutter. You can position yourself far enough away from the camera(s) so that the animals will be less apprehensive of your presence.

A remote control unit has to be used in conjunction with a winder or motor drive. If one or the other isn't used you defeat the purpose of the remote system. It would be foolish to fire the camera from a distance and then have to walk to the camera and advance the film for the next shot. If the camera has a winder or motor drive, you can take pictures until the camera's film is depleted.

If you like to take aerial shots, you might want to attach the camera to a large helium-filled balloon or even attach it to the basket of a hot-air balloon. Something I'd like to try, but have never had the courage to do, is to attach the camera to a large box kite, which can be purchased or made.

There's a wide range of uses for a remote control system, and the results can be very interesting, making the viewer wonder how you got the picture.

Another remote control system from Nikon. Instead of using radio waves it relies on infrared to fire the camera. Photo courtesy Nikon, Inc.

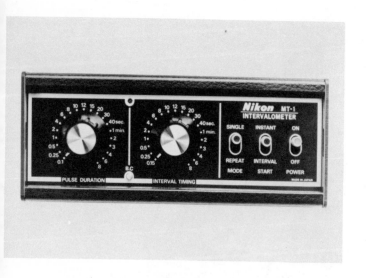

Interval Timer

Another device for taking remote control pictures is an interval timer. The unit, or intervalometer, attaches to the winder or motor drive and fires the camera in present sequences. Spiratone sells an inexpensive timer that can be set at 1, 2, 5, 10, 20, 30, 40, 50, 60, 80, 100 or 120 seconds. You can take pictures at any one of those intervals. For instance, if your pet cat is about to have kittens, you might want to set the camera on a tripod, set the proper exposure, and focus. Attach the timer and leave the cat in peace while it has its kittens and the miracle of birth is captured on film.

The Nikon MT-1 Intervalometer with a range of up to eight minutes between exposures. Photo courtesy Nikon, Inc.

This simple projection system lets you look at your slides on a small tabletop screen or project them on a screen at a limited distance.

Slide Projectors and Related Equipment

Slides are far less expensive to produce than color prints. The problem is their small size, which is the same as the size of the film you use. Small slides from 35mm or 110 cameras are not easy to view unless they are placed in a small tabletop or hand-held viewer. You still have a problem, because only one person at a time can really view the slides.

A slide projector is not an inexpensive item, but if you put together interesting slide shows they are well worth the money. Many types are available, with each offering a unique method for

This Rollei auto focus slide projector will let you present your slides to a receptive audience. Photo courtesy Rollei of America, Inc.

A Slide Cube™ System projector from Bell & Howell lets an audience view your slide shows on a screen or other reflective surface. Photo courtesy Bell & Howell/ Mamiya Company.

holding the slides—the Slide Cube™ System from Bell & Howell, straight trays, or the popular Kodak Carousel. Once you buy a projector you will want to invest in some sort of projection screen. It can be a simple tabletop model for your own personal viewing and slide editing, or it can be a large screen for showing your slides to an audience.

From a single projector and screen, you can progress to investing in special equipment for using two projectors and units that enable you to dissolve or fade one picture over the next. You might even want to buy a tape recorder that enables music or narration to be added to your slide shows; a special inaudible signal changes the slide from one to the next automatically. As your equipment for presentation and the quality of your slides grow, you might become the most popular speaker and slide presenter in town.

Once you own a projector, you might want to invest in a free-standing screen such as this 40″×40″ projection screen from Kodak. Photo courtesy the Eastman Kodak Company.

Here's a beginner's set of darkroom equipment to help you process your own black-and-white film and prints. Photo courtesy the Bogen Photo Corporation.

Making Your Own Slides or Prints

Depending on your own needs and whether you wish to process photographs yourself as well as taking pictures, you might want to set up a darkroom. Processing your own film and making your own prints can be costly and time-consuming, but it can also be fun and rewarding. It's possible that you prefer to simply take pictures. Then don't invest in darkroom equipment. If you want complete control of your pictures, from exposing the film to finishing the print or slide, then think about setting up a darkroom.

You don't need to add a room to your home. You can make use of your bathroom at night. You'll need to invest in chemicals, film-holding reels and tanks, a thermometer, a timer, a graduate for measuring chemicals, and half-gallon or gallon containers for holding the mixed chemicals.

That's just for developing film. It sounds a bit difficult, but once you've done it a few times, especially black-and-white, you'll think it's a snap. However, that's just the beginning. There's a wide range of chemicals to choose from, including developers with different characteristics in development times and film-grain production. A whole new set of chemicals is used for making black-and-white prints, processing color films, and producing color prints.

In all honesty, darkroom equipment could make an entire book and darkroom tricks could fill another volume. Fortunately, there are quite a few books on the market that cover both topics.

My point is that processing your own films and prints can be done at home if you're willing to invest in the equipment and take the time to

learn how it's done. You can learn by reading books and instruction sheets, or you can enroll in a photography class that allows you to get practical darkroom experience. It's one sure way to find out if your interest is stimulated enough to invest in such equipment.

You might also consider joining a local camera club that meets once or twice a month in your town or city. There's always a member or two who's willing to help the beginning photographer learn more about taking good pictures and producing the final result. Make sure the person knows what he or she is doing and isn't a photographer who happens to be color blind but insists that all his or her color printing is outstanding. I've found there are one or two of those in many camera clubs.

Getting the Most from Your Pictures

One thing that's always amazed me about beginning as well as seasoned photographers is what they do with their pictures. In most cases the finished slides or prints are stuck away in a closet or drawer. The pictures are only enjoyed when they are returned from the processing lab. Once they are quickly reviewed, they get put away to be forgotten.

Your pictures are an investment. They were taken to capture memories that can be renewed every time you or someone else looks at the image. To get an idea of what can be done with your pictures, you might want to pick up a copy of Kodak's *Photo Decor—A Guide to the Enjoyment of Photographic Art*. It will give you an idea of what can be done with good photography to enhance any home or office.

Another book is *Photo Display,* published by Doubleday & Company. I wrote it, so I know what's in it. The book will give you an idea of how to display your photographs in a number of ways, from how to put together an enjoyable photo album and framing your prints to how to put together a slide show that won't put your viewers to sleep.

Get the most from your photography. There's no sense in investing in camera equipment if you're not going to make use of it. It's also foolish to take pictures if someone isn't going to look at them. No doubt you'll take quite a few pictures that aren't really worth looking at. That's to be expected. Every photographer takes pictures that fall into categories of bad, average, good, and occasionally outstanding. Get rid of the bad ones, store the average ones, share the good ones, and by all means display the outstanding pictures in one way or another.

Even when you think you can distinguish between good and bad photography, there's still a problem. The viewer will also have to be the judge of the photograph. You may think your photo is outstanding, but another person with different interests or photographic understandings may think it's only fair or good. That happens in photography because it's a personal experience or endeavor. Each individual has different things that stimulate his emotions. Don't try to please everyone. Start by pleasing yourself and then gradually try to please the majority of viewers.

The only time you really have to worry about pleasing the other guy is when you're trying to make a living from photography or have entered your work in some sort of photographic competition. Then you'll want your client or the judge to think your work is the best there is.

Equipment: One-third of the Battle

I've covered all the photographic equipment that's of major importance to the beginning photographer. There's a good chance I've missed something you may already own and use on a regular basis. If so, I apologize. As a photographer, I'm picture-oriented and not an equipment fanatic. I'm more interested in getting the best possible picture with the equipment I have available.

That doesn't mean I don't get yearnings for specific cameras and their accessories. I'm a realist in the sense that I know what I can and can't afford. If I have to improvise, then that's what I do.

Camera equipment is just one-third of the battle in getting quality photographs. Subject matter and how it's handled by the photographer—meaning composition and exposure—is another. The final third is processing. A film and print processor can make or destroy an image. If you do it yourself, you have no one to blame for errors except yourself.

When the film is shipped off to a lab for processing, you may find results far from pleasing. At times, the best labs can screw up the works. Chemicals can get depleted or contaminated, and film gets lost once in a while. (There's nothing more surprising than getting back some prints with pictures of people you've never seen before.) All you can do is swear a little bit, and the processor will usually supply a new roll of film to replace the one that was lost. Many times the images can never be replaced, and the photographer has to suffer the loss.

The other common occurrence I have found with some labs, certainly not all, is scratched film. Many times you'll think that you forgot to clean your camera and it was your own fault.

Often that's the case. Other times you'll send off three rolls of film and find the second roll you shot is scratched. You can assume your camera did it, or you can put the blame on the lab that processed your film. It happens every now and then. If you find a lab that constantly returns scratched film, you had better search around for a new processor or learn to do it yourself.

Putting all three thirds together isn't an easy task. One roll of film may show that you had the right equipment and processing, but you struck out on the subject. Another roll may show that you had good equipment and subject handling, but the processing was far from good. A third roll shows good subject handling and processing, but the equipment let you down.

That's photography—a true challenge for beginner and pro. When all three thirds fall into proper place, you get the visual rewards. Knowledge acquired from photographic experience will help the thirds to fall into place on a more consistent basis. Seldom will you achieve 100 percent success, but you'll be close enough to make you say, "Boy, I'm starting to catch on."

Chapter VIII

Accessory Improvisation and Construction

Not all of the camera equipment you use and own has to be purchased from a specialty retailer. With a little creative know-how, you can fabricate accessories to help you get the pictures you want. Some are nothing more than household items converted into camera accessories; others are useful photographic tools that you can make.

Beanbag Camera Support

I've been waiting for a book to be published titled, *How to Take Better Pictures from Your Car*. From the many photos I've seen, it's obvious that a great number of beginning and seasoned photographers take pictures leaning or looking out a car's open window. (Quite a few are taken through closed windows, too!)

I hate to admit my guilt, but I've taken a very limited number of pictures exactly the same way. Of course, my reason was the weather. It was either raining, snowing or too cold to leave the warm interior of the car. No matter what the reason, it isn't the best way to get quality pictures.

However, if you're prone to driving your car and stopping to take pictures, you might find a small beanbag support of value. It's a nice acces-

sory to rest on the edge of a car door to give your camera a little extra support and help prevent unnecessary camera movement. An added bonus is the protection it offers, preventing a camera or lens from striking metal.

The bean- (or sand-)filled bag isn't restricted to use when shooting from cars. It's also useful for close-up work at ground level, or it can be placed on a tree limb or tripod as a cushioned resting spot for a long telephoto lens.

No doubt you could use a needle and thread to hand-stitch the bag, but I've found that a few minutes of instruction from a friend on the workings of a sewing machine is well worth the time and effort. Once you know how the machine works, you can sew up a bag or two in just a few minutes.

Any fabric will work—nylon, canvas, suede, cotton, etc. The size of the bag will depend on your camera. The one illustrated here is for use with a 35mm single-lens reflex. It's nine inches long and about five inches wide, and is filled with small, uncooked white beans.

I don't usually carry the beanbag in my camera case. Instead, I keep it under the seat of my car, which is generally within walking distance from where I'm taking pictures. If I need the beanbag, I can go get it. There's no sense in hauling around extra weight if you are not going to use that particular piece of equipment.

This small beanbag is easy to make and helps give support to your camera, in addition to protecting it from unnecessary damage.

Impromptu Reflectors

Anything that's light in color can be used to reflect light. A white piece of cardboard, a painted wall, even tinfoil can act as a reflector to help throw needed light into a shaded area. Cardboard does not fold well for easy handling, and you wouldn't want to carry a 16"×20" piece of white cardboard if you're trying to be mobile. Tinfoil is lightweight and rolls up for easy storage, but it has a tendency to tear.

An alternative reflector, which can roll up to be easily carried, is window screen. It's not the kind used to keep out bugs, but is the kind placed directly on the window to keep out harsh light. One side is like a mirror. When fill light is needed, you can unroll the reflective window screen and position it to bounce flash or reflect natural sunlight.

Also, you might consider carrying a small mirror in the bottom of your camera bag. You'd be surprised how useful it can be for photographing small objects like flowers or insects.

I've met two specialized photographers who relied on mirrors for putting extra light where they wanted it. One was a nature photographer who specializes in bird pictures. All his photos were taken with long telephoto lenses to catch the birds in their natural habitats.

The birds, nesting or sitting in trees, were in heavy shade, but with the use of a large mirror the photographer could literally flash light onto the subjects, putting a little sparkle in their eyes.

You might think the reflected sunlight would scare the birds from their roosting place. So did I. As a test, I stepped into my backyard, armed

159

with a mirror, and commenced to flash light on every little dove and sparrow I saw. For the most part, the mirror's light did not bother the birds. What works for one photographer might work just as well for you.

The other photographer who used mirrors specialized in food pictures. Much of his work was done in a studio, using controlled lighting. He had two movable mirrors, which he used to add a touch of light to shadowed areas in the photos. Since he was using artificial light, he didn't have the harsh reflections sunlight would produce.

By using a small mirror you can actually flash light into shadowed areas.

Diffusion Screens

Often, diffused lighting is more pleasing than the bright light produced by the sun or by direct flash. Depending on the size of the subject and the light source, there are two easy ways to diffuse light.

Some flash systems offer diffusion screens which can be placed in front of the unit or, if the circumstances are right, can bounce the light off a wall or ceiling. However, when conditions aren't right and when the unit doesn't have an accessory diffusion screen, you can improvise by placing a clean white handkerchief over the flash. For a single exposure, use your hand to hold the cloth in place; for repeated usage of the flash, the handkerchief can be held securely in place using a rubber band.

If your camera and flash are automatic, you won't have to worry about adjusting exposure. The camera will do all the work for you. With manually operated equipment, you will have to compensate for the light reduction caused by the handkerchief. By bracketing your pictures one or two stops and allowing more exposure (e.g., if normal operation would be $f/8$, open up the lens one, one and a half, or two stops—$f/5.6$, $f/4$, etc.), you should get a properly exposed slide or negative.

If you plan to use a handkerchief regularly in your flash photography, you might want to run a test roll of film using the makeshift diffusion screen. Keep records of your f/stops and distances from the subject. When the film is processed you can decide what is the best exposure to use.

A hand-held diffusion screen is useful for shooting small objects like flowers, insects or whatever. Check with your local art supply dealer to see if he sells sheets of translucent acetate. The acetate is a flexible material, so you may want to purchase or make a wood frame and then attach the acetate using tape or staples. The frame will support the material and give you something rigid to hold on to.

When shooting, you hold the screen between the sun and the subject. No doubt it will be difficult to hold the screen in one hand and the camera in the other, so either secure the screen in place or mount the camera on a tripod.

Clamps

Every now and then, depending on your photography, you are going to need some sort of clamp to aid in your work. You might need a clamp to hold something up, or you might need it to hold an object out of the way.

A couple of clothespins tossed into a camera bag can be useful for holding small branches out of lens sight when doing nature studies. The pins can also be used to support a reflector or diffusion screen while you concentrate on your camera's operation and the photo's composition.

Besides the easily obtainable clothespins, browsing through a hardware store will give you a selection of clamps to choose from. For the most part, the clamps found in a hardware store will be heavier and stronger than the clothespins. If you need the added strength and your photography requires repeated use of clamps, they might be worth the investment.

Filters

If you've done much photography with filters, you know they can be expensive if you have to buy every single one. There are a couple of filters you can make, using a little ingenuity.

Do you like soft focus? If you do, one easy way to obtain the effect is to shoot through the fine weaving of women's nylon stockings or pantyhose. I'll admit the idea sounds rather foolish, but all you need is a small piece of the material, large enough to be stretched over the front of your lens.

By stretching the material over the front of the lens you can soften the image. It's difficult to focus through the material, so focus first, then

By placing a piece of nylon stocking over the front of your camera lens you can soften your pictures without investing in a soft-focus filter.

stretch the hose over the lens and hold it in place with your hand or a rubber band.

Another way to accomplish soft focus is by using petroleum jelly in front of the lens. Note that I said in front of the lens and not on the lens. The jelly is difficult to remove and there's a good chance that you'll scratch your lens when you try to remove it.

A very thin layer of petroleum jelly can be smeared on a clear filter like an ultraviolet (UV) or skylight. The effect depends on where you place the jelly and how thick it is. You can cover the whole filter, for total diffusion, or you can smear it just around the edges, allowing for sharp focus in the center.

When you're finished using the jelly-covered filter, take it off the camera and wrap it in a protective piece of cloth until you get a chance to wash it off with warm, sudsy water. The petroleum jelly catches all sorts of dirt and dust which, if you're not careful, can scratch the filter when you clean it.

Another easy-to-make filter is the cross screen. It's one of the filters you like to have in your bag, but it seldom gets used. At the same time, when you need the star effect it can produce, it's nice to know that the screen is safely tucked away in the bottom of your camera bag.

The filter is made using a fine-mesh window screen or similar material. Locate several types of screen and test them in front of your lens to see what sort of starlike effect is the most appropriate for your pictures. Once you've decided, you can keep the small piece of screen in the bottom of your bag and, when needed, hold it in front of the lens. If you prefer, buy step-up and step-down rings and cut the screen to fit between the two rings or purchase regular filter holders from your photo retailer.

One other special-effect method you might want to try is cardboard cutouts. The cutouts are held in front of your camera lens when you're taking pictures, to produce unusual shapes.

Take a piece of black cardboard and cut a small square, circle, triangle or other design out of the material. Hold the cutout in front of the lens and look through the camera's viewfinder. Move the cardboard toward and away from the lens; you'll see how the image changes. These cutouts are based on photographic wants more than on photographic needs. The gimmicks, as I call them, may appeal to some photographers while others may feel they aren't even worth trying.

Water Spray Bottle

A window cleaner, a spray bottle or a misting device is a common photographic tool used by nature and food photographers. Next time you see a picture of a pretty flower or a single vegetable covered with drops of water (giving the ap-

The flower on the right was hit with a spray of water from a trusty water bottle. You might want to carry a spray bottle if you plan to shoot flowers or plant foliage.

pearance that it has just been in a gentle rain), you can be fairly confident that the photographer has used a misting device.

Those little drops of water help perk up the subject and can add interesting light reflections. If you know you're going to be shooting flowers or certain still lifes, keep a spray bottle handy. If a little moisture will help the picture, give it a shot or two of instant rain.

Weather Protector

There's nothing quite as distracting to photography as adverse weather conditions. Heavy winds with blowing dust, rain or snow all play havoc with most equipment. Dust has a way of getting into the camera, causing scratches on the film every time you advance it for the next picture. Moisture from rain or snow has a way of condensing on the lens, or even on the mirror or the focusing screen inside the camera body. With these hazards one might decide to stick with fair-weather or indoor picture-taking—but you're better off running the risk of bad weather. Some of the better photographs are taken by photographers who risk their lives and equipment by tackling the elements.

With a basic investment in clear plastic bags, you can protect your equipment. Certainly the plastic bag will keep the rain off the camera, and if you work it just right, by cutting a hole here and there, you can even take pictures while the bulk of the camera stays protected.

Sudden changes in temperature, like walking from the ski lodge out onto the slopes, will cause condensation both inside and outside the camera. The only way to prevent the moisture build-up is to eliminate it. Again, plastic bags may help. One method is to place the camera in a plastic bag and then try to produce a vacuum by sucking all of the air out of the bag before you seal it. Before you use your camera in the change of environment, give it a chance to acclimate or adjust to the change in temperature. A little protection for your equipment is better than none, and may offer an opportunity to take the pictures you want.

Portable Blind

Any wildlife photographer knows the importance of a good blind. If you have the urge to try your hand at capturing animals in their natural environment, you might want to invest a little money and time in making a portable blind.

All that's needed, once you decide on the dimensions, are cardboard boxes, strong wrapping tape, and a few yards of camouflage material. The material can be purchased from fabric, sporting goods or army surplus stores.

The cardboard boxes are cut into panels of equal size and then joined together using the strong tape. A small space should be left between the panels when they are being taped together. This will allow you to fold up the blind for easy storage and carrying.

Once all the panels are joined, you can cover them with the camouflage material, using tape or some sort of adhesive such as white glue. When that's dry you're ready to fold up your blind and head for a likely spot in the wilderness.

The blind is unfolded and can be zigzagged so it stands on its own. You might want to add a few branches from indigenous plants to get the blind to blend with the surroundings. The next step is to set up the camera, and then comes the wait for the proper wildlife to get into lens range. Wildlife photography is for the patient or for those with extremely long telephoto lenses.

Fig. 4. A blind made from cardboard panels.

Studio Light Stands

Using selected wood, a tape measure, a drill, a screwdriver and a saw, you can make your own, not-so-portable light stands. They are to be used with studio lighting fixtures that have a spring clamp.

There are a number of ways to build the stands, and you'll need a minimum of three to get you started in studio photography.

Fig. 5. A studio light stand made from 2×4's.

The column portion of the stand will have to be six or eight feet tall. It's made from a 2×4 or a 1×3, which you can purchase from a lumber supply dealer. Be sure to choose straight wood.

While at the lumberyard you should pick up the base material, which can be either 4×4's or 2×4's. Each light stand will require about five feet of wood for the base.

Once all your materials and tools are gathered, you can construct the stands rather quickly. The bases are two lengths of 2×4's or 4×4's, notched and crossed so that they fit snugly together and lie flat on the ground (Fig. 5).

After the base is constructed, the upright is attached. You can use metal L's and wood screws so the columns can be put together and taken apart. An alternative is to nail the upright directly to the base.

The lights will clamp directly to the column. You may find that the clamps can't hold the light as well as the reflector and any other attachments you are using. Tape or even a small nail will keep the clamp in place while you are using the lights. Tape should also be used to hold the light's electrical cord to the column to keep it out of your way and prevent you from tripping over it.

I managed to survive studio photography for several years using these homemade light stands. When I was ready to commit myself to regular studio photography and could afford the cost, I purchased light stands which could collapse and be placed in carrying bags.

Backdrop Support

If you have decided to build the previously mentioned light stands, you might also want to consider making a backdrop support. If you do much portrait, product or still-life photography, you'll find backdrop papers of use. These seamless papers can be purchased in an array of colors and in various widths. Photo retailers generally sell the seamless paper, but I have found it to be less expensive when purchased from a retailer specializing in display materials for store

windows. Check in the yellow pages of your phone book under display fixtures and materials.

Make two supports just like the ones mentioned for the light stands, but use the heavier woods: 4×4's for the base and 2×4's for the eight-foot columns or uprights. When the stands are completed, you'll need to drill two one-inch holes, one near the top of each column. Then you'll need to insert one-inch-diameter dowels into the holes. (Two-foot-long dowels should be adequate.) Six inches should stick out one side of the column, and the other 18 inches should protrude out the other. These dowels will hold the seamless paper, which will slide over the 18-inch lengths.

When you're ready to use the backdrop, just pull it down so it rests on the floor. You'll have eight feet of clear background for taking clean portraits or for photographing whatever subject you choose. When you finish shooting pictures, just roll the seamless paper back up on its roll.

Light Box

If you take slide or transparency pictures, you'll know they're difficult to view unless you have a slide projector or a light box. It's extremely difficult to edit transparencies looking at one picture at a time. It's easier to lay them on a backlighted surface and compare color saturation, composition, focus, etc.

You can purchase elaborate light boxes as well as simple ones. Likewise, with a few tools, materials, and your own design, you can make a light box to fit your individual needs.

The first consideration is the size of your transparencies. If you shoot 35mm slides you may want to look at one or two rolls (20 or 36 exposures) of film at a time. If so, the dimensions of your light box should be large enough to hold two rolls of processed film. If you shoot large-format film, such as 4″×5″, you need a large light box so you can view several transparencies. The number depends on what is comfortable for you.

Once the dimensions of your light box are written down, you'll need to buy the materials. These consist of wood for the frame or box portion, a white Plexiglas viewing surface, which can be purchased from many glass and mirror

This homemade light box is large enough to hold three rolls of 36-exposure slides for editing and sorting. An afternoon of cutting wood, nailing, gluing and wiring was all it took to make a useful photographic accessory that should last a long time.

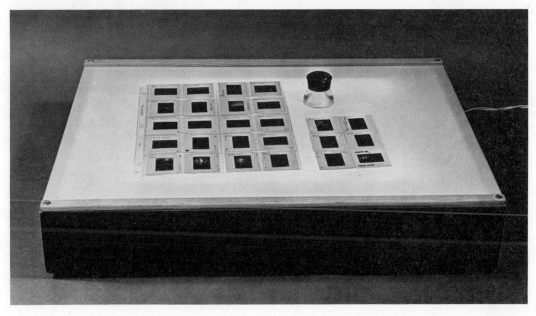

dealers, and fluorescent light fixtures, which come in an assortment of lengths. Regular incandescent light bulbs produce too much heat and will melt the Plexiglas viewing surface.

When making the light box, build it deep enough so that the fluorescent fixtures can be placed vertically instead of horizontally; this will give you nice even lighting, without any unnecessary shadows.

A little wiring, plus adding an in-line switch to the electrical cord, and you're done. No longer will you have to load up the slide projector for editing slides—nor, if you're a large-format photographer, will you have to hold the transparency to a lighted window, trying to decide whether it's as sharp as it could be.

These two electronic cable releases serve the same purpose, and both work well. However, one cost just a couple of dollars while the other cost more than ten.

Electronic Cable Release

Early in this book I discussed cable releases and mentioned that some motor drives and winders require a special cable release to work. You can buy the cable releases from photo retailers or, for quite a bit less money, you can make your own.

You don't need to know too much about your camera except that it needs an electronic cable release. Take your camera and winder or motor drive to a Radio Shack or other store that sells electronic equipment. Tell a knowledgeable sales clerk what you're looking for. He or she should be able to help.

Illustrated here are two electronic cable releases. One is an Olympus relay cord I purchased for about $11.00. It looks nice and it works. The other electronic cable release, for use with an Olympus Winder I, is made with a square push-button switch, 24-gauge speaker wire, and a sub-miniature plug. I borrowed a soldering iron to make the connections. The total cost was under three dollars. It's not nearly as refined as the Olympus relay, but it works—and I can make it any length I want or need.

With the money I saved I can buy a roll of film and have it processed. If you're budget-minded, cost-saving equipment you can make is something to consider.

This simple-to-make tripod catch bag was made of scrap canvas. It's only used when the tripod is going to be left in one place for an extended period of time.

Tripod Catch Bag

For the first project in this chapter, the beanbag support, I said that it was worth the time and effort to learn how to use a sewing machine. This project and the next require sewing machine knowledge. Both are simple to make and useful.

The tripod catch bag is for use whenever you use a tripod in a stationary position for an extended period of time, such as for studio work. It will enable you to change filters or lenses quickly and give you someplace to put them without having to take time to stick them in a lens case or back into a camera bag.

The triangular catch bag illustrated here was made from scrap canvas material. Three loops were sewn to the triangle's corners, and then the legs of a tripod were inserted into each of the loops. When the catch bag stretches out, it will stop sliding down the widespread legs of the tripod. The one you make will depend on the size of your tripod. You can guess at the dimensions; unless you make the loops and the triangle too big, the bag will stop sliding down the legs of the tripod at some point. Ideally, you want the bag just below the head of the tripod, within easy reach.

Using this method, you can place all the accessories you might need within easy reach before you start taking pictures. When you take something off the camera, you can place it in the catch bag. When you're all done shooting for the day, you can put everything back in its proper place until you're ready to take pictures again.

167

All dressed up and no place to go? Stalking through the desert, it's easier to carry a tripod in some sort of case. This one was made from canvas.

Tripod Carrier

A tripod is a bulky and unruly thing to carry. You pick it up by the head or by a leg, and two or three legs spread apart. A rubber band around the legs will keep them together, but it's still difficult to handle the thing.

Several tripod manufacturers sell tripod carriers for their equipment. A simple alternative is to make your own. A heavy material should be used, because tripods are heavy and their con-

stant rubbing against the fabric could eventually wear a hole through the material. Canvas or a heavy denim would be the best material for the carrier.

Measure your tripod when it's folded and the legs are compressed. That's the size bag you'll need. Make one or two carrying straps, one for hand carrying and one for shoulder carrying. Add a flap, sew on a couple of pieces of Velcro, and it's done. If you know what you're doing, you can have the bag done in thirty minutes or less.

Buy It or Make It, but Use It

This chapter has been a collection of camera tools and equipment I've made and used regularly at one time or another. The ideas were not put together to take up space in the book, but to give you an idea of what a little imagination, time and money can do to help you get the photographs you want. Photography equipment helps in taking pictures, but the photographer, who knows how to use these tools and understands the principles of quality pictures, is the one who clicks the shutter and captures the image on film.

Owning every accessory made for your camera will not guarantee good pictures. I'm sure there are people who use nothing but a simple, one-lens camera and take good pictures with some degree of consistency. At the same time, I'm sure there are people who own the finest photographic equipment made and never take good pictures except on rare and unexpected occasions.

I have a group of friends who meet once or twice a week for lunch or dinner. They may talk about politics, gold prices, or other current events, but most of the time they talk about photography and photographic equipment. They all own equipment ranging from moderately priced to costly. Some of the individuals take pictures on a regular basis and the others seem to collect equipment, wheeling and dealing at every chance

they get. They may buy a new lens or camera body just to have it a few days to hold it, study its construction and then sell it. They love well-made cameras and treat them like jewels. I know they are all capable of taking good pictures, if not outstanding ones, but they seldom do.

Knowing this group is like having a talking photographic equipment library. One of the members will have an answer to any question. If you need a piece of specialized photo equipment, they'll know where it can be purchased at a reasonable price.

At first, you envy the group for their knowledge, but at the same time you realize that they are missing out on the biggest part of photography—taking good pictures. Photography is an opportunity to capture a split second of life—a piece of life that's here one-thousandth of a second and then gone. Sure, there are some pictures you can take more than once, especially if you are in a controlled environment like a studio. Then there are the pictures that can't be duplicated—your baby's first step or first birthday, your first house or car . . . the list could go on and on. Pictures can rekindle memories of yesterday, today and tomorrow if you're willing to take the time to aim the camera and click the shutter.

As a beginning photographer, you have an opportunity to gear yourself toward quality picture-taking without getting too involved with the mechanics and accessories. There's no harm in knowing what's available for various photographic situations. Then, if the accessory is needed, you can get it and use it properly.

Somehow there has to be a happy medium between camera equipment and a photographer's visual understanding. It's possible that a camera body, three lenses, a filter or two, a tripod and one or two other accessories will enable the photographer to capture all the precise images he wants on film. If there were such a medium, I wish I knew what it was. Then I wouldn't have to say, "I could have gotten that picture if only I had . . ." The statement is one of my favorite excuses for not getting good pictures, and it also gives me a reason to purchase more photography-related equipment.

Annotated Bibliography

It's doubtful that any one person will have all the answers to your photographic questions. There's far too much photography-related information to put into a single book, if it's to be presented with any detail.

Purchase, borrow and read pertinent books, magazines and pamphlets to learn what you can about photography and its related equipment. Keep in mind that each book will have its limitations. One pitfall of certain publications is the time involved to organize, research, write, rewrite and eventually publish. By the time a magazine is published, three months may have passed since one of its stories was started in a typewriter. Books may take one, two or even three years before they end up in the library or on the shelf of your local bookstore, and after that much time has passed some of the contents may be out of date. Photo magazines like *Modern Photography* and *Popular Photography* will keep you as up to date as possible on photographic trends.

Once you comprehend the possible limitations of the printed word, delve into the pages of a variety of publications. There is certainly a vast selection to choose from. By studying the work of other photographers you can start to learn style, technique and the elements that make quality photographs.

If necessary, to improve your photographic skills, mimic the work of others. When that's successfully accomplished and the skill is acquired, develop your own style. It would be simple to say that the more pictures you take, the better you're going to get. That's not necessarily true, unless you study the pictures and learn from each mistake. If you don't have someone, such as a skilled photography teacher, to constructively criticize your work, you're going to have to rely on the words and illustrations that cover the pages of books and magazines.

On the following pages I've listed a limited number of photographic books that would be of interest to the beginner. It's very difficult to keep up with all the new books being released from various publishers. The best way is to stop by a well-stocked bookstore and browse through their photo section, picking up the ones that stimulate your interest. If you think the book has information you'll need, buy it or write down the title and author; then pay your local library a visit to see if they have it on their shelf. Photo books, like camera equipment, should give you a return on your investment by teaching you the art of photography, whether in words or by showing you the work of other photographers.

By Author:

Davis, Phil. **Photography.** Dubuque, Iowa: Wm. C. Brown Co., 1972. (*This happens to be the book that introduced me to the world of photography. The third edition was published in 1979.*)

Hattersley, Ralph. **Beginner's Guide to Photography.** Garden City, New York: Doubleday & Company, 1974.

———. **Beginner's Guide to Darkroom Techniques.** Garden City, New York: Doubleday & Company, 1976.

———. **Beginner's Guide to Photographing People.** Garden City, New York: Doubleday & Company, 1978.

———. **Beginner's Guide to Color Photography.** Garden City, New York: Doubleday & Company, 1980. (*Hattersley has been around as a photographer, teacher, and regular contributor to* POPULAR PHOTOGRAPHY *magazine. He says, "Some of the ideas are very far out, but nobody is asked to believe them." His books are lessons in photography and style from a unique individual.*)

Hedgecoe, John. **The Photographer's Handbook.** New York: Alfred A. Knopf, 1979. (*A comprehensive, attractive and useful book filled with choice illustrations. A good book for the serious photographer.*)

Snyder, Norman; Kismaric, Carol; and Myrus, Don. **The Photography Catalog.** New York: Harper & Row, 1976. (*A big, somewhat dated book with a variety of information on equipment, techniques and sources.*)

Jacobs, Lou, Jr. **How to Take Great Pictures with Your Single-Lens Reflex.** 1977.

Shipman, Carl. **Understanding Photography.** 1974.

———. **SLR Photographers Handbook.** 1977.

———. **How to Select & Use Canon SLR Cameras.** 1977.

———. **How to Select & Use Pentax SLR Cameras.** 1977.

———. **How to Select & Use Nikon & Nikkormat SLR Cameras.** 1978.

The Eastman Kodak Company. Rochester, New York. (*Manufacturers of cameras, film and equipment. They understand photography and produce a number of useful reference books.*)

Adventures in Existing-Light Photography.
Kodak Films—Color & Black-and-White.
Filters and Lens Attachments.
Better Instant Pictures with Kodak Instant Cameras.
Adventures in Color-Slide Photography.
Encyclopedia of Practical Photography (14 volumes).
Photo Decor—A Guide to the Enjoyment of Photographic Art.
The Joy of Photography. (Published by Addison-Wesley Publishing.)

By Publisher:

American Photographic Book Publishing Company (AMPHOTO). Garden City, New York. (*Amphoto specializes in photography-related books and has a wide assortment to choose from. A random selection of interest to beginning photographers is listed below.*)

Avon, Dennis; Hawkins, Andrew. **Photography: A Complete Guide to Technique.** 1979.

Heiberg, Milton. **The Olympus Guide.** 1978. (Somewhat dated.)

———. **The Yashica Guide.** 1979.

Laurence, Mike. **The Canon Guide.** 1979.

Mitchell, Bob. **Amphoto Guide to Travel Photography.** 1979.

Smith, Robb. **Amphoto Guide to Filters.** 1979.

H. P. Books. Tucson, Arizona.
(*A relatively new publishing house that is expanding their photography book line yearly.*)

Dennis, Lisl. **How to Take Better Travel Photos.** 1979.

Petersen Publishing Company. Los Angeles, California. (*A complete line of inexpensive books from the publisher of Petersen's* PHOTOGRAPHIC *magazine.*)

Brooks, David. **Figure Photography.** 1974.

Helprin, Ben. **Photo Lighting Techniques.** 1973.

Jacobs, Lou, Jr. **Basic Guide to Photography.** 1973.

Lahue, Kalton C. **Petersen's Big Book of Photography.** 1977.

———. **Interchangeable Lenses.** 1975.

Owens, William J. **Close-Up Photography.** 1975.

Yob, Parry C. **Photo Equipment You Can Make.** 1973.

———. **Photo Equipment You Can Make,** Volume 2. 1976.

Time-Life Books. New York, New York.
(*A series of books in the Life Library of Photography. There are seventeen volumes plus a yearly addition called* Photography Year. *Most are well worth the investment.*)

Photography as a Tool.
Special Problems.

The Print.
Great Photographers.
The Great Themes.
Travel Photography.
The Studio.
Light and Film.
Color.
The Camera.
Frontiers of Photography.
Caring for Photographs.

The Art of Photography.
Photographing Children.
Photojournalism.
Photographing Nature.
Documentary Photography.

The preceding list of books is just a sample of what is available. There are numerous other titles covering the work of individual photographers. By studying their work you can learn about style and technique.

Directory of Manufacturers and Distributors

The following manufacturers, distributors and wholesalers are listed to help you in searching for photographic equipment and information. The first place to look is your local photo supply dealer. The retailer should have a supply of brochures or pamphlets describing various merchandise. If your local camera shop can't be of help, use the following addresses to write for specific information.

AIC Photo, Inc.
168 Glen Cove Road
Carle Pace, New York 11514

Arm Rest Products
188 Industrial Drive Suite 16
Elmhurst, Illinois 60126
(*Manufacturer of camera and binocular support devices.*)

Asanuma Corporation
1639 E. Del Amo Blvd.
Carson, California 90746
(*A wide range of various mount lenses and assorted camera equipment, e.g. tripods, cases, filters, flash brackets, lens hoods, etc.*)

Bell & Howell/Mamiya Company
7100 McCormic Road
Chicago, Illinois 60645
(*Mamiya cameras, lenses and accessories.*)

Berkey Marketing Companies, Inc.
25-20 Brooklyn-Queens Expressway West
Woodside, New York 11377
(*Ascor lighting, light meters, Slik tripods, view cameras, Konica, ZERO Halliburton camera cases.*)

Bogen Photo Corporation
100 South Van Brunt Street
Englewood, New Jersey 07631
(*Studio equipment: studio light and camera stands, Bowens Nonolite, reflectors, specialty cameras, slide copier, etc.*)

Braun North America (BNA Photo)
55 Cambridge Parkway
Cambridge, Massachusetts 02142
(*Braun electronic flash and related photographic equipment.*)

The Brewster Corporation
50 River Street
Old Saybrook, Connecticut 06475
(*Lighting and background setups, portable panels, light reflectors.*)

Calumet Scientific, Inc.
1590 Touhy Avenue
Elk Grove Village, Illinois 60007
(*Calumet view cameras, lenses, Horseman cameras, tripods, electronic flash systems, quartz lighting.*)

Canon USA, Inc.
10 Nevada Drive
Lake Success, New York, 11042
(*Canon cameras and accessories.*)

Celestron International
2835 Columbia Street
Torrance, California 90503
(*Celestron telescopes and accessories.*)

Chinon Corporation of America
43 Fadem Road
Springfield, New Jersey 07081
(*Chinon photographic equipment.*)

Coast Photo Manufacturing Company
118 Pearl Street
Mt. Vernon, New York 10550
(*Coastar lenses, tripods, cable releases, flash brackets, camera cases, and other photographic accessories.*)

Dot Line Corporation
11916 Valerio Street
North Hollywood, California 91605
(*Light meters, camera straps, tripods, cable releases, eyecups, bellows, filters—a complete line of camera accessories.*)

Eastman Kodak Company
343 State Street
Rochester, New York 14650
(*Films, cameras, filters, and a complete line of photography-related books and literature.*)

Edmund Scientific
101 E. Gloucester Pike
Barrington, New Jersey 08007
(*Special-effect filters, special lenses; write for catalog.*)

Ehrenreich Photo Optical Industries (EPOI), Inc.
101 Crossways Park West
Woodbury, New York 11797
(*Nikon, Bronica, Metz lighting and other photographic equipment.*)

Focus Photographic Outfitter
P.O. Box 1005
Kalispell, Montana 59901
(*A unique line of camera cases and a photographer's vest.*)

Fuji Photo Film Company, Ltd.
350 Fifth Avenue
New York, New York 10001
(*Fuji cameras and equipment. Fuji color films.*)

Ikelheimer-Ernst, Inc.
601 West 26th Street
New York, New York 10001
(*Fiberbilt camera cases.*)

Ilford Inc.
70 West Century Road
Paramus, New Jersey 07652
(*Ilford films, photographic papers and chemicals.*)

Kalt Corporation
Box 511
2036 Broadway
Santa Monica, California 90406
(*A vast selection of camera accessories. Tripods, film holders, light meters, flash units, reflectors, camera bags, etc.*)

Keystone Camera Corporation
468 Getty Avenue
Clifton, New Jersey 07015
(*Electronic flash and Keystone cameras.*)

Kuban Hitch Company
5280 N.E. Main
Minneapolis, Minnesota 55421
(*A special camera strap that holds the camera securely in place, allowing freedom of movement.*)

Larson Enterprises, Inc.
P.O. Box 8705
18170 Euclid Street
Fountain Valley, California 92708
(*Reflectasol, portable backgrounds, and other accessory lighting equipment.*)

E. Leitz, Inc.
Link Drive
Rockleigh, New Jersey 07647
(*Minox and Leica cameras, B + W filters.*)

Lowel-Light Manufacturing
421 W. 54th Street
New York, New York 10019
(*Location lighting systems and their accessories.*)

Minolta Corporation
101 Williams Drive
Ramsey, New Jersey 07446
(*Minolta cameras and their accessories.*)

Nikon Inc.
623 Stewart Avenue
Garden City, New York 11530
(*Nikon cameras, lenses and accessories.*)

Olympus Camera Corporation
145 Crossways Park West
Woodbury, New York 11797
(*Olympus cameras, Zuiko lenses and accessories.*)

Osawa & Company (USA) Inc.
521 Fifth Avenue
New York, New York 10017
(*Lenses, filters, tripods, flash accessories, etc.*)

Pentax Corporation
9 Inverness Drive East
Englewood, Colorado 80112
(*Pentax cameras and accessories. Introduced the first system 110 pocket camera with interchangeable lenses and winder.*)

Polaroid Corporation
549 Technology Square
Cambridge, Massachusetts 02139
(*Polaroid instant cameras and film.*)

Rollei of America, Inc.
Box 1010
Littleton, Colorado 80120
(*Rollei cameras and accessories.*)

Safari Camera Case, Inc.
P.O. Box 19971
Houston, Texas 77024
(*A solid, lightweight case for 35mm cameras with telephoto lens attached.*)

Smith-Victor Corporation
301 N. Colfax Street
Griffith, Indiana 46319
(*A good assortment of supporting lighting systems, light stands, reflectors, etc.*)

Spiratone, Inc.
135-06 Northern Blvd.
Flushing, New York 11354
(*Lenses, filters, camera cases and a wide assortment of camera accessories via mail order. Send for current catalog.*)

Tasco Incorporated
1075 N.W. 71st Street
Box 380878
Miami, Florida 33138
(*Binoculars and the Tasco binocular with built-in 110 camera.*)

Tenba
510 Broadway
New York, New York 10012
(*A rugged line of camera cases.*)

Testrite Instrument Company
135 Monroe Street
Newark, New Jersey 07105
(*Tripods, copy stands, lighting accessories.*)

Tiffen Manufacturing Corporation
90 Oser Avenue
Hauppauge, New York 11787
(*A good assortment of photographic filters.*)

Unitron Instruments, Inc.
101 Crossways Park West
Woodbury, New York 11797
(*Sigma lenses, Bronica cameras, and electronic flash.*)

Velbon International Corporation
2433 Moreton Street
Torrance, California 90505
(*All types of camera tripods.*)

Vivitar Corporation
1630 Stewart Street
Santa Monica, California 90406
(*Quality lenses, filters, tripods, cameras and flash units.*)

Yashica, Inc.
411 Sette Drive
Paramus, New Jersey 07652
(*Yashica cameras, Contax cameras, lenses, flash units and Yashica accessories.*)